P9-CDI-812

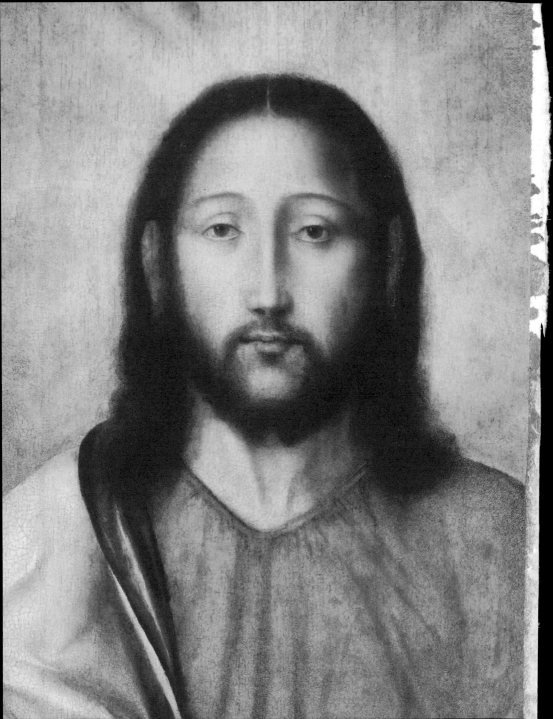

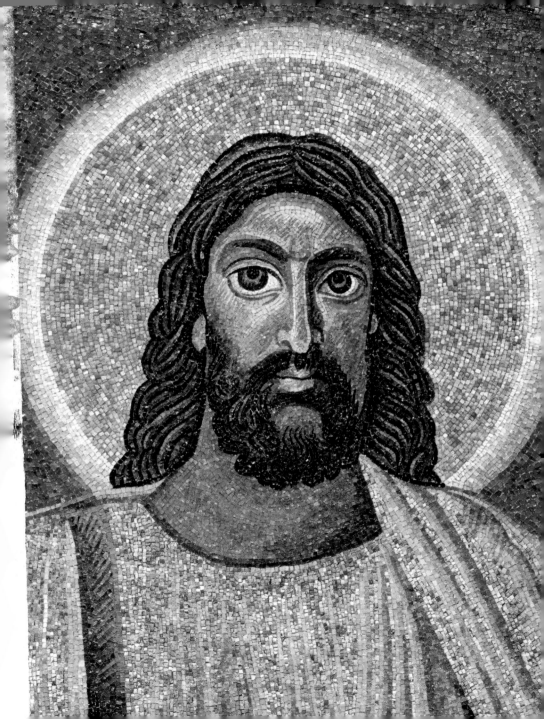

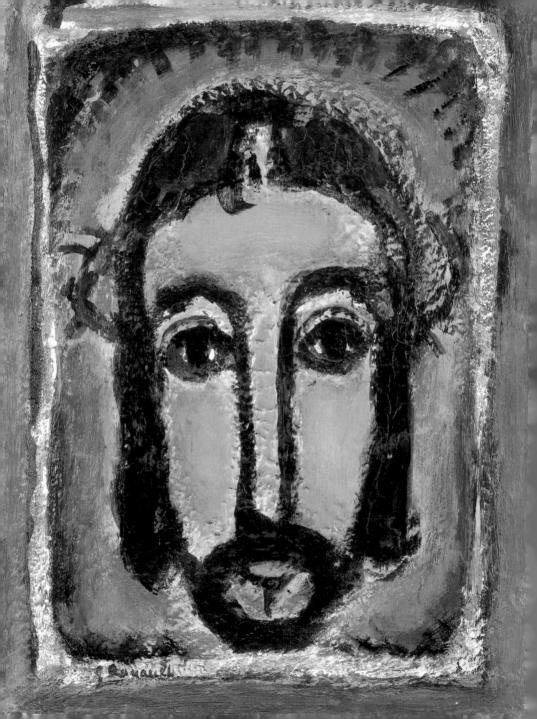

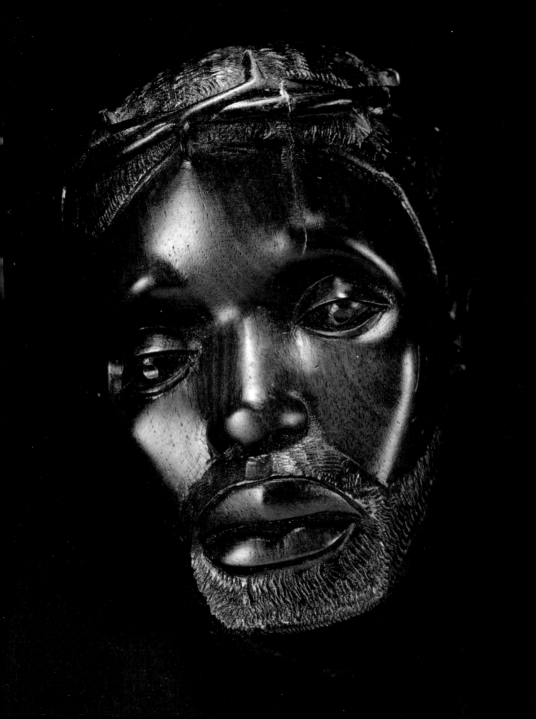

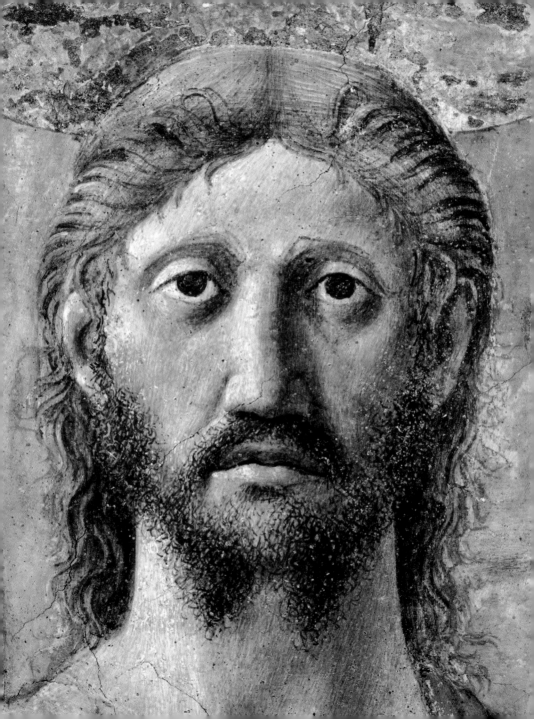

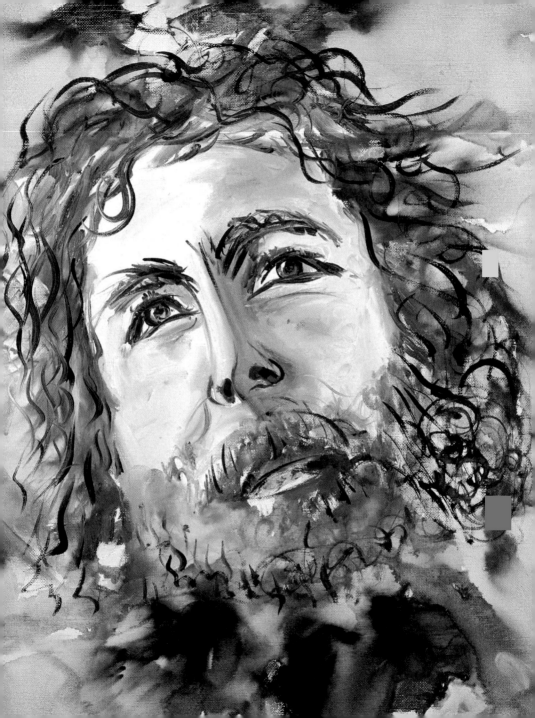

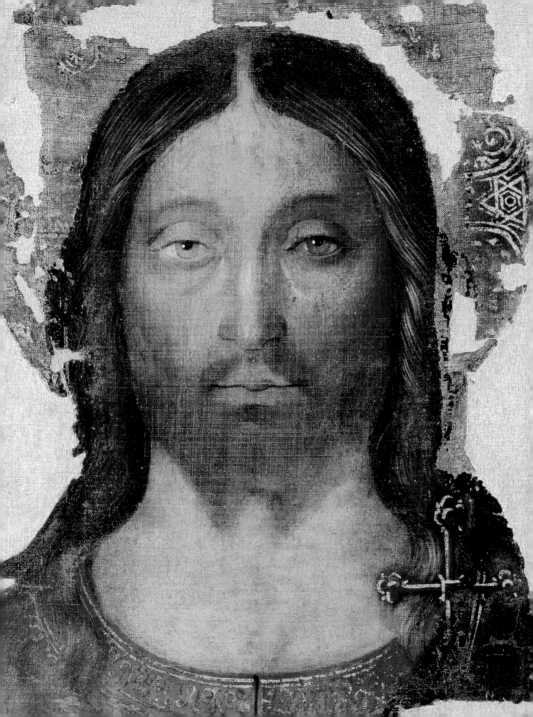

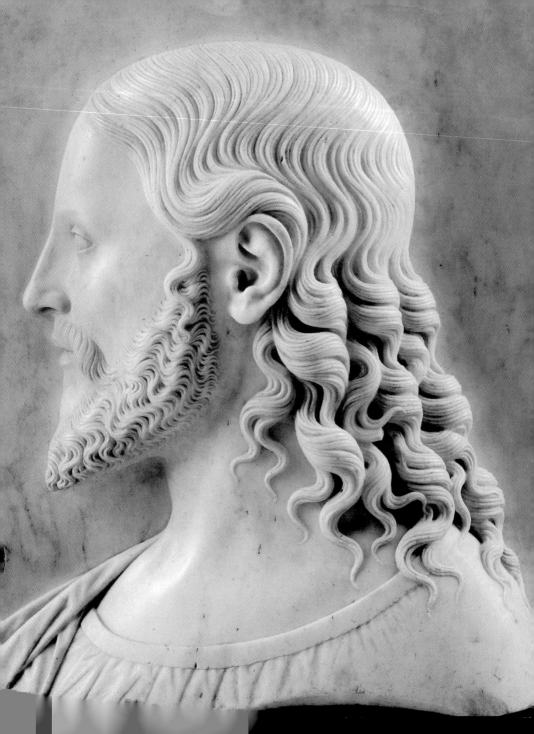

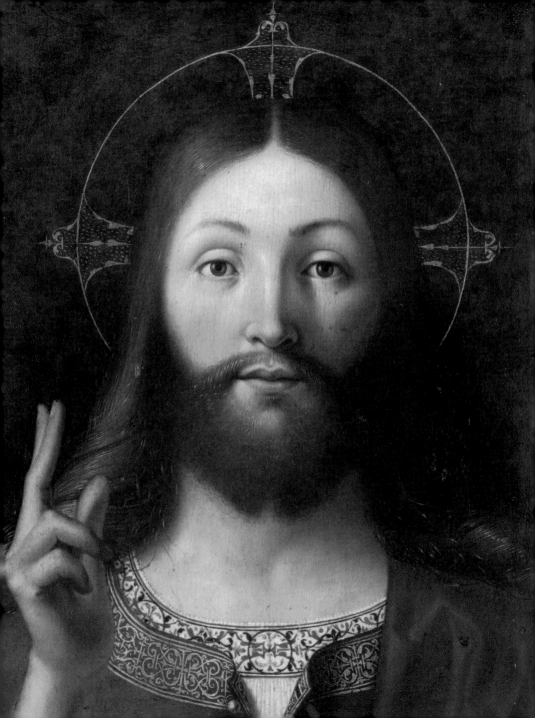

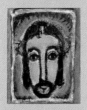
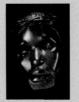
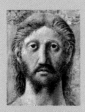
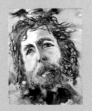

THE FACE OF JESUS **9**

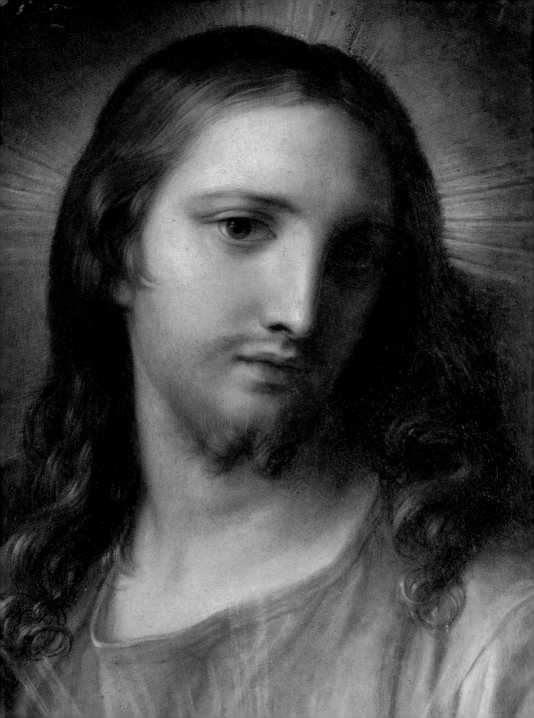

THE FACE OF JESUS

EDWARD LUCIE-SMITH

Abrams, New York

Library of Congress Cataloging-in-Publication Data

Lucie-Smith, Edward.
 The face of Jesus / Edward Lucie-Smith.
 p. cm.
 Includes index.
 ISBN 978-1-4197-0080-4
 1. Jesus Christ—Art. 2. Jesus Christ—Biography. 3.
Christian art and
symbolism. I. Title.
 N8050.L73 2011
 704.9'4853—dc22

 2011014140

Published in 2011 by Abrams, an imprint of ABRAMS.
All rights reserved. No portion of this book may be
reproduced, stored in a retrieval system, or transmitted
in any form or by any means, mechanical, electronic,
photocopying, recording, or otherwise, without written
permission from the publisher.

Printed and bound in Italy
10 9 8 7 6 5 4 3 2 1

Abrams books are available at special discounts when
purchased in quantity for premiums and promotions as
well as fundraising or educational use. Special editions
can also be created to specification. For details, contact
specialsales@abramsbooks.com or the address below.

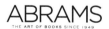

ABRAMS
THE ART OF BOOKS SINCE 1949

115 West 18th Street
New York, NY 10011
www.abramsbooks.com

PAGE 10 **Sacred Heart**
Pompeo Batoni
1708–1787

RIGHT **Christ**
Maria Martins
1910–1973

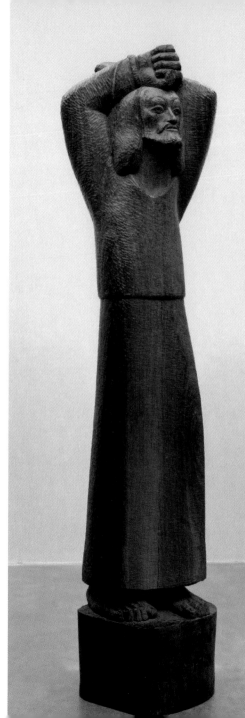

CONTENTS

INTRODUCTION

The image of Christ—particularly the face of Christ—is the central subject of Christian art. It is, therefore, the most important image in Western art from the time of the conversion of Emperor Constantine in 312 AD until the present. As Christianity spread beyond the boundaries of the Middle East, where it began, and Europe, where it originally flourished, this image became important in other cultural contexts as well. My aim is to describe this process, following the progress of Christ's mission on earth by linking images from many periods of art to the narrative offered by the Gospels.

Many people are convinced that they know exactly what Christ looked like— a handsome man, just leaving youth for full maturity, with a broad, open brow, long hair, and a beard. In fact, the Gospels give us no physical description of Christ. The nearest they get to it is in a passage in St. Matthew, where Judas kisses Christ so that the soldiers who have come to arrest him can tell him apart from his disciples (Matthew 26.48). This suggests that Christ looked very much like the other Jewish men of his native Palestine, with no distinctive physical features. The anti-Christian author Celsus, who lived in the second century, described Jesus as "short and ugly." Early Christian theologians, such as Justin Martyr, who also lived in the second century, agreed that Jesus was physically unprepossessing, "with no beauty that we should desire him."

It was only two centuries later that a tradition grew up, sponsored by Church fathers such as St. Jerome and St. Augustine of Hippo, that Jesus was ideally beautiful in face and body. For Augustine he was "beautiful as a child, beautiful on earth, beautiful in heaven."

The earliest images of Christ are inconsistent. Some show him as a beardless shepherd boy, carrying a lamb on his shoulders. Others depict him as a variant of the pagan father gods, Zeus and Serapis. It was this second tradition that prevailed, because it offered an easy transition to the idea of the risen, eternal Christ as

Good Shepherd
Early Christian sculpture
c. 250 AD

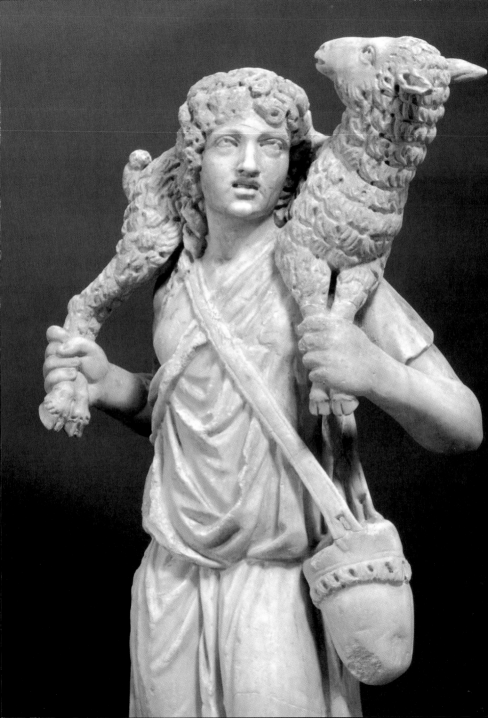

ABOVE **Christ of Mercy (detail)**
Byzantine mosaic
c. 1100

ABOVE **Head of Christ from Lorsch**
Sculpture
Early 12th century

the moral arbiter and ruler of all things. The supposedly miraculous image imprinted on the Turin Shroud clearly exercised a major influence over subsequent depictions, but it is worth noting that this emerged into public view as late as 1390, nearly a millennium and a half after Christ's death on the cross.

Images of Christ, while usually adhering in a loose way to the convention described—long hair, a beard, and features more Caucasian than Semitic—vary quite widely. More widely, indeed, than many believers are prepared to admit. They are formed and reformed according to both religious and cultural circumstances, and respond to changing styles of figurative art. In this book, I look at some of these changes, and at the same time demonstrate how the underlying archetype, once fully developed, tended to remain the same. Its claim to authenticity, however, is not based on history as such, but on the fact that so many people continue to recognize and believe in it. If we have any kind of Christian background

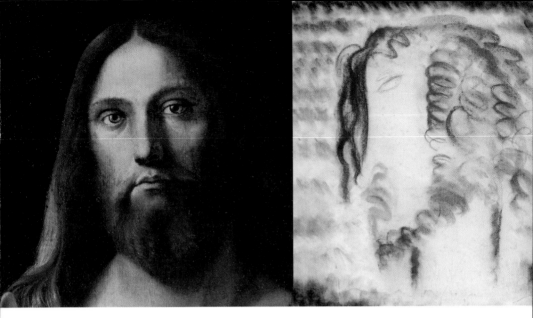

Above Salvator Mundi (detail)
Benedetto Diana
1460–1525

Above Head of Christ
Jean Fautrier
1898–1964

(and even among those who count themselves as skeptics or unbelievers), this archetype is inextricably bound to our culture.

The variations to be found in the images of Christ spring from not one but several different sources. The first source is theological. The Byzantine church, and the various churches of the Orthodox rite that were its successors, produced images that were more otherworldly, less directly human, than those that were made in the West. The images of Christ produced in this context tended to emphasize holiness and spiritual power rather than common humanity. They used a highly developed symbolic language to present complex religious ideas in a way that made these accessible even to the illiterate. Byzantine images of the Pantocrator ("ruler of all") are examples of this.

In Western art, which was for many centuries purely Catholic, the emphasis was increasingly placed on the dramatic nature of Christ's mission. Christ's facial

expressions were an important part of the Gospel narrative—compassionate, illuminated with spiritual power, or suffering both physically and spiritually to redeem humankind.

The new naturalism introduced into art by the great painters of the Renaissance equipped artists to portray many nuances of facial expression. This ability became linked to the theological ideas introduced by St. Ignatius of Loyola (1491–1556), founder of the Jesuit Order, in his Spiritual Exercises. The worshiper was encouraged to identify very directly with the sufferings of Christ. To contemplate the face of Christ, as seen in a painted image or a sculpture, became a matter of personal empathy. The more realistic and dramatic the image, the easier it became to reach this state of mind.

The stylistic development of Western painting and sculpture went hand in hand with this theological evolution. Baroque art, with its emphasis on openly expressed emotion, is in a very real sense the child of St. Ignatius's approach to

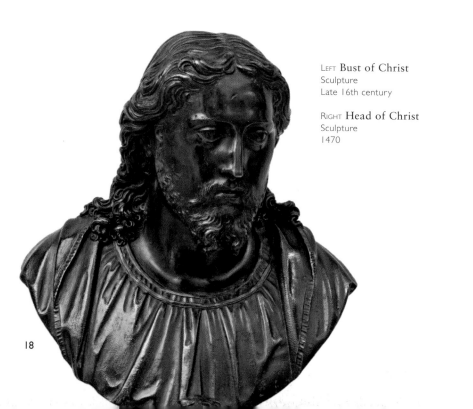

LEFT **Bust of Christ**
Sculpture
Late 16th century

RIGHT **Head of Christ**
Sculpture
1470

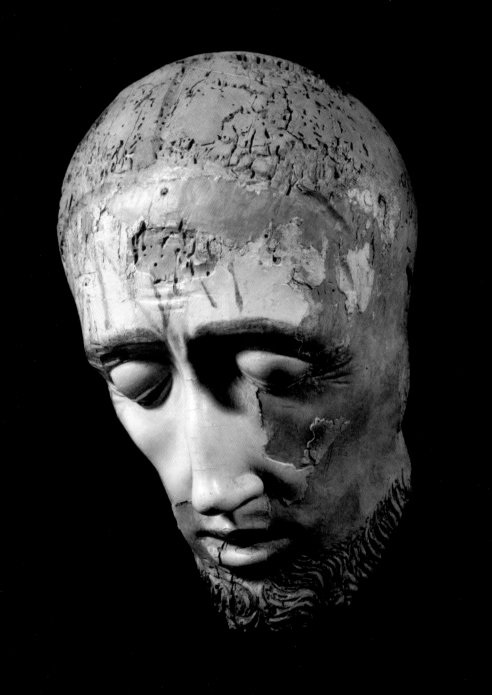

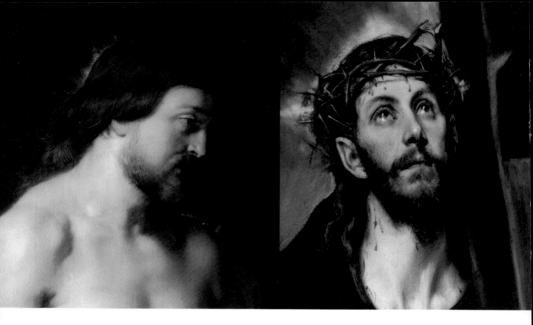

Above **Rockox Triptych (detail)**
Peter Paul Rubens
1577–1640

Above **Christ Carrying the Cross (detail)**
El Greco
c. 1541–1614

theology. Nowhere was the idea of physical and mental agony more openly expressed than in the images of Christ's Passion produced by leading Baroque artists such as Rubens.

Baroque artists created a typology for the depiction of Christ, and in particular for the portrayal of Christ's features, that is still in use today. It has developed in three different but related ways, all of them highly significant. In the first place, there has been a search for ways to make portrayals of Christ relevant to Christians who may come from many ethnic backgrounds—images that reflect the status of Christianity as a universal religion. Secondly, Baroque painting has been a major source of inspiration for filmmakers—the democratic art form of our time. Films of the life of Christ almost invariably refer to paintings from this epoch. Thirdly, and perhaps even more significantly, images of Christ very clearly inspired by source material of this kind have become part of popular culture. The paintings of Rubens and his peers are now the inspiration for T-shirts, and even for tattoos.

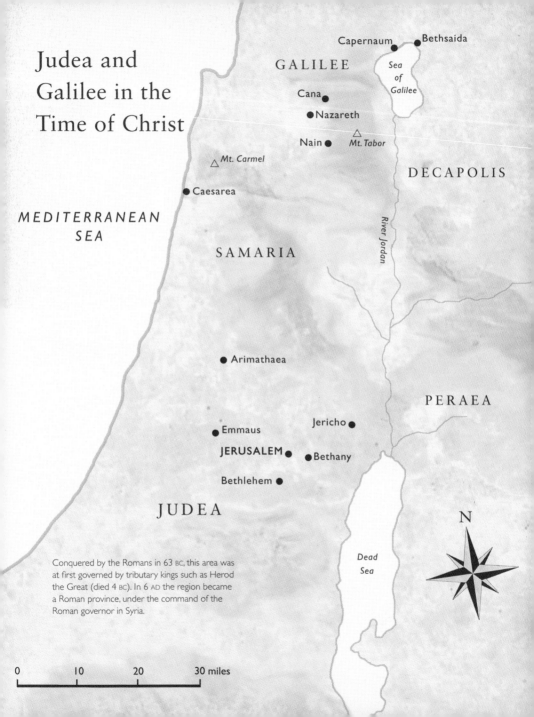

Judea and Galilee in the Time of Christ

Capernaum
Bethsaida
GALILEE
Sea of Galilee
Cana
Nazareth
Nain
Mt. Tabor
DECAPOLIS
Mt. Carmel
Caesarea
MEDITERRANEAN SEA
SAMARIA
River Jordan
Arimathaea
PERAEA
Emmaus
Jericho
JERUSALEM
Bethany
Bethlehem
JUDEA
Dead Sea
N

Conquered by the Romans in 63 BC, this area was at first governed by tributary kings such as Herod the Great (died 4 BC). In 6 AD the region became a Roman province, under the command of the Roman governor in Syria.

0 10 20 30 miles

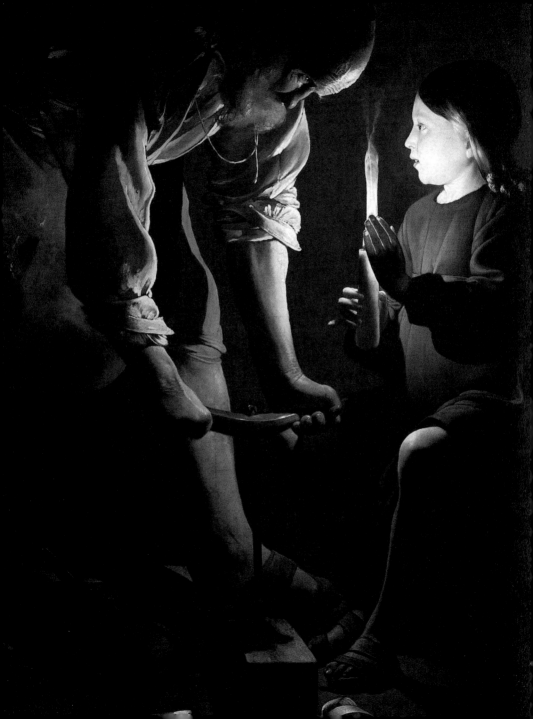

BIRTH AND EARLY LIFE

THE STORY OF CHRIST'S BIRTH IN A STABLE, celebrated by humble shepherds watching in the fields, by Wise Men traveling from afar, and by angels singing in the heavens, is one of the most famous in the world. It is known to and touches the hearts of all Christians, and has inspired myriad wonderful works of art. It is one of the most important scenes in the narrative of Christ's life on earth.

Yet there are aspects that believers aren't always fully aware of, so deeply imbedded is the story in our collective consciousness. One is that the narrative appears in only two of the four canonical Gospels—Matthew and Luke—but not in Mark or John. The two evangelists tell the story in different ways. It is Luke, for example, who tells us about the shepherds who came to worship, but not about the Wise Men. In Matthew, it is the other way round. Only Matthew describes the hurried Flight into Egypt, to escape from assassins sent by Herod. Christ's birth was miraculous, and it was immediately recognized as such, both in the heavens and by mortal men. Precisely because of this, Christ's life was immediately plunged into danger.

On one thing both Luke and Matthew agree. Both are anxious to emphasize that the young Jesus was completely part of the Jewish community of his time. Luke speaks of Christ's mother ritually presenting her baby in the Temple (Luke 2.21–28), and of the child Jesus stunning the learned doctors in the same Temple with his wisdom (Luke 2.41–52). These are almost the only glimpses we get of Christ's early life, before the beginning of his mission. Matthew is more interested in Christ's regal ancestry: "So all the generations from Abraham to David are fourteen generations; and from David until the carrying away into Babylon are fourteen generations; and from the carrying away into Babylon unto Christ are fourteen generations." (Matthew 1.17).

St. Joseph and Jesus in the Carpenter's Shop
Georges de la Tour
1593–1652

The Nativity

The Nativity is the most touching story in the whole of the Gospels, and it is not surprising that it has evoked an immediate and often very personal response from artists of all historical epochs. These paintings are the most delicately imagined scenes in the whole of Christian art. Christ himself inevitably appears as a generic newborn, without much to distinguish him from other infants. The sense of his importance comes from those who come to watch and worship him.

ABOVE **Nativity (altar detail)**
Catalan Romanesque
c. 1200

RIGHT **Nativity 21**
Raymond Poulet
b. 1934

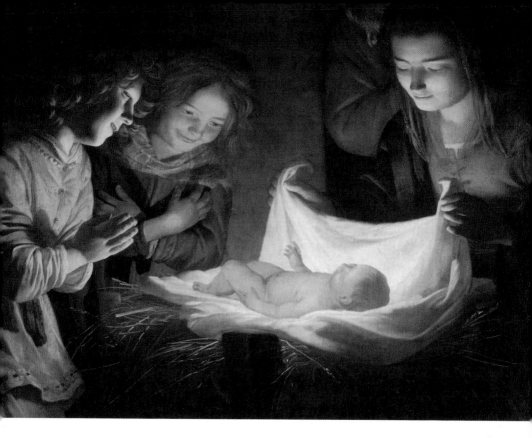

ABOVE **Adoration of
the Child**
Gerrit van Honthorst
1592–1656

RIGHT **Birth of Christ
Tahitian-style**
Paul Gauguin
1848–1903

FAR RIGHT **La Nativité**
Philippe de Champaigne
1602–1674

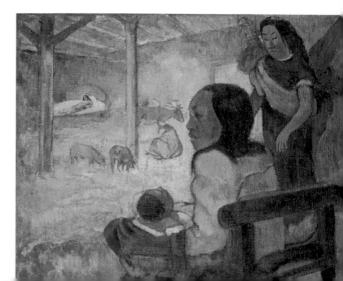

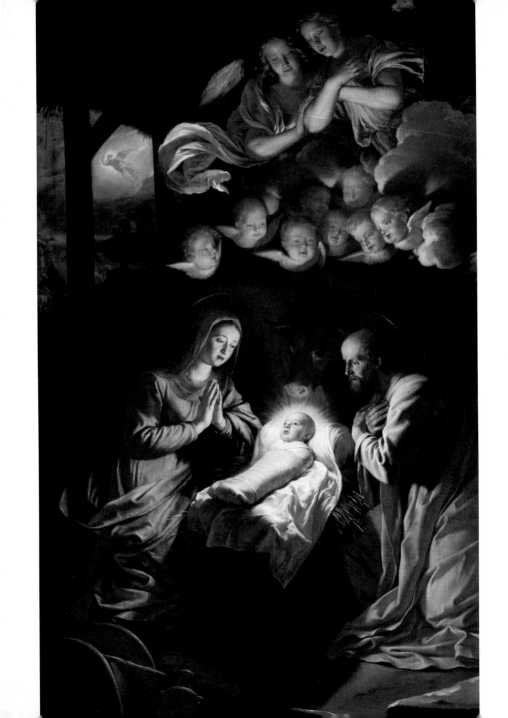

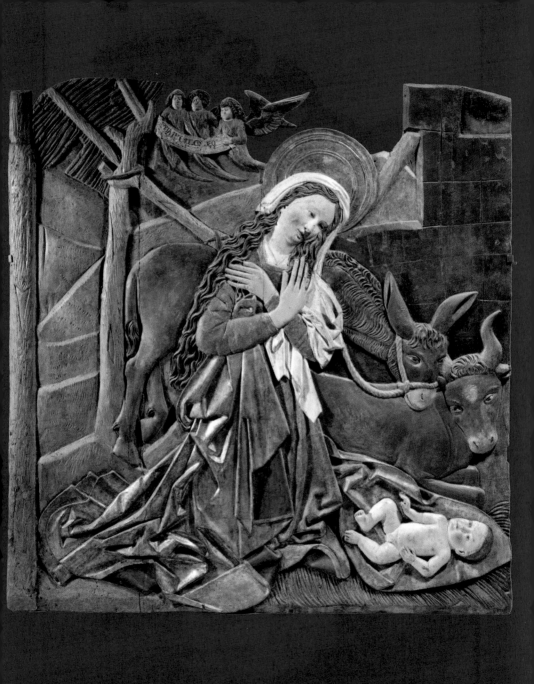

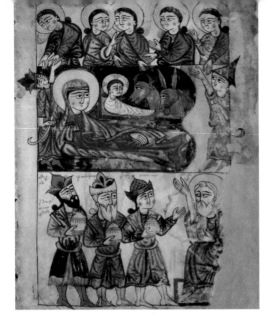

FAR LEFT **Nativity relief on carved and painted wood**
German
c. 1510

LEFT **Nativity and Adoration of the Magi**
Vardan
15th century

BELOW **Nativity, 20th Century**
Charles Walch
1896–1948

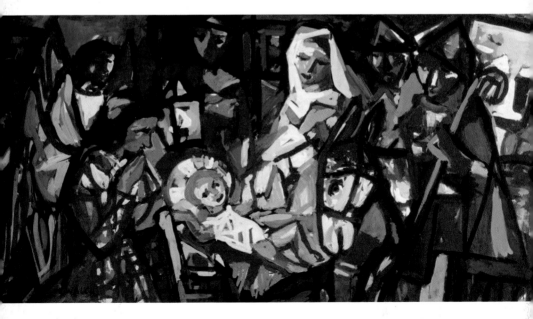

Adoration of the Shepherds

An angel announces Christ's birth to a group of shepherds watching their sheep.

15 And it came to pass, as the angels were gone away from them into heaven, the shepherds said one to another, Let us now go even unto Bethlehem, and see this thing which is come to pass, which the Lord hath made known unto us.

16 And they came with haste, and found Mary and Joseph, and the babe lying in a manger.

(Luke 2.15–16)

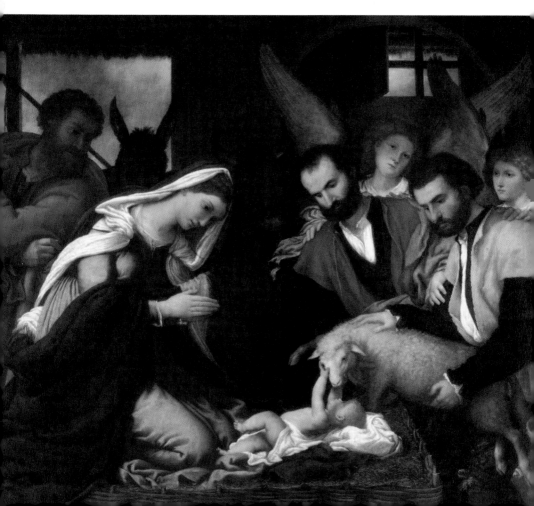

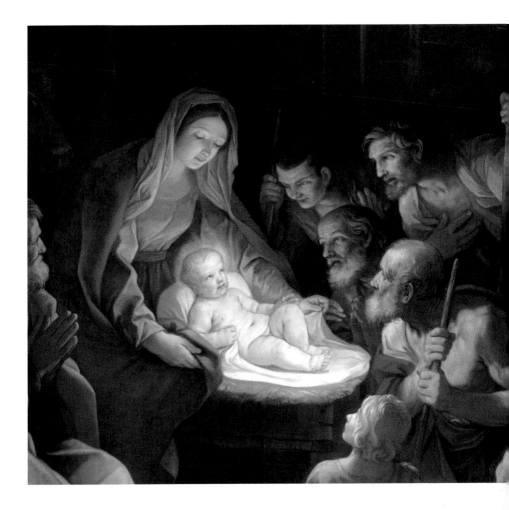

LEFT **Adoration of the Shepherds**
Lorenzo Lotto
c. 1480–c. 1556

ABOVE **The Adoration of the Shepherds (detail)**
Guido Reni
1575–1642

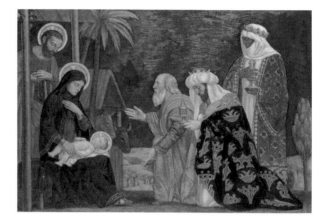

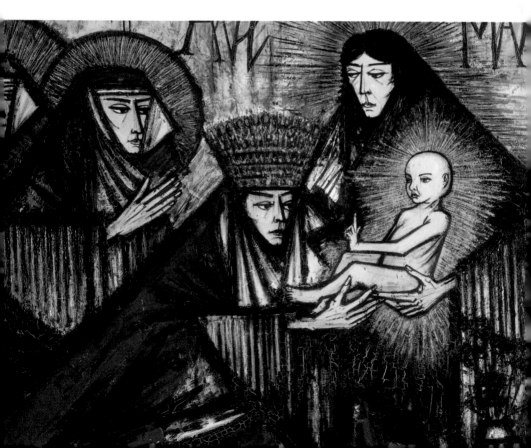

Three Wise Men

The Gospel of St. Matthew describes how these wise men were guided on their journey by a star that "came and stood over where the young child was. And when they were come into the house, they saw the young child with Mary his mother, and fell down, and worshiped him: and when they had opened their treasures, they presented unto him gifts; gold, and frankincense, and myrrh."

Tradition preserves the names of the Wise Men, often referred to as the Magi, as Caspar, Melchior, and Balthazar. These details are not given in the Gospels, which say simply that they were men "from the east"—implying Persia. In art, Balthazar is often shown as black. The richness of their gifts led to the Wise Men being thought of as royal, and artists usually portrayed them in splendid attire.

BELOW
Adoration of the Magi
Diego Velázquez
1599–1660

OVERLEAF
Adoration of the Magi
Stained glass
1290–1300

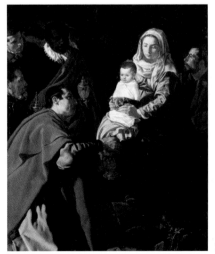

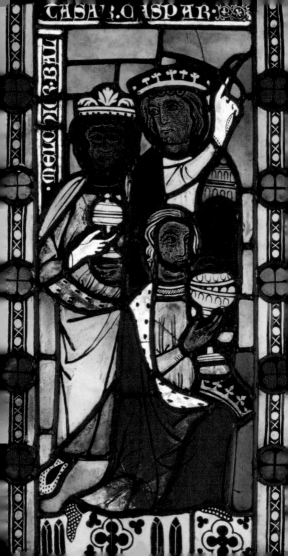

FLIGHT INTO EGYPT

13 And when they were departed, behold, the angel of the Lord appeareth to Joseph in a dream, saying, Arise, and take the young child and his mother, and flee into Egypt, and be thou there until I bring thee word: for Herod will seek the young child to destroy him.

14 When he arose, he took the young child and his mother by night, and departed into Egypt:

15 And was there until the death of Herod: that it might be fulfilled which was spoken of the Lord by the prophet, saying, Out of Egypt have I called my son.

16 Then Herod, when he saw that he was mocked of the wise men, was exceeding wroth, and sent forth, and slew all the children that were in Bethlehem, and in all the coasts thereof, from two years old and under, according to the time which he had diligently inquired of the wise men.

(Matthew 2.13–16)

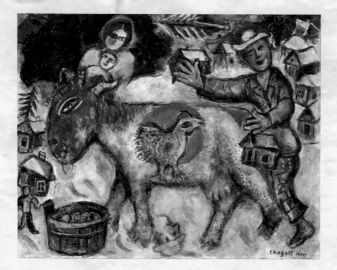

LEFT **In the Village**
Marc Chagall
1887–1985

RIGHT **Flight into Egypt**
Renaud Levieux
c. 1625–1690

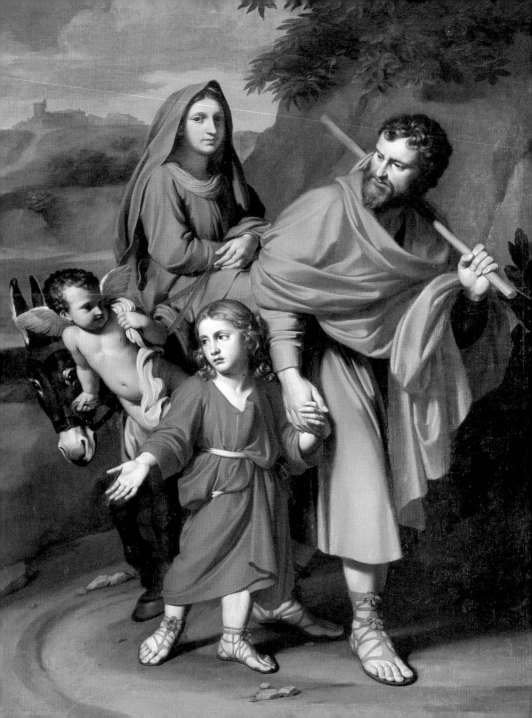

Herod the Great, ruler of Judea, heard from the Wise Men who came to look for the infant Christ, that the child was to be the "King of the Jews."

Herod read this as a prophecy that the boy would be a rival to his own power. He commanded the visitors to bring back news, so that he could go and worship this miraculous baby. The Wise Men, however, were warned in a dream not to return to Herod. Joseph, too, was warned by an angel to take his family away from danger.

The description of Joseph and Mary's flight into Egypt appears only in the Gospel of St. Matthew (see page 36).

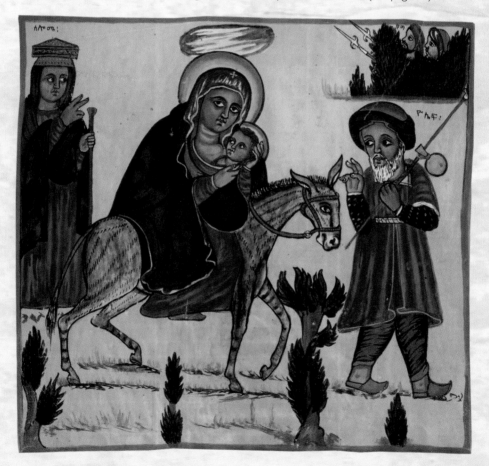

FAR LEFT **Flight into Egypt**
Ethiopic manuscript
c. 1650

LEFT **The Flight into Egypt**
Georges Rouault
1871–1958

BELOW **Flight into Egypt
(detail)**
Giovanni di Corraduccio
1440–1495

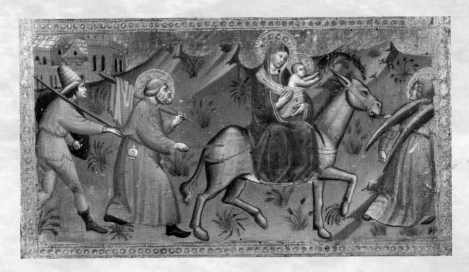

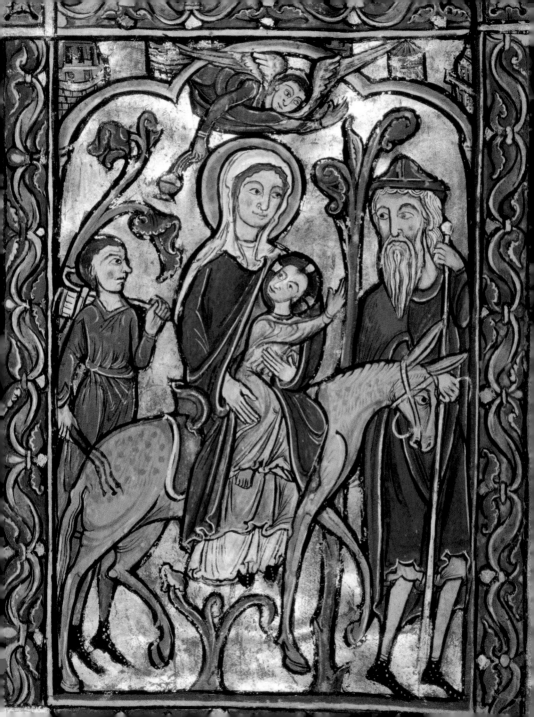

When this is put together with the account of Christ's presentation in the Temple, it creates a problem of timing. Christ was circumcised on the eighth day after his birth, and presented in the Temple, according to the rule laid down by Leviticus, thirty-three days after that (Luke 2.21–24). This means that the Holy Family must have fled to Egypt, and then returned safely, within forty days.

A further difficulty is presented by the fact that Herod the Great, who instigated the Massacre of the Innocents that followed the flight, died in 4 BC. This was four years before the official date for the birth of Christ.

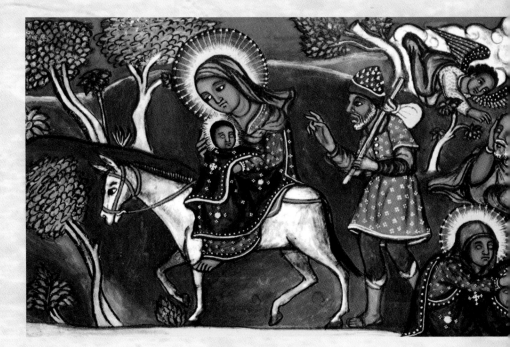

LEFT **Flight into Egypt**
Miniatures of the Life of Christ
c. 1200

ABOVE **Flight into Egypt**
Coptic
c. 1730–c. 1755

There are fewer conventions for the depiction of Jesus as a child than there are for portrayals of him as an adult man. When Christ is shown in art as something more than a baby, artists seem to have looked at classical images of Cupid or Eros. This is particularly obvious in the work of the artists of the Italian Renaissance, who were heavily influenced by classical art. The Madonna is invariably shown with a head scarf, required dress for Orthodox Jewish women.

1. Byzantine pendant of Christ
13th–14th century

2. Madonna and Child (detail)
Sassoferrato
1609–1685

3. Holy Family (detail)
Pompeo Batoni
1708–1787

4. The Good Shepherd
Bartolomé Esteban Murillo
1618–1682

5. Madonna and Child (detail)
Bartolomé Esteban Murillo
1618–1682

6. The Bruges Madonna (detail)
Michelangelo
1475–1564

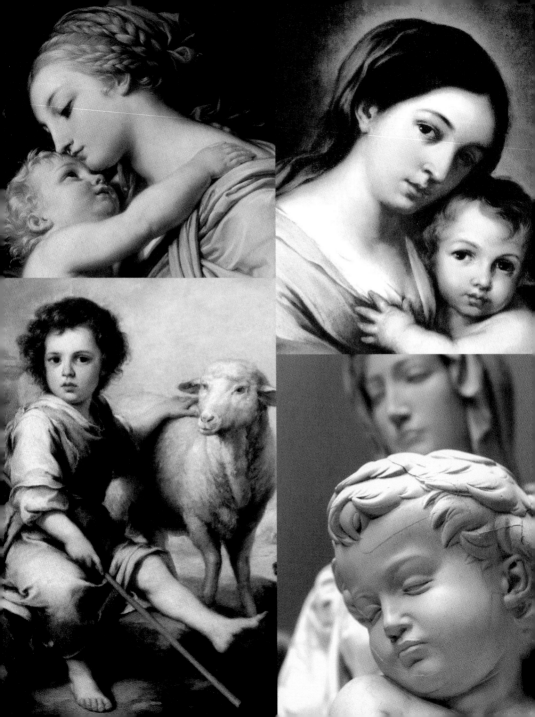

Circumcision

Jesus was circumcised to show that he belonged to the Jewish people, according to God's covenant with Abraham:

10 This is my covenant, which ye shall keep, between me and you and thy seed after thee; Every man child among you shall be circumcised.

11 And ye shall circumcise the flesh of your foreskin; and it shall be a token of the covenant betwixt me and you.

12 And he that is eight days old shall be circumcised among you, every man child in your generations, he that is born in the house, or bought with money of any stranger, which is not of thy seed.

(Genesis 17.10–12)

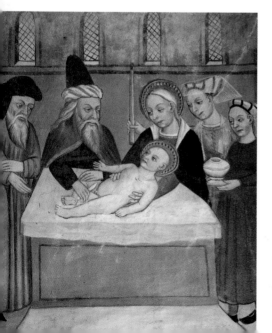

LEFT **Circumcision**
Scenes from the life of Jesus Christ
15th century

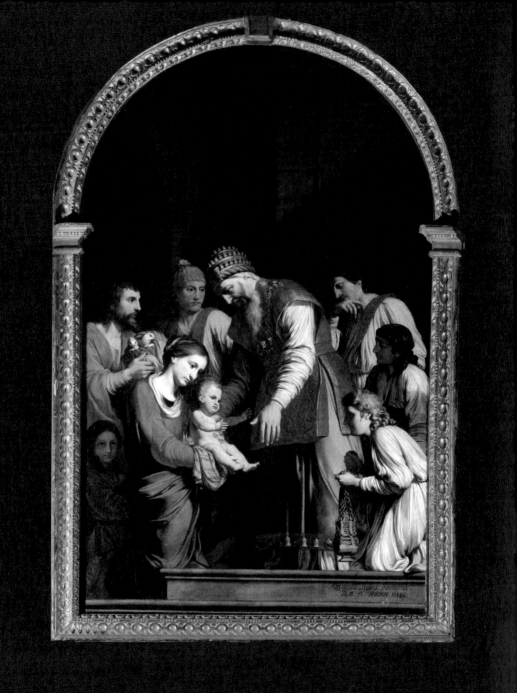

Presentation in the Temple

The Old Testament Book of Leviticus ordained that a woman who bore a male child was considered ritually unclean for a week. The child would be circumcised on the eighth day, but the mother must continue purification for a further thirty-three days. The parents should then bring the child to the temple in Jerusalem and make two sacrifices, a lamb and a young pigeon, or two pigeons only if they could not afford a lamb (Leviticus 12.1–8). Christ's parents followed the ritual, and while they were at the temple, Christ's future importance was recognized by two individuals: Simeon and Anna the prophetess. "And Simeon blessed them, and said unto Mary his mother, Behold, this child is set for the fall and rising again of many in Israel; and for a sign which shall be spoken against." (Luke 2.34).

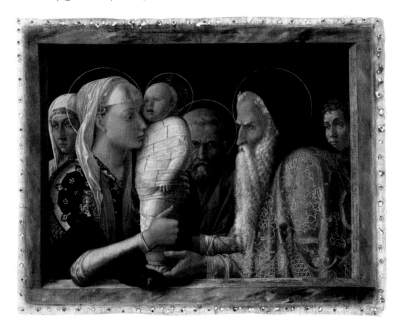

LEFT **Presentation of Jesus in the Temple**
Renaud Levieux
c. 1625–1690

ABOVE **Presentation of Jesus to the Temple**
Andrea Mantegna
c. 1431–1506

OVERLEAF **Presentation in the Temple**
Pietro Cavallini
c. 1250–c. 1330

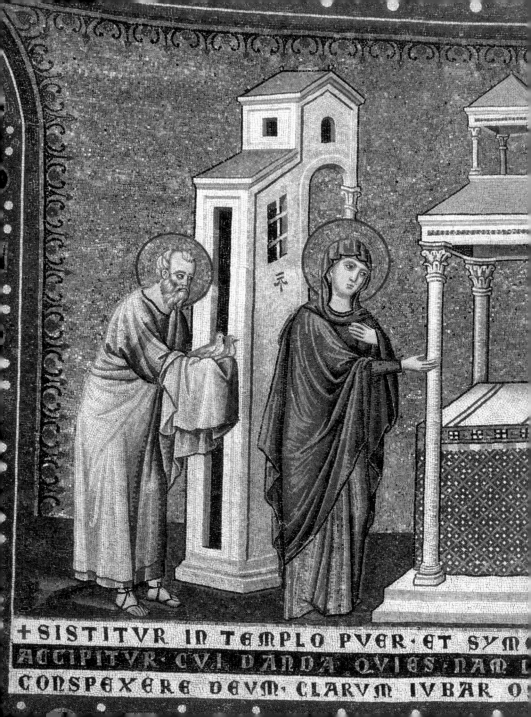

+ SISTITVR IN TEMPLO PVER · ET SYM
ACCIPITVR · CVI DANDA QVIES · NAM
CONSPEXERE DEVM · CLARVM IVBAR O

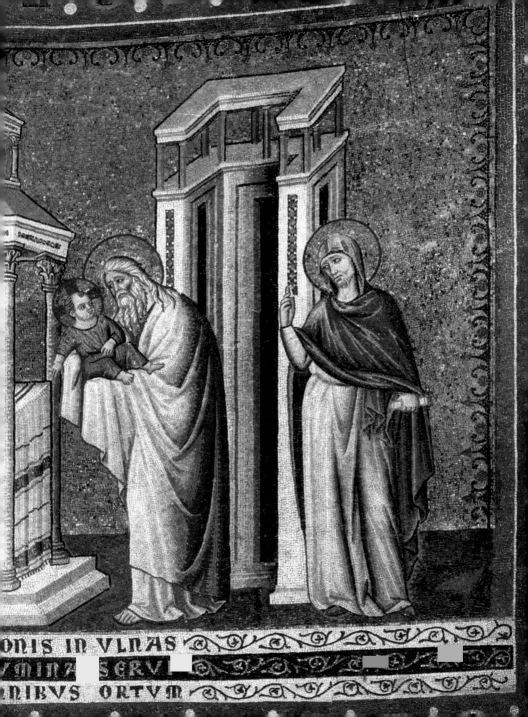

ONIS IN VLNAS
MINA SCRV
NIBVS ORTVM

Christ Among the Doctors

This is the only Gospel story we have concerning Christ's childhood, as opposed to his birth or manhood. Christ's parents went to Jerusalem every year for the Feast of Passover. When he was twelve years old, they did so as usual. A day's journey into their return, they realized that the child was not with them.

45 And when they found him not, they turned back again to Jerusalem, seeking him.

46 And it came to pass, that after three days they found him in the temple, sitting in the midst of the doctors, both hearing them, and asking them questions.

47 And all that heard him were astonished at his understanding and answers.

48 And when they saw him, they were amazed: and his mother said unto him, Son, why hast thou thus dealt with us? Behold, thy father and I have sought thee sorrowing.

49 And he said unto them, How is it that ye sought me? Wist ye not that I must be about my Father's business?

(Luke 2.45–49)

Christ Among the Doctors
Albrecht Dürer
1471–1528

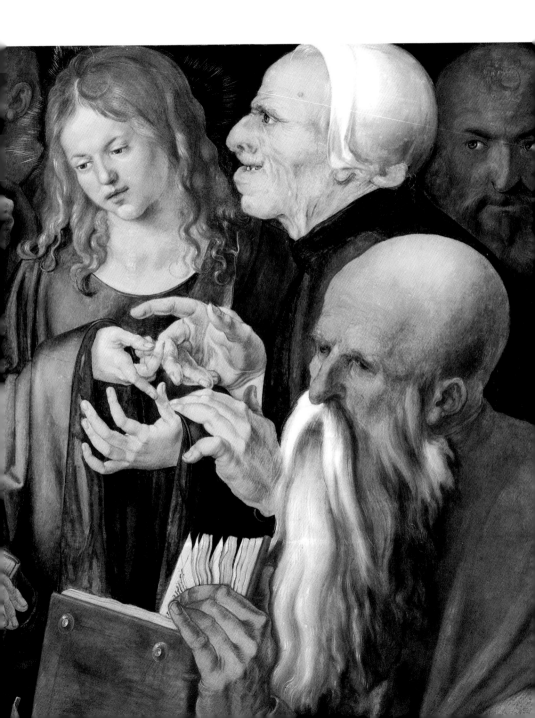

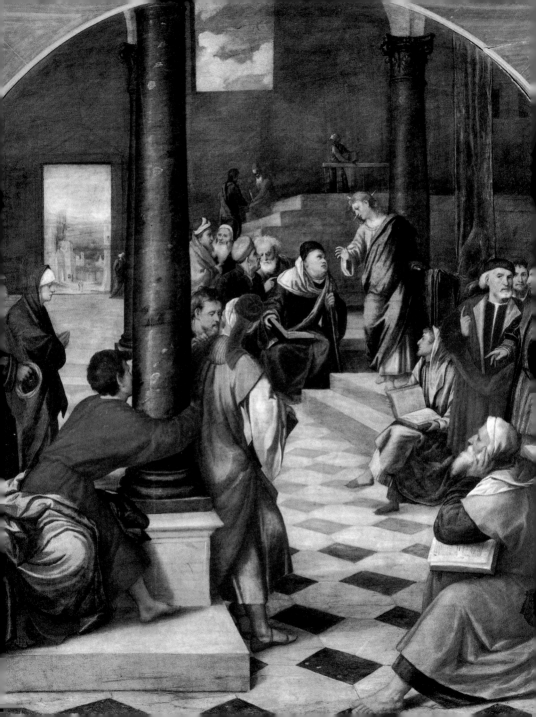

Christ Among the Doctors
Bonifacio de' Pitati
c. 1487–1553

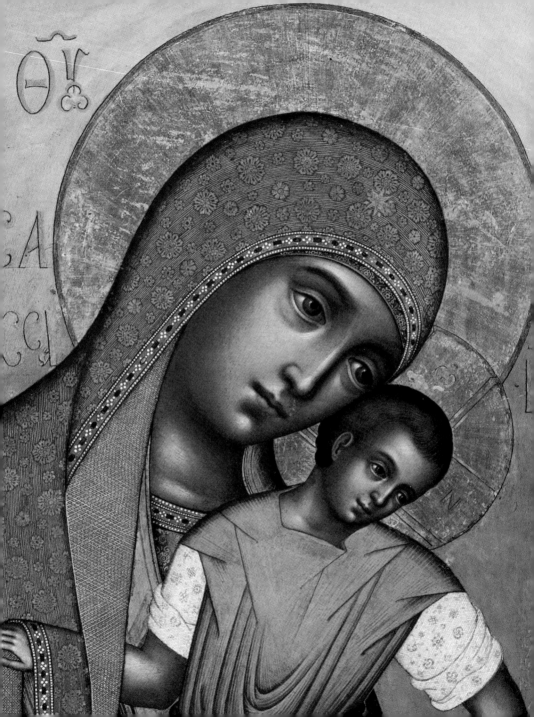

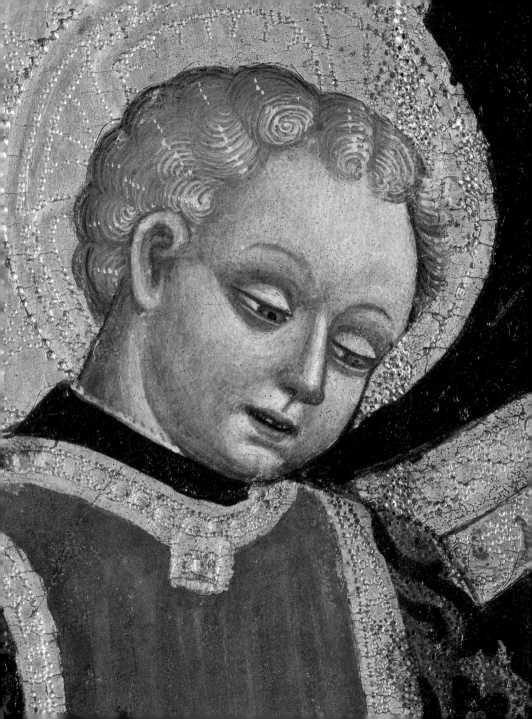

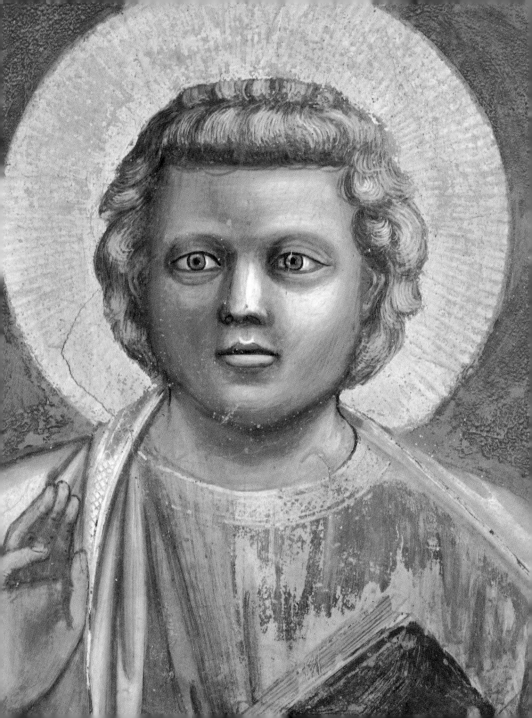

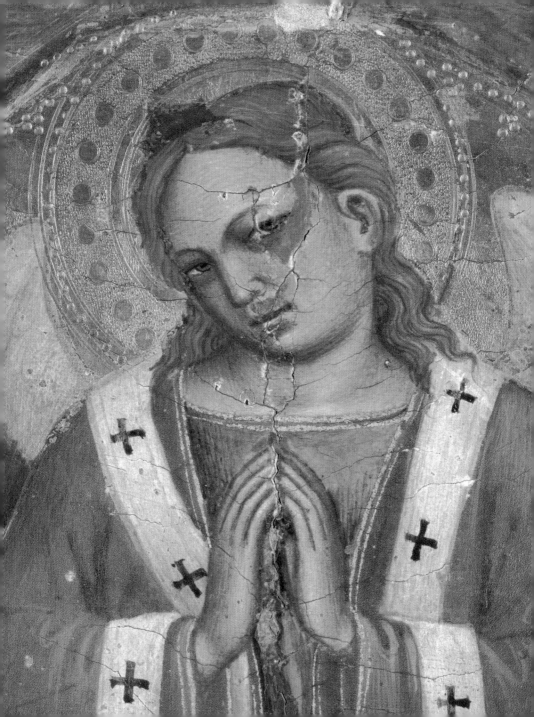

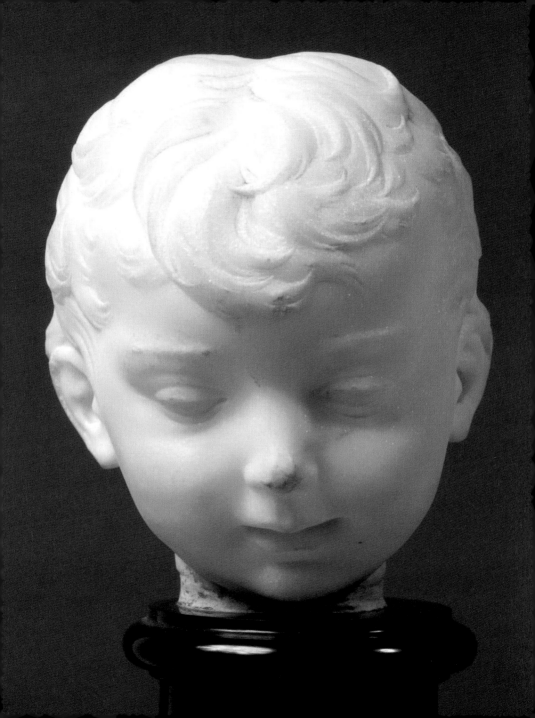

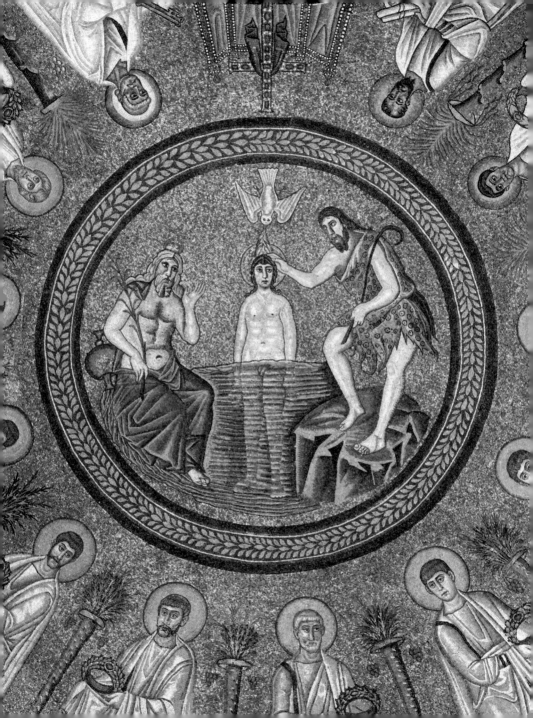

CHAPTER 2

THE BEGINNING OF CHRIST'S MISSION

ALL FOUR GOSPELS AGREE ON THE IMPORTANCE OF CHRIST'S ENCOUNTER with John the Baptist. John was already celebrated as an itinerant preacher. Many of those who heard him, and came to be baptized by him in the River Jordan, thought he might be the promised Redeemer mentioned in many places in the Old Testament. John rejected this and immediately recognized Christ as his superior.

The baptism of Christ by John was understood by both as a crucial event: "And Jesus, when he was baptized, went up straightway out of the water: and, lo, the heavens were opened unto him, and he saw the Spirit of God descending like a dove, and lighting upon him." (Matthew 3.16).

Following the Baptism, Christ goes into the Judean wilderness, where he prays and fasts for forty days. The devil comes to tempt him, first suggesting that he use his miraculous powers to turn stones into bread, then taking him to a high place, and telling him to throw himself down, as God's angels will surely rescue him; and finally offering him all the kingdoms of the world, if he will bow down and worship Satan.

Having triumphed over the devil, Christ returns home to Nazareth, and begins to preach. In the synagogue, he reads aloud from the book of the prophet Isaiah, citing the passage: "The Spirit of the Lord GOD is upon me; because the LORD hath anointed me to preach good tidings unto the meek; he hath sent me to bind up the broken-hearted, to proclaim liberty to the captives, and the opening of the prison to them that are bound." (Isaiah 60.1). Christ's mission is rejected by those who think they already know him: "Is not this the carpenter, the son of Mary, the brother of James, and Joses, and of Juda, and Simon? and are not his sisters here with us? And they were offended at him." (Mark 6.3).

Baptism of Christ
Byzantine mosaic
Early 6th century

63

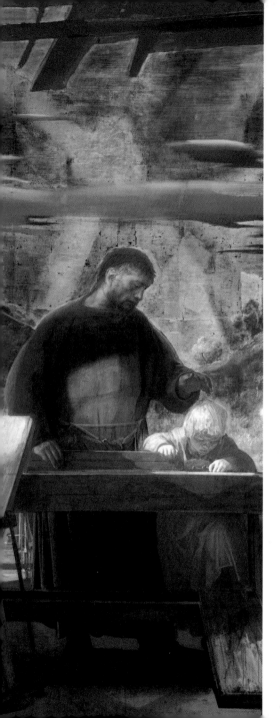

Christ in the Carpenter's shop

The Gospels tell us almost nothing about Christ's early life. Where we do find a description of Christ in the carpenter's shop run by his father is in the Apocryphal Infancy Gospel of St. Thomas, which has the following story:

"And His father was a carpenter, and at that time made ploughs and yokes. And a certain rich man ordered him to make him a couch. And one of what is called the cross pieces being too short, they did not know what to do.

The child Jesus said to His father Joseph: Put down the two pieces of wood, and make them even in the middle. And Joseph did as the child said to him. And Jesus stood at the other end, and took hold of the shorter piece of wood, and stretched it, and made it equal to the other."

Left **St. Joseph**
Pietro Annigoni
1910–1988

Right **Holy Family**
Nicolas Vleughels
1668–1737

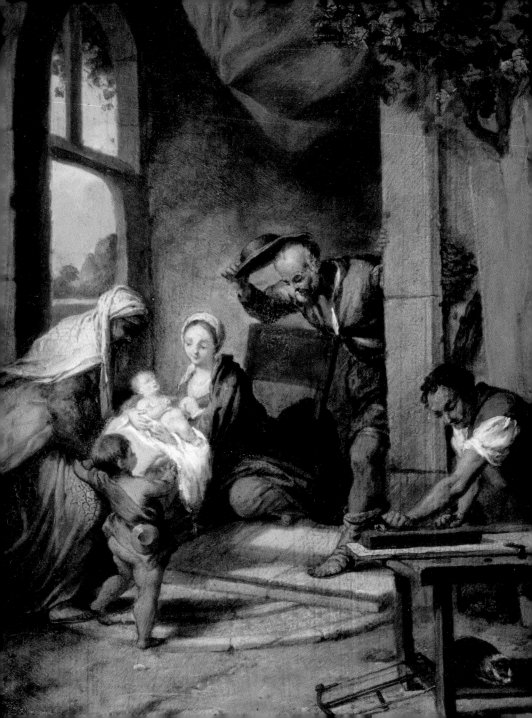

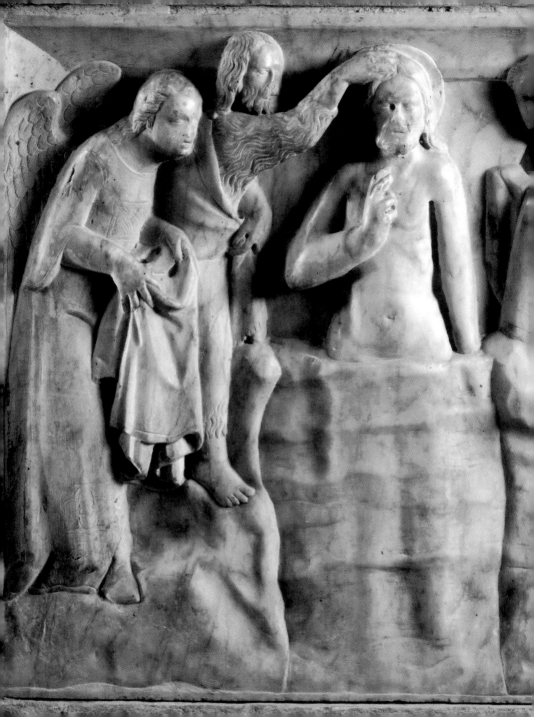

Jesus' Baptism

4 John did baptize in the wilderness, and preach the baptism of repentance for the remission of sins.

5 And there went out unto him all the land of Judaea, and they of Jerusalem, and were all baptized of him in the river of Jordan, confessing their sins.

6 And John was clothed with camel's hair, and with a girdle of a skin about his loins; and he did eat locusts and wild honey;

7 And preached, saying, There cometh one mightier than I after me, the latchet of whose shoes I am not worthy to stoop down and unloose.

8 I indeed have baptized you with water: but he shall baptize you with the Holy Ghost.

9 And it came to pass in those days, that Jesus came from Nazareth of Galilee, and was baptized of John in Jordan.

(Mark 1.4–9)

The Baptism of Christ
Giovanni di Agostino
d. 1350

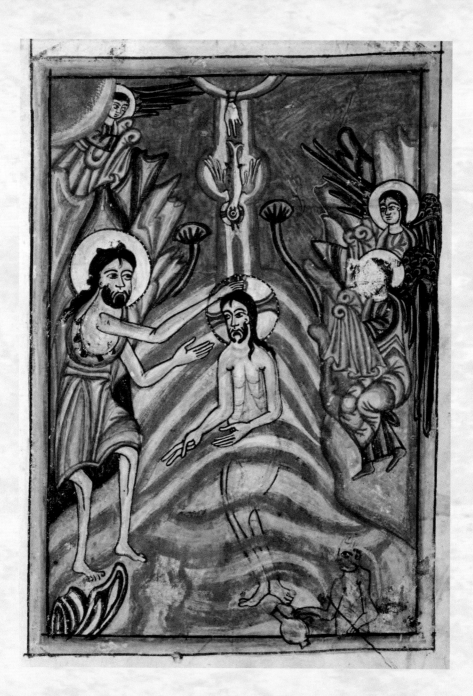

John the Baptist is mentioned by the Jewish historian Josephus, who became a friend of the Emperor Vespasian: "Herod, who feared lest the great influence John had over the people might put it into his power and inclination to raise a rebellion, (for they seemed ready to do any thing he should advise) thought it best, by putting him to death, to prevent any mischief he might cause." (Josephus, Antiquities 18.5.2).

The Herod mentioned in this passage is Herod Antipas, who was the son of Herod the Great.

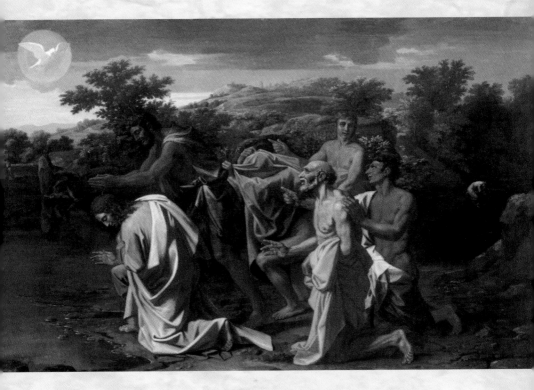

LEFT **The Baptism of Christ**
Karapet di Altamar
15th century

ABOVE **The Baptism of Christ**
Nicolas Poussin
1594–1665

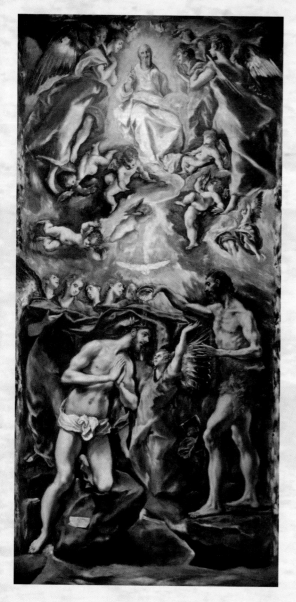

John the Baptist was the son of Elizabeth, who was Mary's cousin. He was six months older than Christ and gathered a large following as an ascetic preacher before Christ became well known. The rite of baptism that he practiced was a ritual washing away of sins.

When Christ requested baptism, John at first refused, on the grounds that Christ was the true Messiah, and greater than himself (Matthew 3.13–15). Baptism marked the beginning of Christ's ministry.

One of the interesting things about representations of the Baptism is that it is almost the only place in the whole sequence of traditional Bible illustrations where Christ is shown as subordinate. It is almost invariably John the Baptist who is shown as the dominant figure, to whom Christ humbly submits. In this sense, Christ is shown as continuing a mission that was already begun. He accepts the Baptist's teaching, and enlarges upon it.

LEFT **Baptism of Christ**
El Greco
c. 1541–1614

RIGHT **The Baptism of Christ**
Lorenzo Monaco
c. 1370–1425

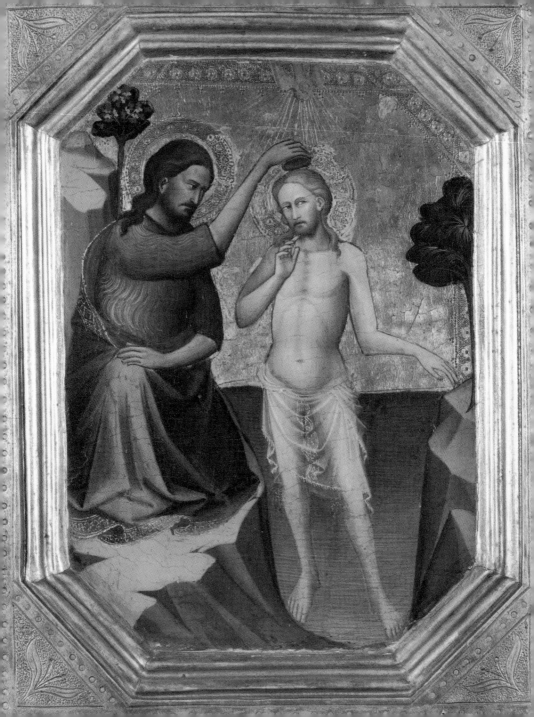

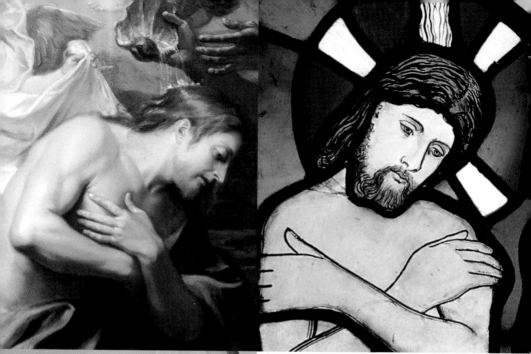

In paintings of the Baptism, Christ is often shown with arms crossed across his breast. Modern experts on body-language usually interpret this as a defensive gesture. Here, however, it is a gesture of humility. Christ, for the moment at least, acknowledges John the Baptist as his superior.

1	3	4	5
2			6

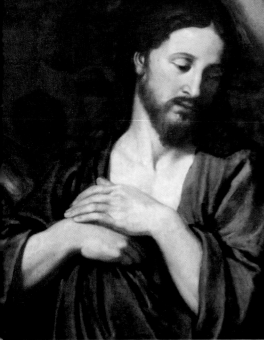

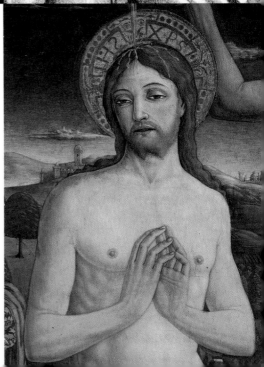

1. The Baptism of Christ (detail)
Antoine Coypel
1661–1722

2. The Baptism of Christ (detail)
Gregorio Sciltian
1900–1985

3. The Baptism of Christ in Jordan (detail)
Edward Burne-Jones
1833–1898

4. The Baptism of Christ (detail)
Renaud Levieux
c. 1625–1690

5. The Baptism of Christ (detail)
Engraving
19th century

6. Baptism of Jesus (detail)
Guidoccio Cozzarelli
1450–c. 1517

Temptation of Christimage

Temptation of Christ
Ilya Repin
1844–1930

The story of Christ's Temptation, as told in two of the Gospels—Matthew 4.1–11 and Luke 4.1–13—offers parallels with tribal shamanistic experience and also with the legend of Gautama Buddha. The shamanic postulant subjects himself to a life-changing ordeal, which often

involves a severe period of fasting. This triggers a series of visions which tell the shaman who he is, what his powers will be, and what he is to become.

The parallel with Buddha, though not exact, is interesting. He was born the son of a king more than five hundred years before Christ, in what is now Nepal. He abandoned his high position to live the life of an ascetic, begging for alms in the street. After collapsing from self-starvation and self-mortification, he spent forty-nine days in concentrated meditation, until at last he reached the condition of Enlightenment.

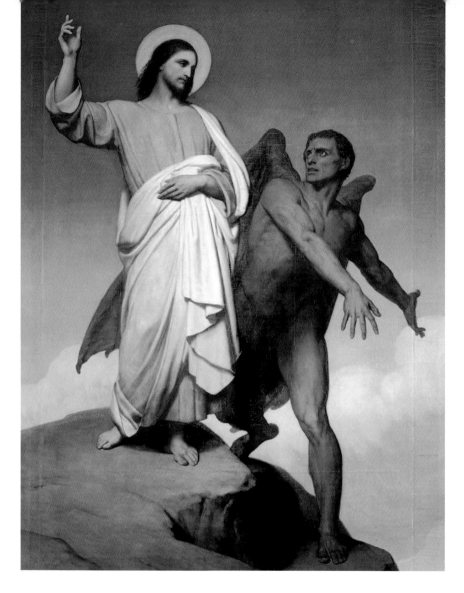

Above **The Temptation of Christ**
Ary Scheffer
1795–1858

Right **Jesus Casts Down Satan**
Mattia Preti
1613–1699

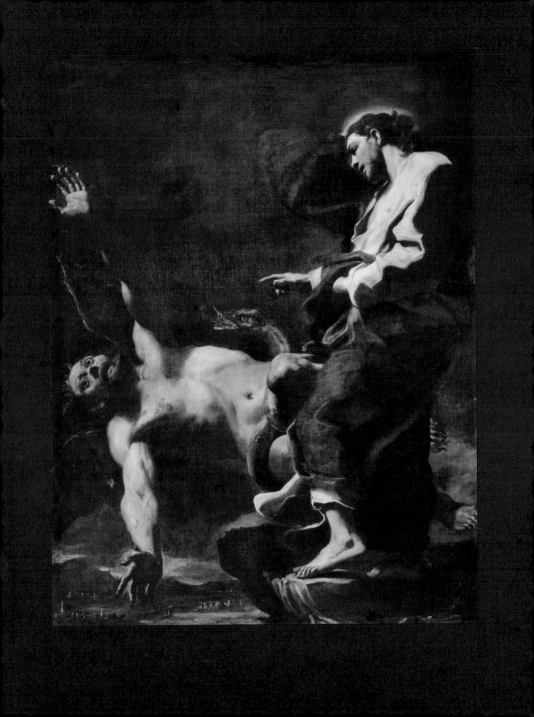

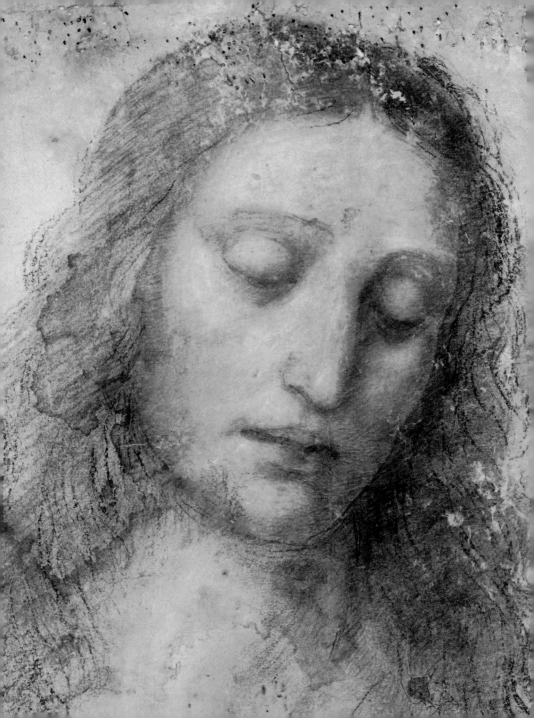

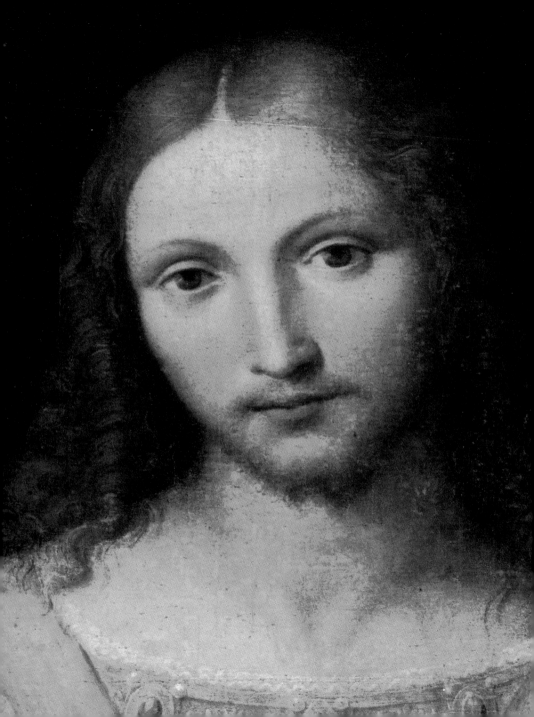

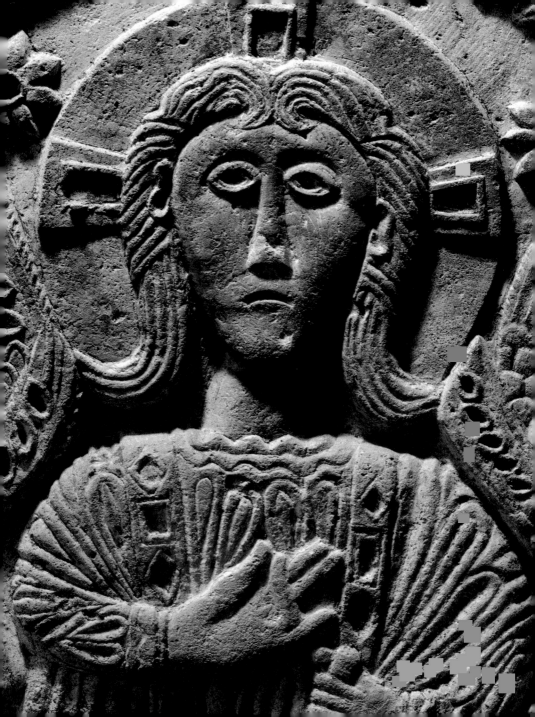

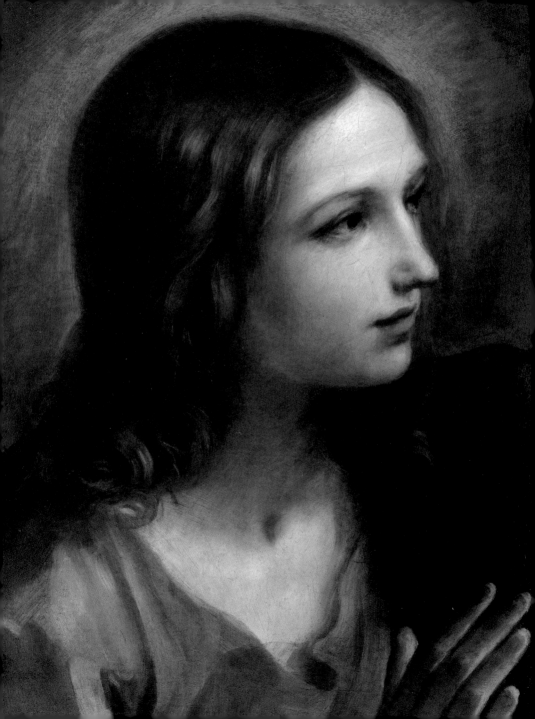

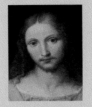

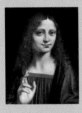

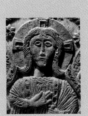

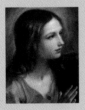

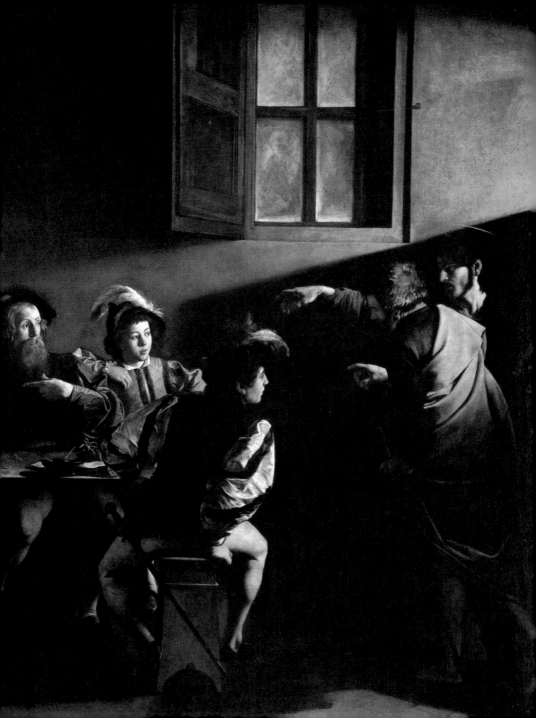

CHRIST AND HIS FOLLOWERS

THE FIRST PART OF CHRIST'S MISSION WAS ENACTED IN GALILEE, a region where he rapidly became widely known as a preacher, teacher, and healer. Some of the most significant events of this time took place in Capernaum, a little port on the other side of the Sea of Galilee, which is really a large lake, fed by the River Jordan. It was here, not in Nazareth, where he grew up, and where the community rejected him (Luke 4.28–31), that Christ recruited the first of his close followers, the fisherman Simon, called Peter, and Andrew, his brother (Matthew 4.18–22; Mark 1.16–20; Luke 5.1–11). Andrew had originally been one of the followers of John the Baptist, and the Gospel of St. John says that it was he who was responsible for bringing his brother to Christ (John 1.40–41), rather than this being the result of a chance meeting, as the other Gospels seem to have it.

Another recruit was Matthew, also called Levi in the Gospels, a tax-collector who belonged to a generally despised profession (Mark 2.13–17; Luke 5.27–32; Matthew 9.9–13). This can be seen as a sign of Christ's indifference to the social conventions of his time.

It is clear that, while Christ's fame spread rapidly, even as far as Syria (Matthew 4.24), for a long while it remained essentially rooted in Galilee. It was while standing on a small hill overlooking the Sea of Galilee that Christ preached the Sermon on the Mount, which was the first full statement of his doctrine (Matthew 5.1–48). His discourse offered the moral foundation upon which Christianity still stands.

Calling of St. Matthew (detail)
Caravaggio
1571–1610

Calling of the Disciples

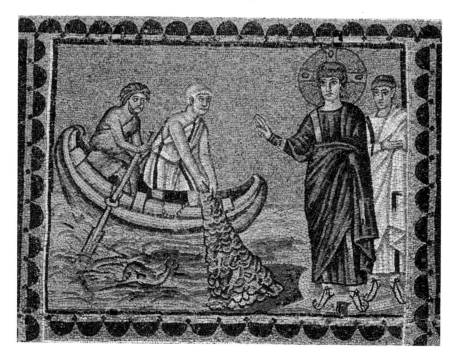

Christ's apostles were all successful, working men. None were beggars or paupers. The brothers Peter and Andrew owned their own boat and ran a small fishery business. Another pair of fishermen, James and John, worked for their father. When Christ called them to follow him "they left their father Zebedee in the ship with the hired servants" (Mark 1.20). The mention of the servants implies that the family was doing well in terms of their business.

ABOVE **The Calling of Peter and Andrew**
Byzantine mosaic
Early 6th century

RIGHT **Calling of St. Peter and St. Andrew**
Giorgio Vasari
1511–1574

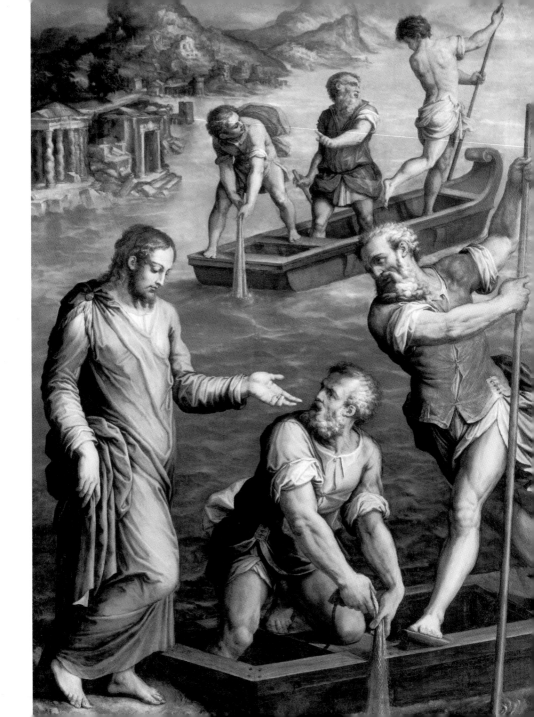

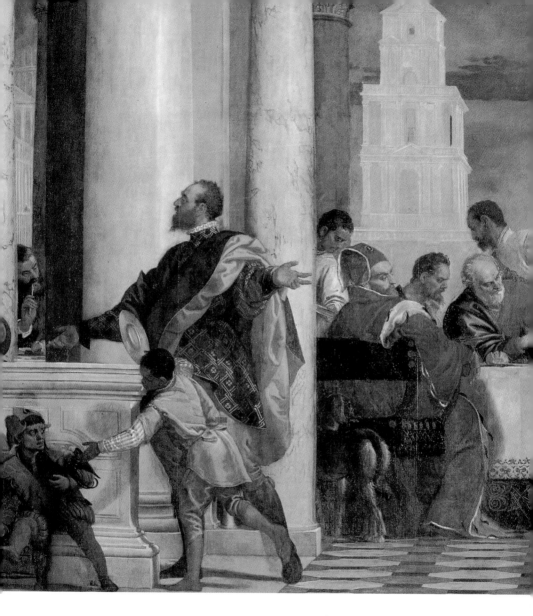

Feast in the House of Levi (detail)
Paolo Veronese
1528–1588

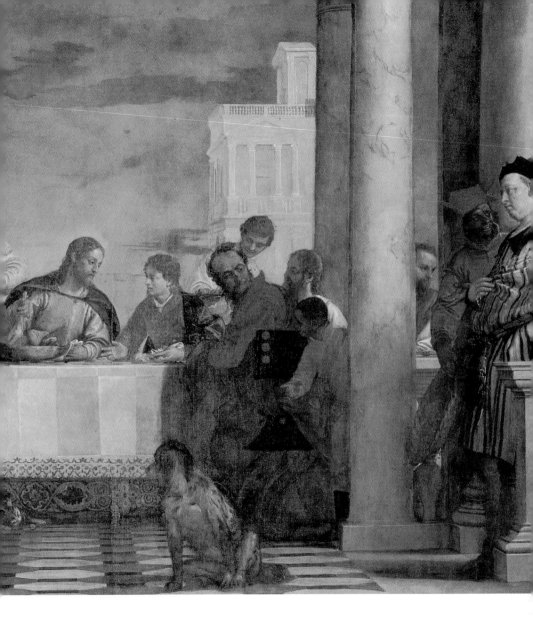

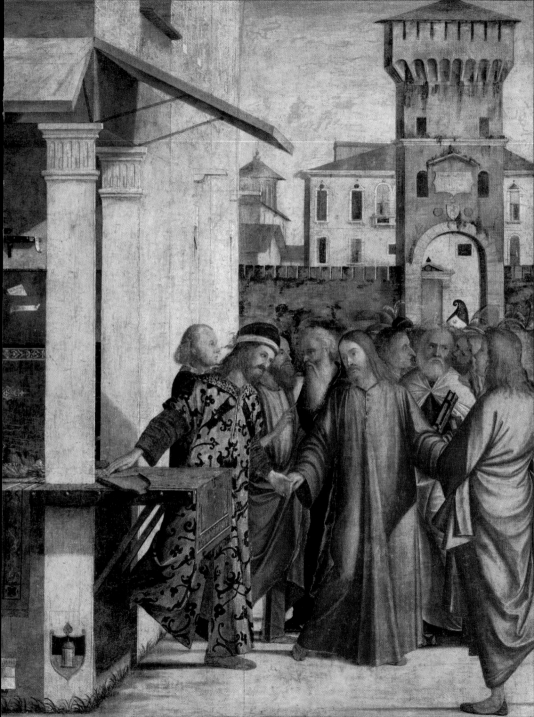

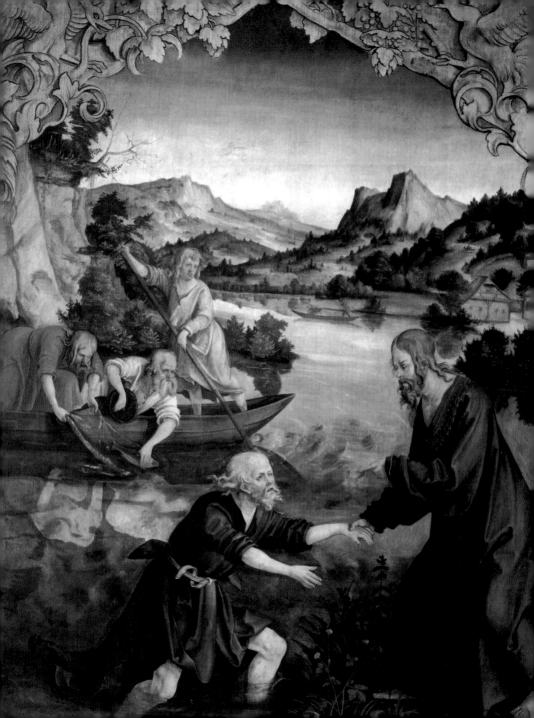

The Miraculous Draught

The Gospels offer two versions of the story of the Miraculous Draught of Fishes. In the Gospel of St. Luke, Christ uses Simon Peter's boat as a platform to preach from, while the fishermen are washing their nets, having caught nothing all night. When Christ finishes speaking, he tells them to launch the vessel and let down their nets, which are immediately filled with fish.

In John, the incident occurs only after the Resurrection. Christ stands on the shore in the early morning, watching them fish unsuccessfully, and, as on previous occasions, is not immediately recognized by those who were closest to him.

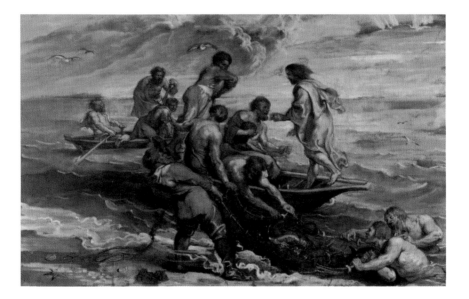

LEFT **The Calling of St. Peter**
Hans von Kulmbach
c. 1480–1522

ABOVE **The Miraculous Draught of Fishes**
Peter Paul Rubens
1577–1640

OVERLEAF **Miraculous Draught of Fishes**
Raphael
1483–1520

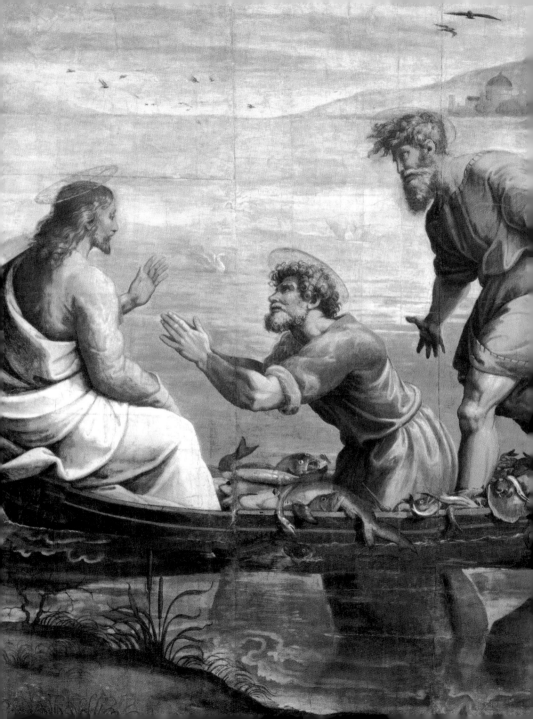

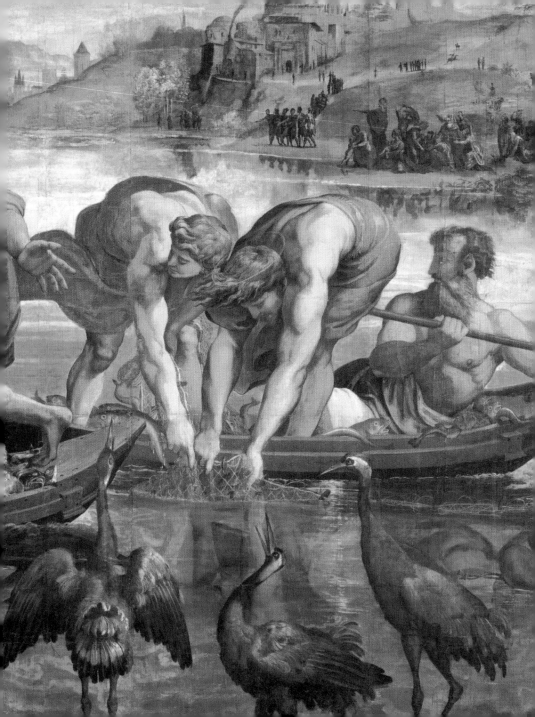

Sermon on the Mount

The Sermon on the Mount is now thought to have been preached from a low elevation between Capernaum and Tagbha, which looks down towards the Sea of Galilee. Formerly called Mount Eremos, it is generally referred to as the Mount of the Beatitudes. The terrain forms a natural amphitheater, which offers room for a large crowd and favorable acoustics. Strong winds blowing towards the lake mean that a speaker's voice carries easily. The sermon is reported fully only in the Gospel of St. Matthew (Matthew 5.1–48).

The Sermon itself is a commentary on the Ten Commandments, given by God to Moses on Mount Sinai (Exodus 20.2–17 and Deuteronomy 5.6–21). Most Christians believe that it contains the core of Christ's teachings about the relationship of human beings to God, and their relationship to one another. Its general tendency is to soften aspects of Moses' teaching. Since the nineteenth century, it has therefore often been seen as an argument for pacifism. Previous to this, it accumulated many layers of often-conflicting interpretation.

The Sermon on the Mount
Cosimo Roselli
1439–1507

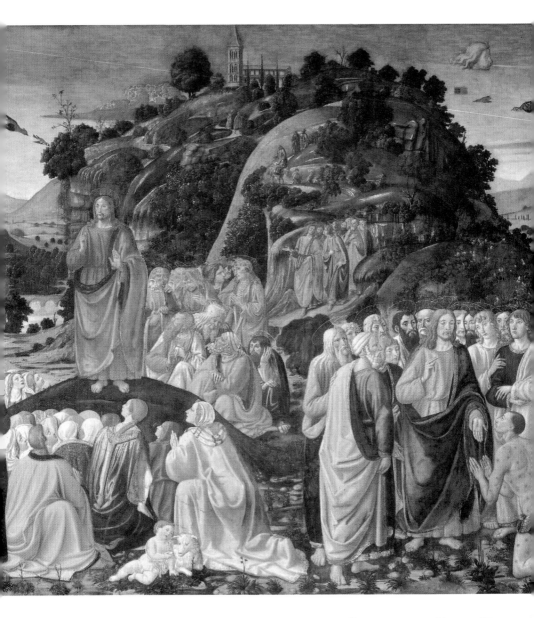

ABOVE **Preaching of Christ**
Master of the Low Countries
15th century

RIGHT **Sermon on the Mount**
Fra Angelico
1387–1455

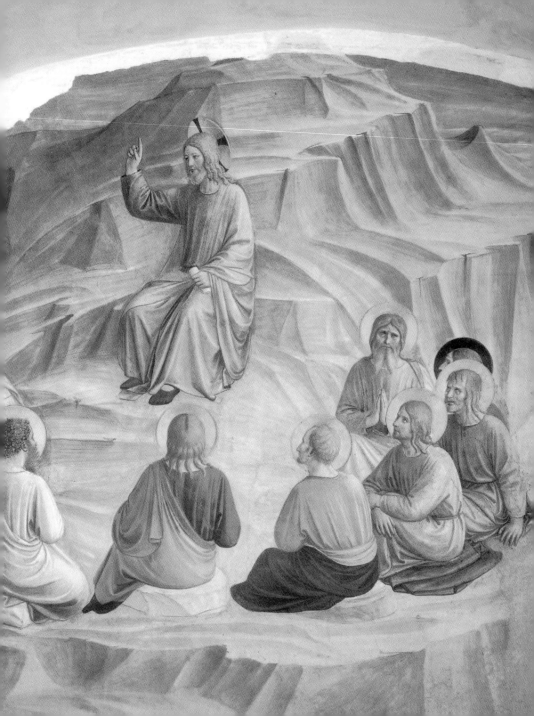

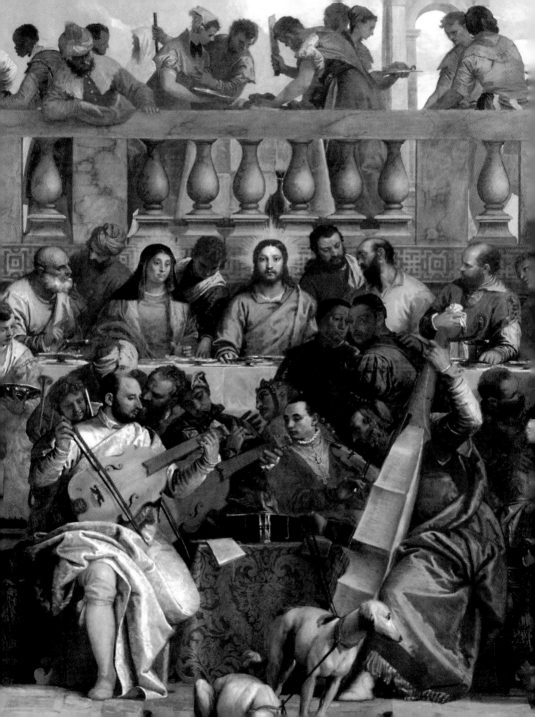

The Wedding Feast at Cana

Recorded only in the Gospel of St. John (John 2.1–12), Christ's miracle at Cana—changing water into wine, when the wine for a wedding feast ran out—was the first public demonstration of his power over nature. Modern theologians have often preferred to interpret it purely allegorically.

However, the story gives us an interesting glimpse of Christ separating himself from the context in which he grew up. When his mother calls his attention to the crisis in hospitality, Christ retorts "Woman, what have I to do with thee? Mine hour is not yet come." (John 2.4).

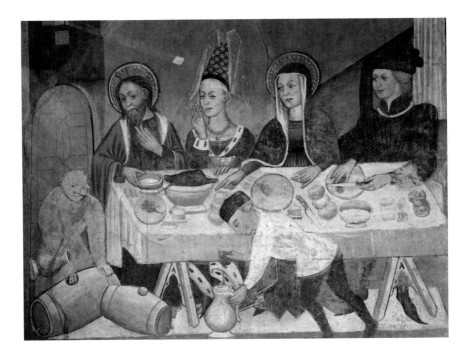

LEFT The Wedding at Cana
Paolo Veronese
1528–1588

ABOVE Scenes from the life of Jesus Christ:
Marriage at Cana
15th century

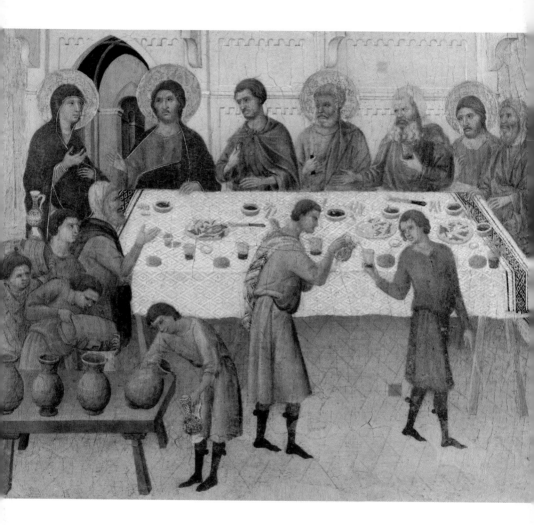

ABOVE **Marriage at Cana**
Duccio di Buoninsegna
c. 1260–1318

RIGHT **Marriage at Cana**
Vardan
15th century

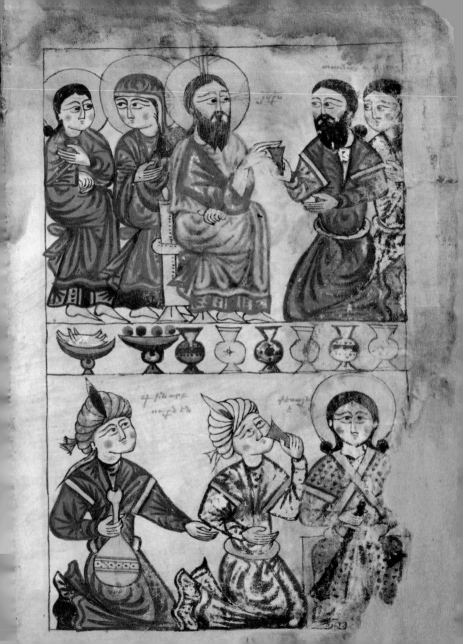

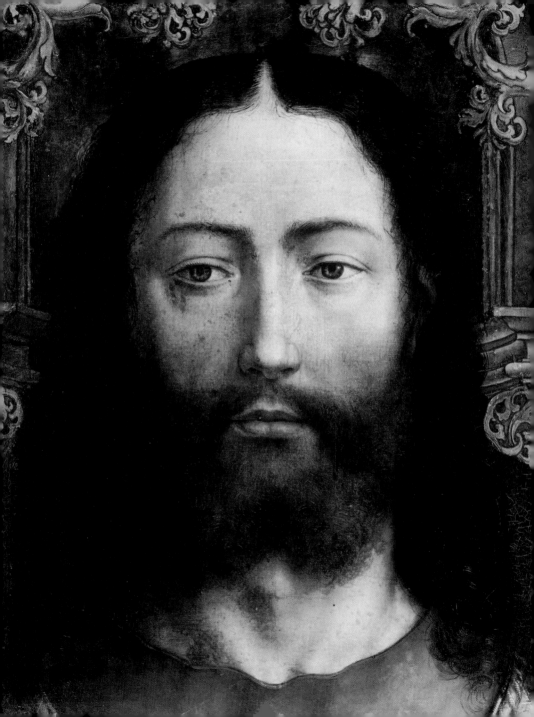

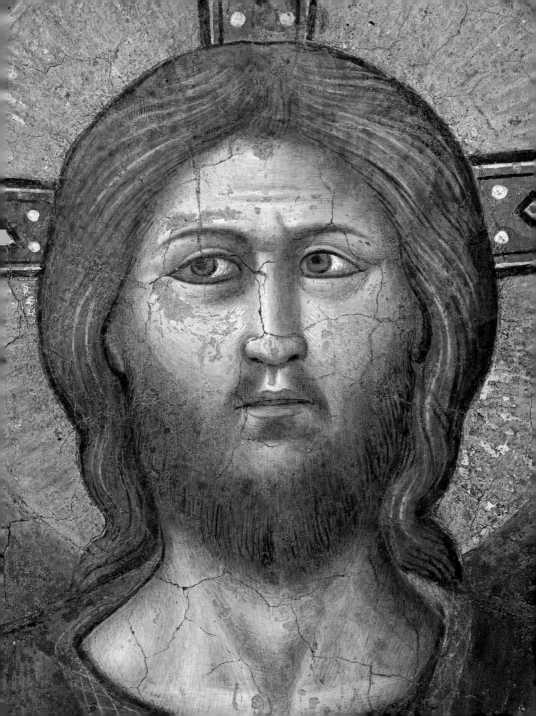

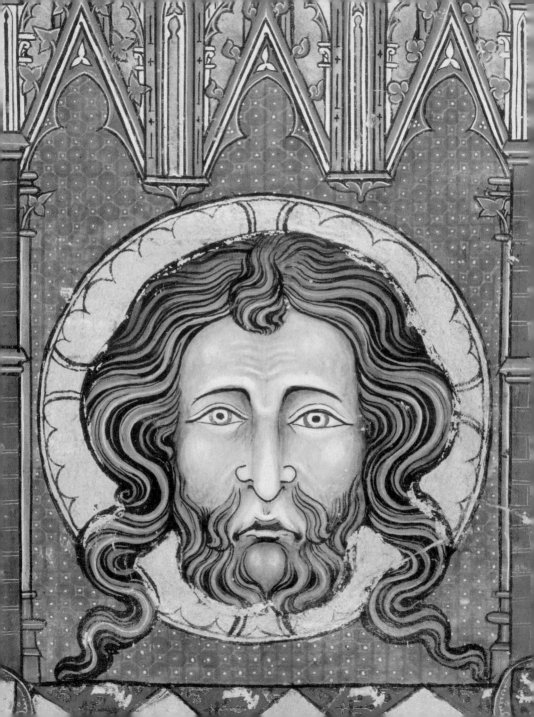

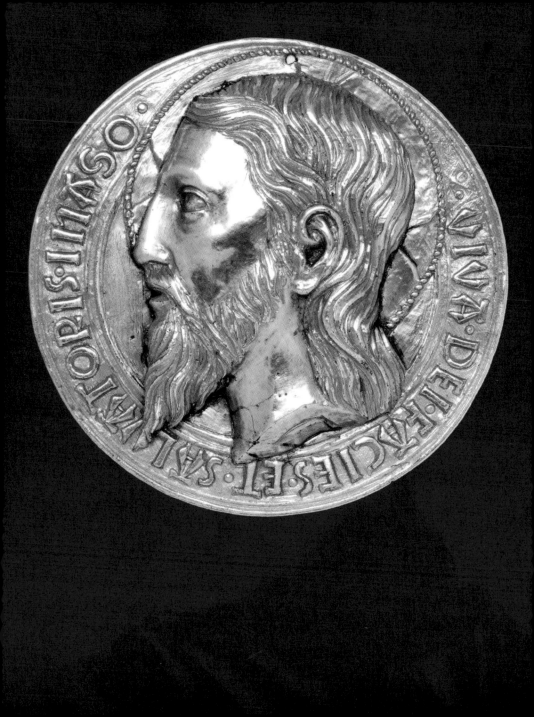

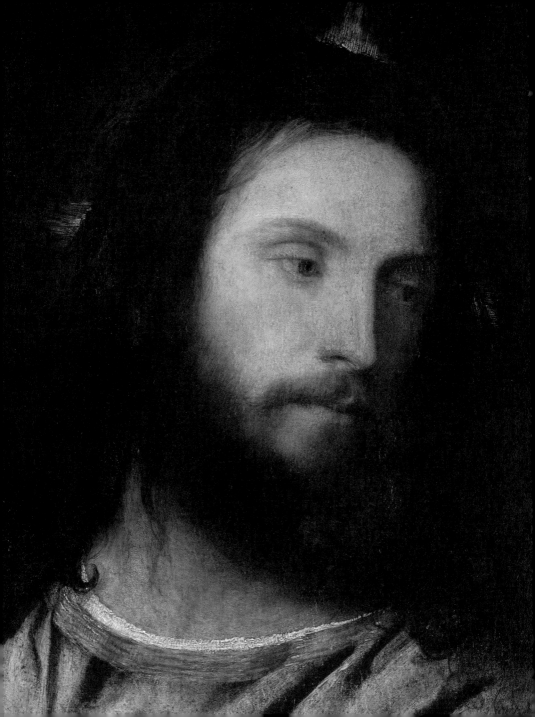

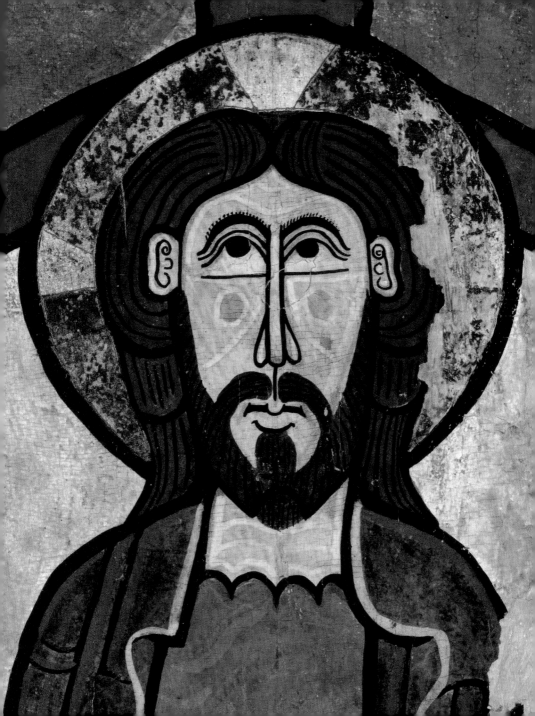

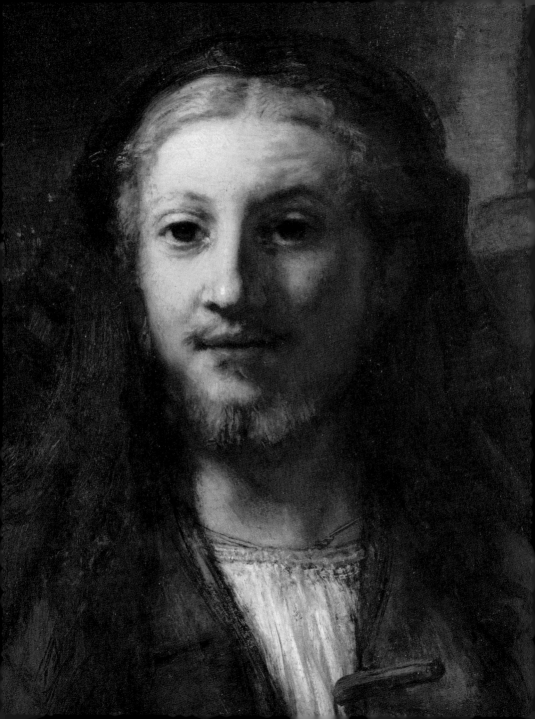

PAGE 106
Christ, the Madonna and the Baptist (detail)
Jan Gossaert
c. 1478–c. 1536

PAGE 107
Last Judgment (detail)
Pietro Cavallini
c. 1250–c. 1330

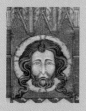

PAGE 108
Book of Hours (detail)
Illumination
c. 1290

PAGE 109
Medallion with the head of Christ
High Renaissance
15th century

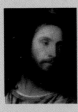

PAGE 110
The Tribute Money (detail
Titian
c. 1488–1576

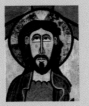

PAGE 111
Altar frontal (detail)
Catalan Romanesque
12th century

PAGE 112
Christ with a Pilgrim's Staff (detail)
Rembrandt
1606–1669

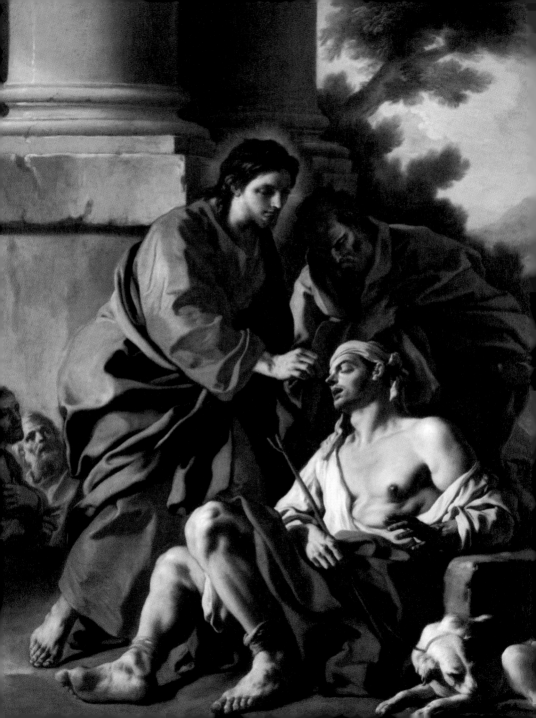

CHAPTER 4

MIRACLES AND COMPASSION

CHRIST'S MISSION WAS MARKED BY A LARGE NUMBER OF MIRACULOUS HAPPENINGS, often linked to his compassionate care for the sorrows and ills of others. Many of these miracles were acts of healing—illustrated by the story of the centurion's servant (Luke 7.10; Matthew 8.5–13), and that of the healing of the paralytic man (Matthew 9.1–8; Mark 2.1–12; Luke 5.17–26). On some occasions, Christ felt called upon to raise the dead. Three examples are the story of the widow's son at Nain (Luke 7.11–17), that of Jairus's daughter (Luke 8.41–56; Matthew 9.18–26; Mark 5.21–43), and, most celebrated of all, the story of the raising of Lazarus, related only in the Gospel of St. John (John 11.38–44). The story of Jairus's daughter also incorporates another incident: that of the "woman with an issue of blood" (abnormal uterine bleeding). The woman touches the hem of Christ's garment, and Christ is immediately aware "that virtue had gone out of him." (Mark 5.30). Rather than being angry, Christ says to the woman, "Daughter, thy faith hath made thee whole."

A striking thing about these stories is Christ's apparent power to heal at a distance, or at his leisure. Jesus gets news that Lazarus, the brother of Mary Magdalene and Martha, is sick, but does not hurry to see him. When he does arrive, he has the tomb opened, and cries in a loud voice "Lazarus come forth." Whereupon the dead man appears, alive, but still in his graveclothes.

The Lazarus story also makes another point: that of Christ's direct communication with God. He tells the bystanders that bringing Lazarus back to life is a demonstration of this. It is stressed again, even more powerfully, in the story of the Transfiguration (Matthew 17.1–13; Mark 9.2–13; Luke 9.28–36). Christ goes up onto a high mountain, accompanied by his disciples, and is seen by them talking to Moses and Elijah. Then a voice comes out of a cloud, saying, "This is my beloved son, in whom I am well pleased." (Matthew 17.5).

Christ Healing a Blind Man
Francesco de Mura
1696–1782

Healing the Centurion's Servant

A centurion, that is to say an officer in the occupying Roman army, in charge of a small garrison in Galilee, appeals to Christ to heal a beloved "servant"—probably a slave—who is deathly sick. The Gospels make it clear that the centurion, despite being one of the occupiers, had established a good relationship with the local community and had even built them a synagogue (Luke 7.3–5). Nevertheless

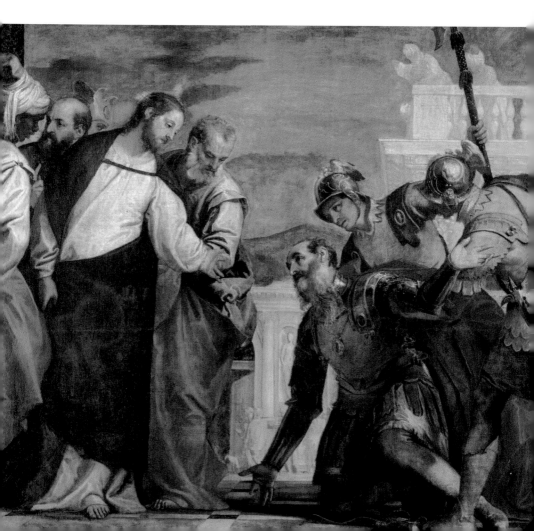

he was an outsider, perhaps even a pagan. Jews would have thought of him as being essentially inferior to themselves.

To some extent, the centurion seems to have accepted this, describing himself as unworthy to receive Christ in his house (Matthew 8.8; Luke 7.6). For Christ, though, what matters is not racial or cultural difference, but the centurion's faith that a miracle of healing can be accomplished, even at a distance. He compares this to the negative attitudes of his own compatriots (Matthew 8.10; Luke 7.9). He also takes pains to emphasize that what he preaches is an all-inclusive religion (Matthew 8.11).

LEFT Jesus Christ and the Centurion
Paolo Veronese
1528–1588

ABOVE Christ Healing the Centurion's Slave
Medieval illumination
11th century

The Widow's Son at Nain

This story appears only in the Gospel of St. Luke. Nain, in modern spelling often Nein, is a now an Arab village in Galilee, nine miles south of Nazareth. It seems to have decreased in size and importance since Biblical times. It can no longer be described as "a city" (Luke 7.12).

Christ arrives there with a throng of followers and encounters a large funeral procession. The dead man is the only son of a widow, and her sole support. Christ feels compassion for the mother's tragedy "And he came and touched the bier: and they that bare him stood still. And he said, Young man, I say unto thee, Arise." (Luke 7.14).

This very public miracle is one of several instances of Christ's power to bring the dead to life. It clearly did much, as Luke tells us, to raise Christ's reputation in Galilee (Luke 7.17).

Jesus Raising the Widow's Son at Nain
James Jacques Joseph Tissot
1836–1902

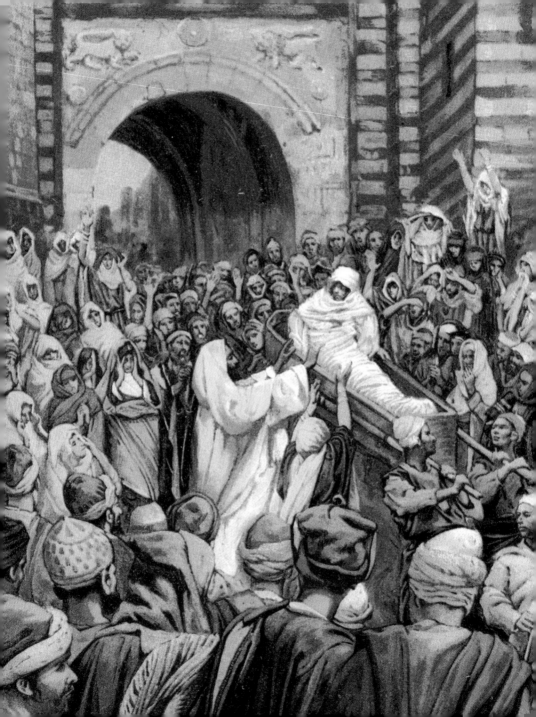

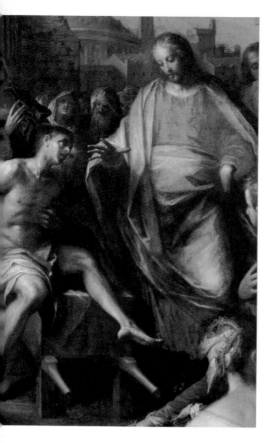

RIGHT **The Resurrection of the Widow's Son at Nain**
Engraving
19th century

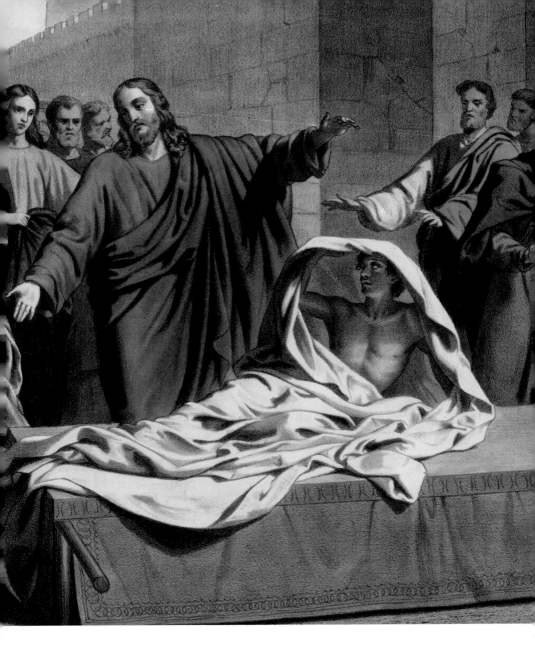

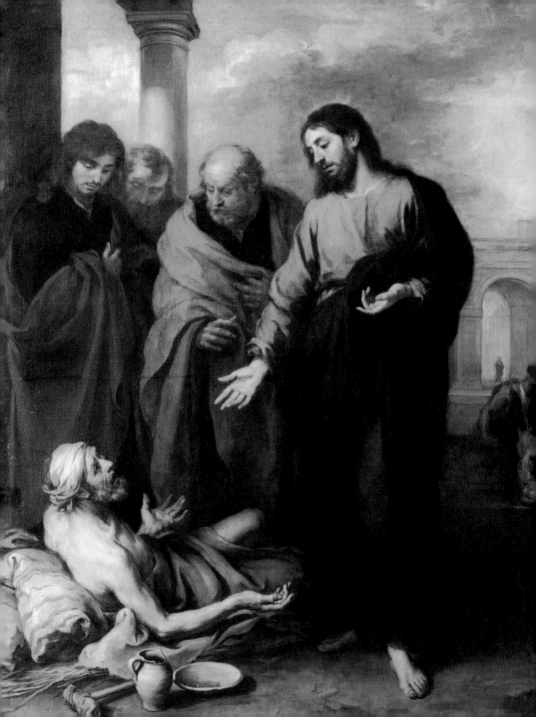

Healing the Paralytic

The story of this act of miraculous healing is told in much the same form in three Gospels—those of Matthew (Matthew 9.1–8); Mark (Mark 2.1–12); and Luke (Luke 5.17–26). Luke adds the picturesque detail that the crowd thronged so thickly about the house where Christ was staying that the helpers who brought the paralyzed man to see him could not get through the door. They had to go up on the roof and remove some of the tiles, in order to bring the sick man into his presence (Luke 5.19). The Pharisees who were present were shocked, not by this, but by Christ's claim to be able to forgive sins.

"But when Jesus perceived their thoughts, he answering said unto them, What reason ye in your hearts?

Whether is easier, to say, Thy sins be forgiven thee; or to say, Rise up and walk?" (Luke 5.22–23).

Christ Healing the Paralytic at the Pool of Bethesda
Bartolomé Esteban Murillo
1618–1682

123

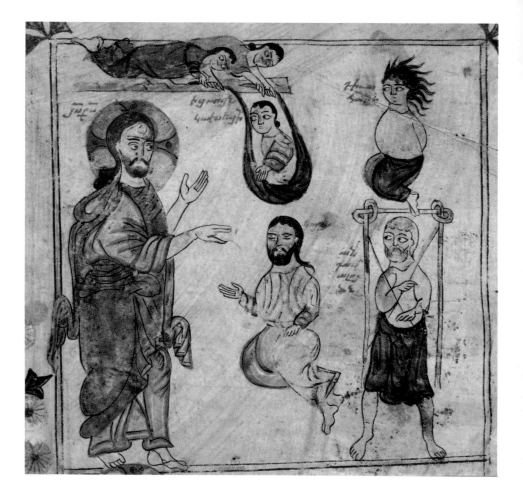

ABOVE **The Miracle of Christ
(healing of the paralytic)**
Byzantine illumination
1305

RIGHT **The Healing of the
Paralytic in Bethesda**
Byzantine mosaic
Early 6th century

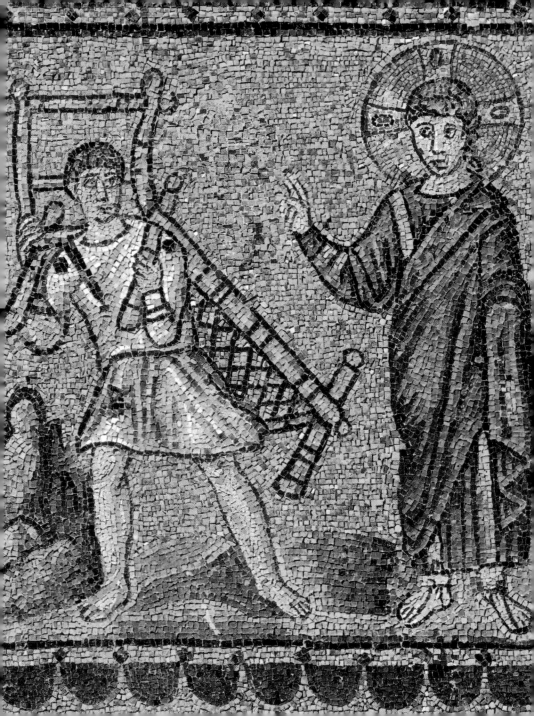

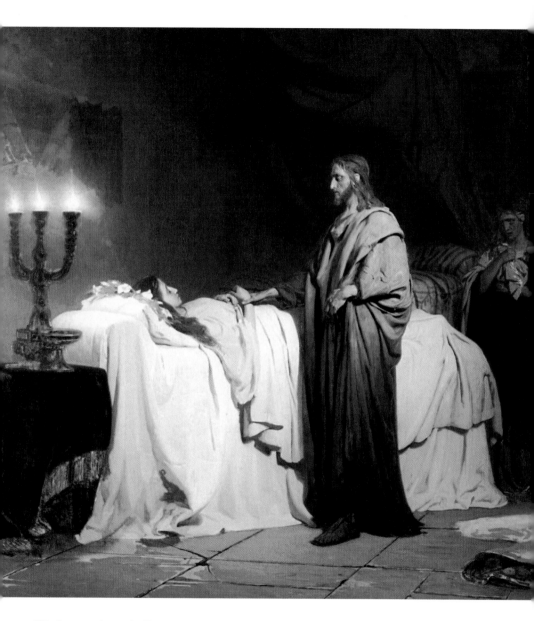

Raising Jairus's Daughter

In this incident, recorded in three Gospels (Matthew 9.18–26; Mark 5.21–43; Luke 8.40–56), Jesus again receives a request for help from a leading figure in the local community. His name was Jairus, "a ruler of the synagogue" (Luke 8.41). This meant that he was the head of the congregation. Christ raises his little daughter from the dead, after all hope has been given up. He also heals a woman with menstrual problems—"an issue of blood twelve years" (Luke 8.43)—who dares to touch him as he moves through the crowd, saying to her "Daughter, thy faith hath made thee whole." (Mark 5.34).

Resurrection of Jairus's Daughter
Ilya Repin
1844–1930

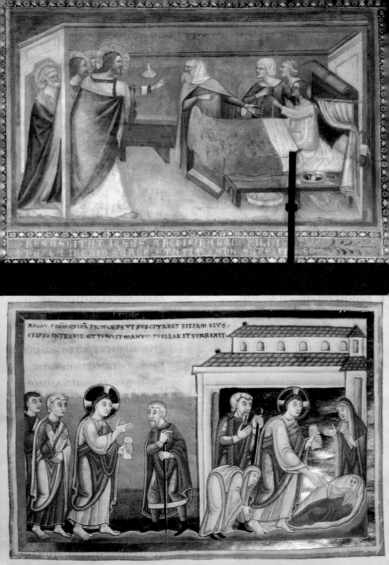

RESUSCITAVIT IESUS ARCHISINAGOGA FILIA[...]
A PUEL [...] SURGE ET STATIM [...]

ROGAV[...] IHM QVIDA PRINCEPS VT SVSCITARET FILIAM EIVS .
[...]IPSE INTRAVIT ET TENVIT MANVM PVELLAE ET SVRREXIT.

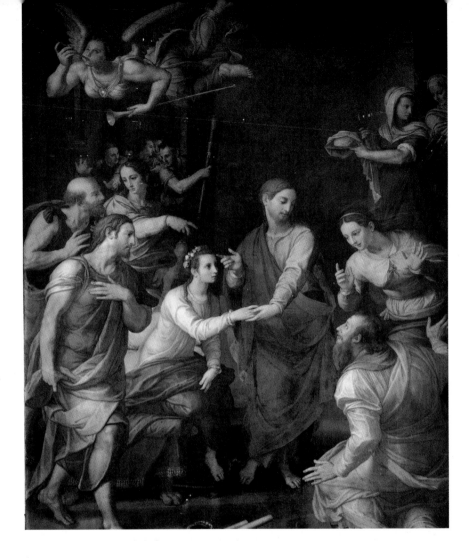

Top Left **Raising of
Jairus's Daughter**
School of Vitale da Bologna
Mid-14th century

Left **Raising of
Jairus's Daughter**
Illumination
11th century

Above **Christ, Raising of
Jairus's Daughter**
Bronzino
1503–1572

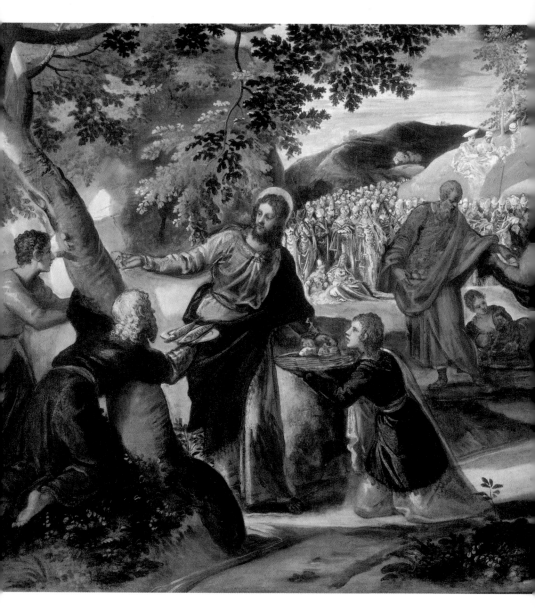

Feeding the Multitude

Christ could be impatient with the demands made by his disciples for signs and wonders.

19 When I brake the five loaves among five thousand, how many baskets full of fragments took ye up? They say unto him, Twelve.

20 And when the seven among four thousand, how many baskets full of fragments took ye up? And they said, Seven.

21 And he said unto them, How is it that ye do not understand?

(Mark 8.19–21)

LEFT AND ABOVE (DETAIL)
Miracle of the Loaves and Fishes
Tintoretto
c. 1518–1594

Images of the feeding of the 5,000 and the 4,000 often take on a sacerdotal air—artists tend to present them as foreshadowings of the Last Supper, though on a massive scale. This is particularly apparent in the way in which Christ is depicted.

1. Multiplication of the
Loaves and Fishes (detail)
Bernardo Strozzi
1581–1644

2. Multiplication of the Loaves
(detail)
Daniel of Uranc
15th century

3. The Multiplication of the
Loaves (detail)
François Mansuy
b. 1725

4. The Multiplication of the
Loaves and Fishes (detail)
Domenico Feti
1589–1624

5. The Multiplication of the
Loaves (detail)
Henry Simon
1910–1987

6. Feeding of the Five
Thousand (detail)
Alexander Bening
15th–16th century

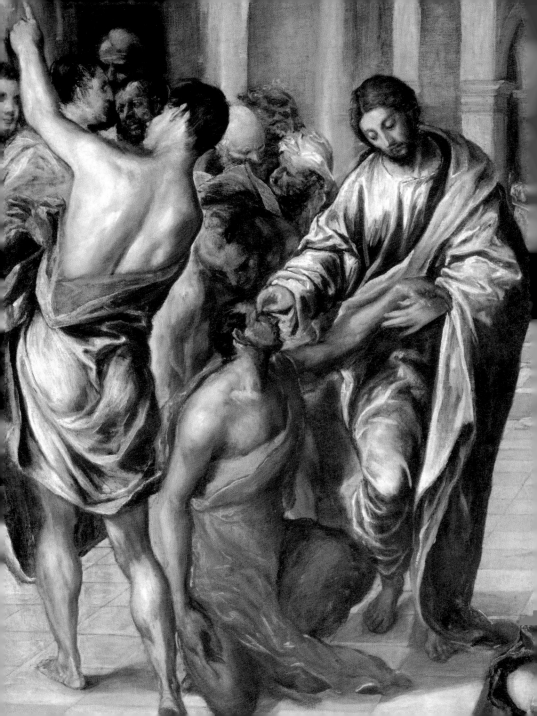

Healing of the Blind Man

The Gospels offer several stories about Christ healing the blind, including Two Blind Men Receive Sight (Matthew 9.27–31); and A Blind Man Healed at Bethsaida (Mark 8.22–26). The images here show another incident from the Gospel of St. John, where Christ heals a man born blind by putting pellets of clay on his eyes, moistened with his own spittle (John 9.1–12). The Pharisees disapproved of Christ's actions because the healing was on the Sabbath (John 9.14–16). They said, "This man is not of God, because he keepeth not the sabbath day."

LEFT **The Miracle of Christ Healing the Blind**
El Greco
c. 1541–1614

BELOW **The Healing of the Man Blind from Birth**
Mosaic
13th century

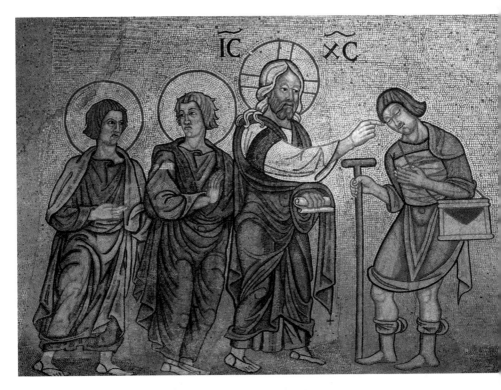

The Transfiguration

The Transfiguration was the sign that the disciples had long requested from their leader. At the conclusion of his brief Second Epistle St. Peter wrote: "For we have not followed cunningly devised fables, when we made known unto you the power and coming of our Lord Jesus Christ, but were eyewitnesses of his majesty." (2 Peter 1.16). The Gospels of Matthew, Mark, and Luke all agree about what took place. Christ led a small group of disciples "up into a high mountain apart." (Matthew 17.1). There "his raiment became shining, exceeding white as snow" (Mark 9.3), and they saw him talking with Moses and Elijah. A voice came from a bright cloud, affirming that "This is my beloved Son, with whom I am well pleased." (Matthew 17.5, also mentioned in Mark 9.7 and Luke 9.35).

BELOW
Transfiguration
Titian
c. 1488–1576

RIGHT **Transfiguration**
Theophanes the Greek
c. 1340–c. 1410

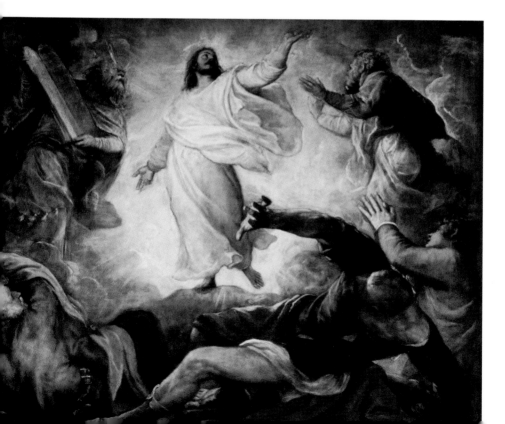

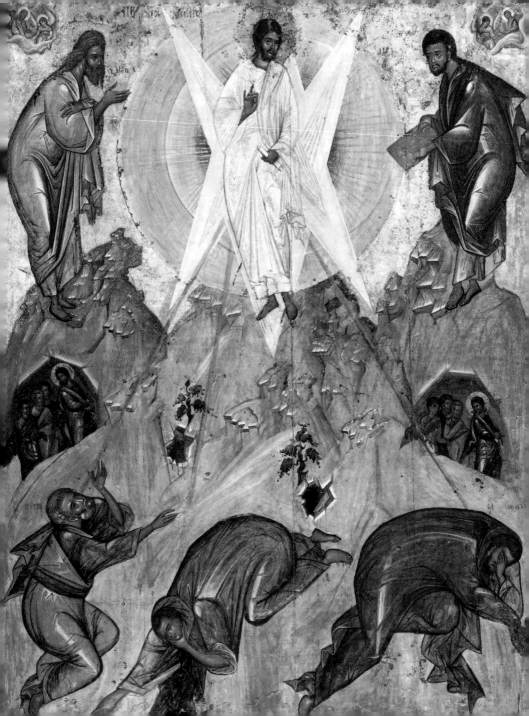

RAISING OF LAZARUS

41 Then they took away the stone from the place where the dead was laid. And Jesus lifted up His eyes and said, Father, I thank thee that thou hast heard me.

42 And I know that thou hearest me always: but because the people which stand by I said it, that they may believe that thou has sent me.

43 And when he thus had spoken, he cried with a loud voice, Lazarus, come forth.

44 And he that was dead came forth, bound hand and foot with graveclothes: and his face was bound about with a napkin. Jesus saith unto them, Loose him, and let him go.

(John 11.41–44)

BELOW **Raising of Lazarus**
Edward Kaiser
1815–1890

RIGHT **Raising of Lazarus**
Peter Paul Rubens
1577–1640

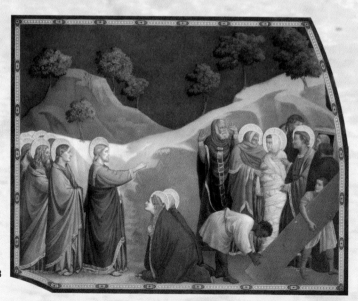

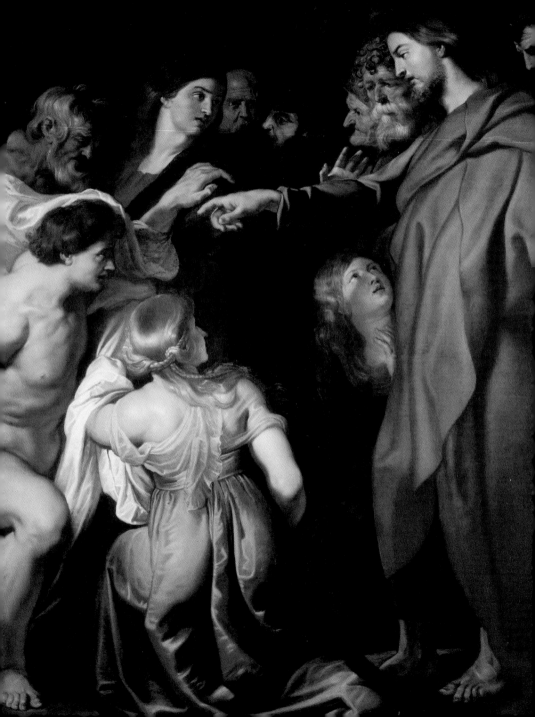

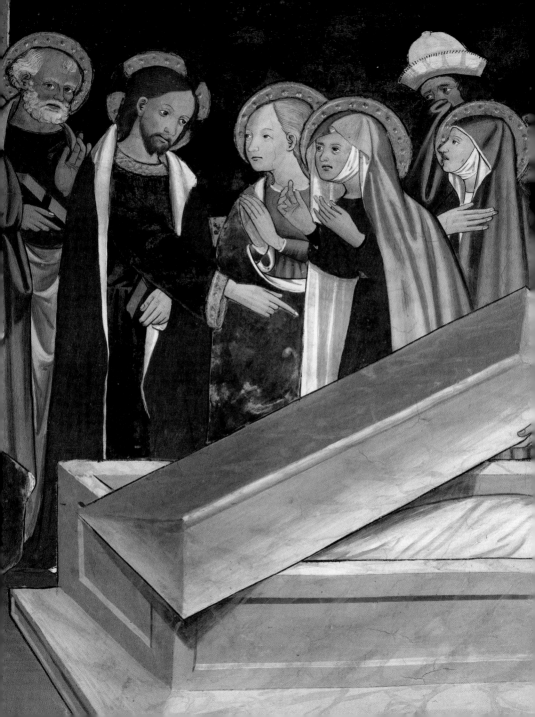

Lazarus was the brother of Martha and Mary, the two sisters who were close to Christ. Like them, he lived in Bethany, which was not in Galilee but in Judea, an area increasingly hostile to Christ and his mission. When Lazarus became ill, and the sisters sent for him, Christ was some distance away. He delayed for two days

LEFT **The Resurrection of Lazarus**
Fresco
15th century

ABOVE **Raising of Lazarus (detail)**
Giotto
1266–1337

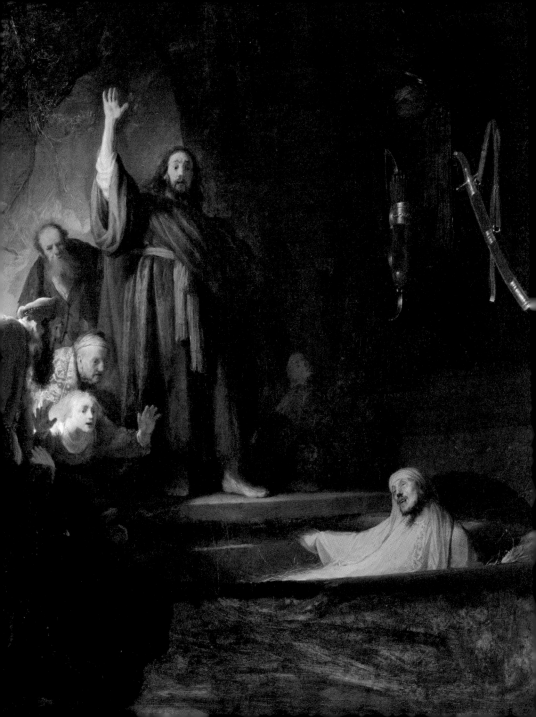

before setting out, and when he arrived, Lazarus was already in his grave. Both sisters reproached him, but expressed their faith that had Christ been present their brother would have lived. He demanded to be taken to the grave, which was in a cave blocked by a stone. Martha objected, saying "by this time he stinketh: for he hath been dead for four days." (John 11.39). Christ replied that, if she believed, she would see the glory of God. The miracle followed.

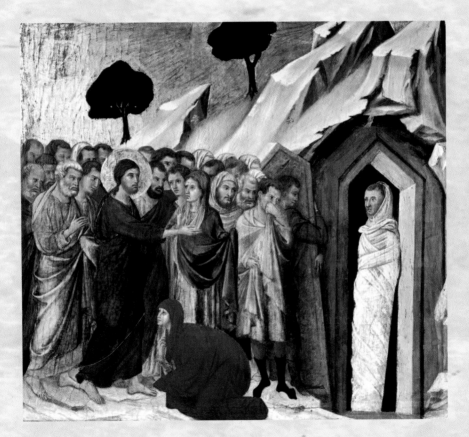

LEFT **The Raising of Lazarus**
Rembrandt
1606–1669

ABOVE **Raising of Lazarus**
Duccio di Buoninsegna
c. 1260–1318

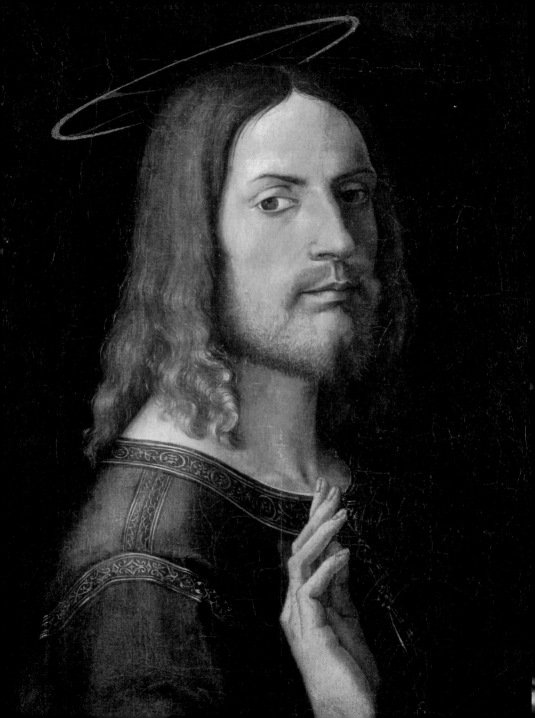

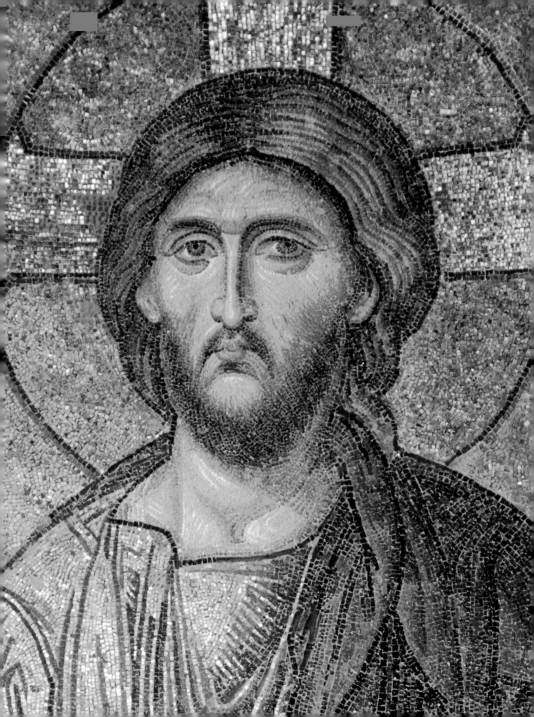

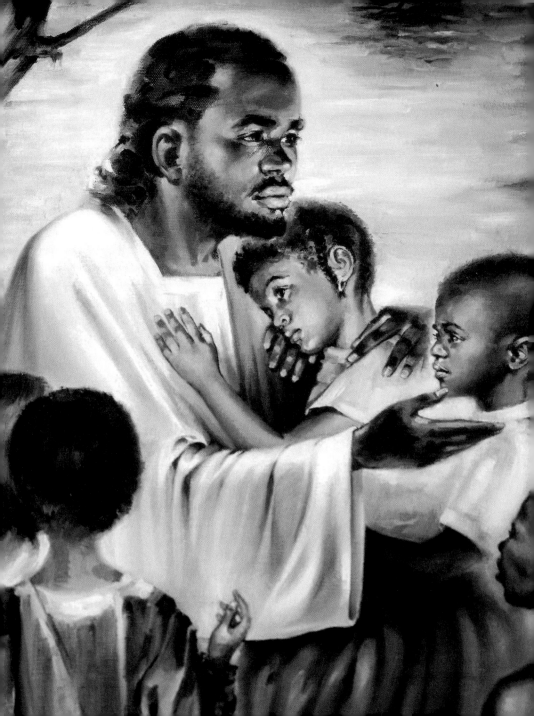

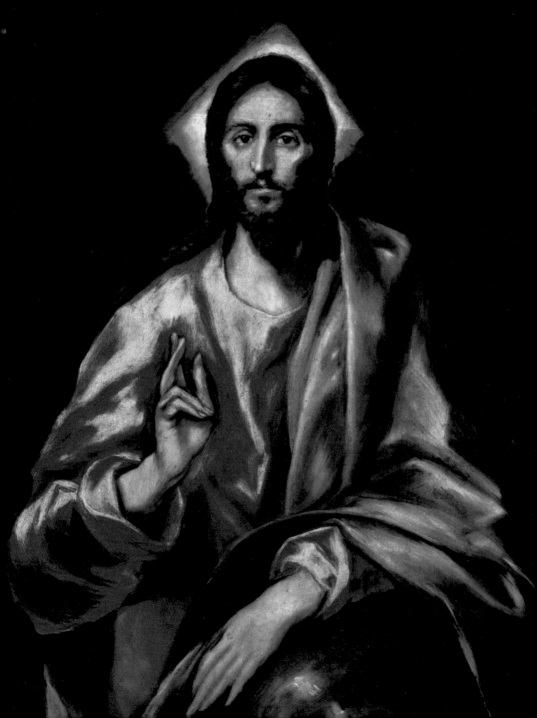

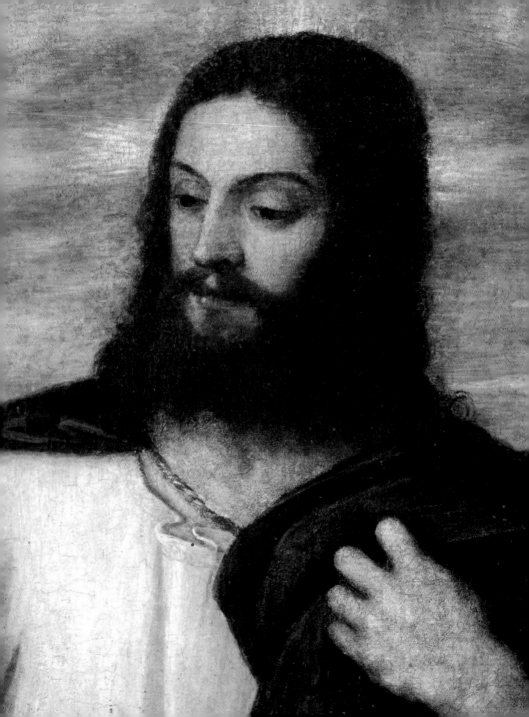

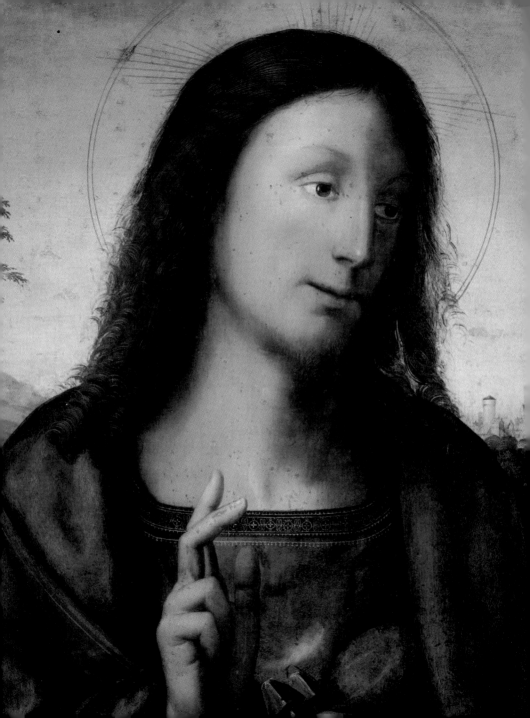

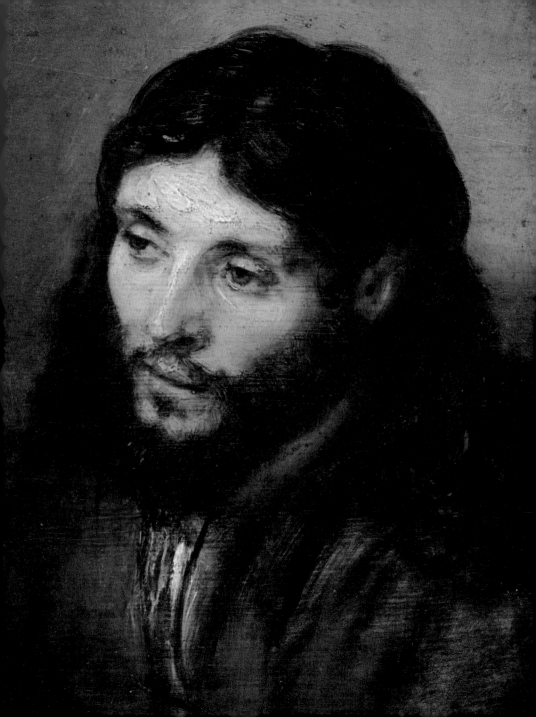

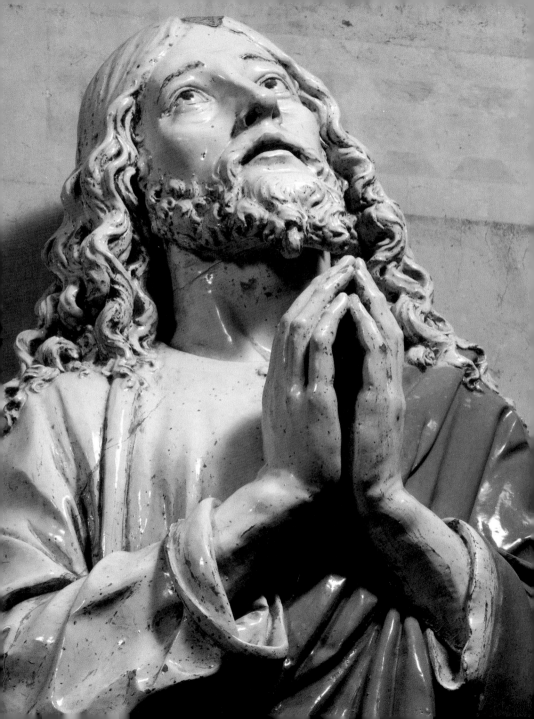

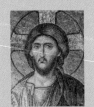
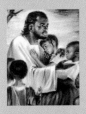
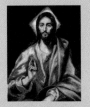
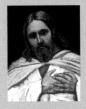

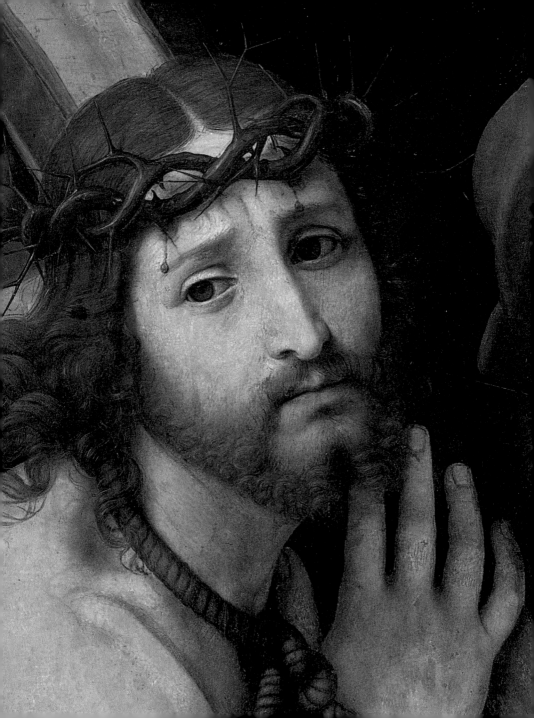

CHAPTER 5

THE PASSION

THE STORY OF THE LAST DAYS OF CHRIST'S MISSION moves at a headlong pace and is described in detail in all four Gospels. It begins with his triumphal entry into Jerusalem, mounted on an ass. People thronged around him, eager to see the man they had heard of, the man who had been performing great miracles. Christ then visits the Temple and cleanses it of its hawkers and moneychangers, whom he sees as defiling the house of God. He eats a Passover supper with his disciples, then spends an agonized night praying in Gethsemane. In the morning, having been betrayed by his apostle Judas, he is arrested. The chief priests, worried by his possible influence, have plotted to put him to death.

Christ is brought first before Caiaphas, the Jewish High Priest, and his Council, then before the Roman governor, Pontius Pilate. Pilate questions him, and, somewhat reluctantly, condemns him to death. Christ is ritually beaten, and is then dressed in a royal robe, crowned with a wreath of thorns and mockingly shown to the people.

He is led away on the road to Golgotha, outside Jerusalem. Though Christ is frequently represented in Christian art as carrying his own cross, the Gospel of St. John is the only text that mentions this. The other three Gospels say that the cross was carried by a man called Simon of Cyrene, who was pressed into service for this task, seemingly by chance (Matthew 27.32; Mark 15.21; Luke 23.26).

Christ was crucified with two thieves on either side of him, one of whom mocked him, while the other repented (an incident mentioned only in Luke 23.39–43). Among the witnesses to the Crucifixion were Christ's mother, his mother's sister, also called Mary, and Mary Magdalene. According to the Gospel of St. John, the three women "stood by the cross" (John 19.25) whereas Luke says "they stood afar off" (Luke 23.49).

Christ Carrying the Cross (detail)
Andrea Solario
c. 1470–c. 1522

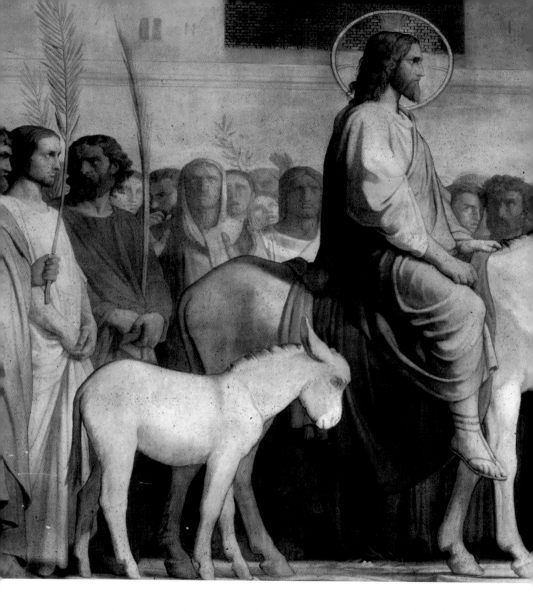

ABOVE AND RIGHT (DETAIL) **Entry of Christ into Jerusalem**
Hippolyte Flandrin
1809–1864

OVERLEAF PAGE 158 **Entry into Jerusalem**
Byzantine painting
Late 16th or early 17th century

Entry into Jerusalem

Christ's path was strewn with palm branches by the crowds which greeted him—these were universal signs of victory, both for members of the Jewish faith and in the pagan world. Later, the tombs of Christian martyrs were often marked with palm branches as a sign of their victory over death. Christ rode an ass rather than a horse as a sign of humility (John 12.12–15). Later it became customary for high ecclesiastics to ride asses or mules in direct imitation of Christ.

OVERLEAF PAGE 159
Christ's Entry into Jerusalem
Central panel of ivory triptych
10th century

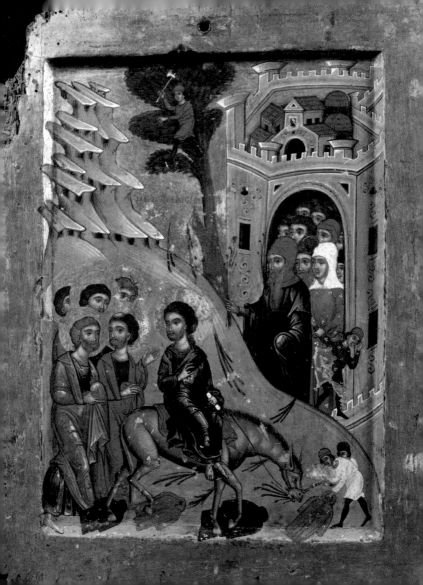

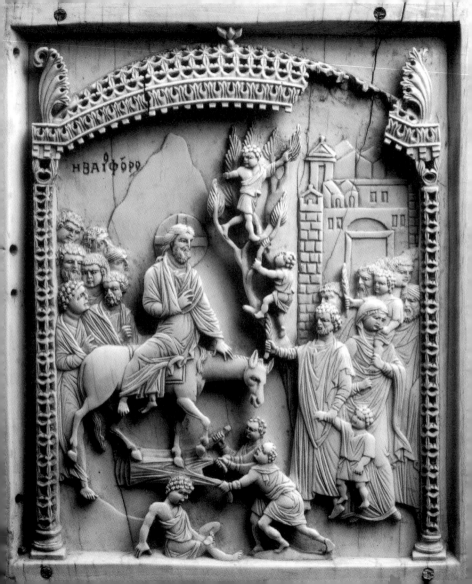

Cleansing of the Temple

The Gospel of St. Matthew says that Christ "cast out all them that sold and bought in the temple, and overthrew the tables of the money changers, and the seats of them that sold doves." (Matthew 21.12). Those whom he threw out made a lucrative business from servicing those who came to offer sacrifices. Christ's parents had offered "a pair of turtledoves, or two young pigeons" (Luke 2.24) when they presented him in the Temple after his birth. Pagan temples were similarly also places of business, with sacrificial birds and beasts for sale on the spot.

ABOVE **Christ Expelling the Money Changers from the Temple**
Salvator Rosa
1615–1673

RIGHT **Expulsion of the Merchants from the Temple**
Rembrandt
1606–1669

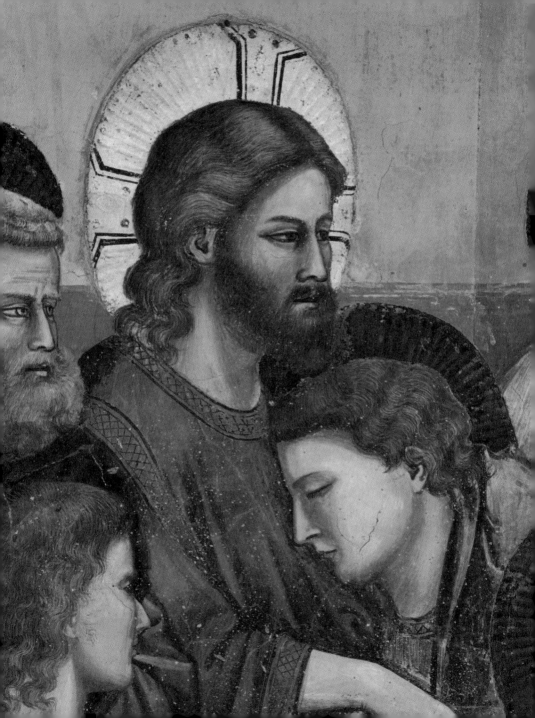

THE LAST SUPPER

16 And his disciples went forth, and came into the city, and found as he had said unto them: and they made ready the passover.

17 And in the evening he cometh with the twelve.

18 And as they sat and did eat, Jesus said, Verily I say unto you, One of you which eateth with me shall betray me:

19 And they began to be sorrowful, and to say unto him one by one, is it I? and another said, is it I?

20 And he answered and said unto them, It is one of the twelve that dippeth with me in the dish.

21 The Son of man indeed goeth, as it is written of him: but woe to that man by whom the Son of man is betrayed! good were it for that man if he had never been born.

22 And as they did eat, Jesus took bread, and blessed, and brake it, and gave it to them, and said, Take, eat: this is my body.

(Mark 14.16–22)

LEFT **The Last Supper** (detail)
Giotto
1266–1337

BELOW **Last Supper** (detail)
Domenico Ghirlandaio
1449–1494

163

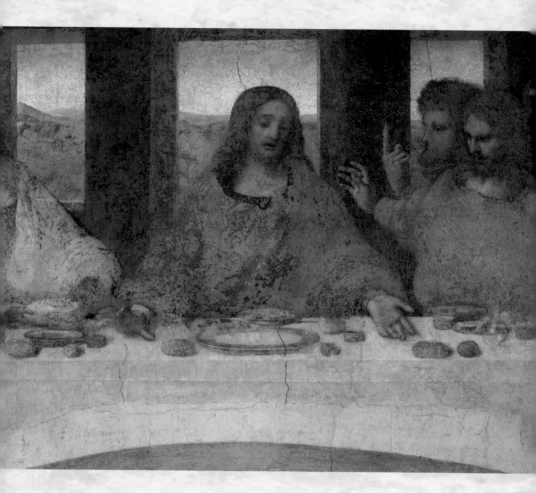

The Last Supper was a version of the Passover feast, commemorating the escape of the Israelites from Egypt. It was called Passover because the Israelites who had marked their door posts with the blood of a spring lamb escaped the slaughter of the first-born, the last and worst of the Ten Plagues visited upon the Egyptians (Exodus 12.12). The Israelites left in such a hurry that they could not wait for bread to rise, so for the duration of Passover no leavened bread is eaten.

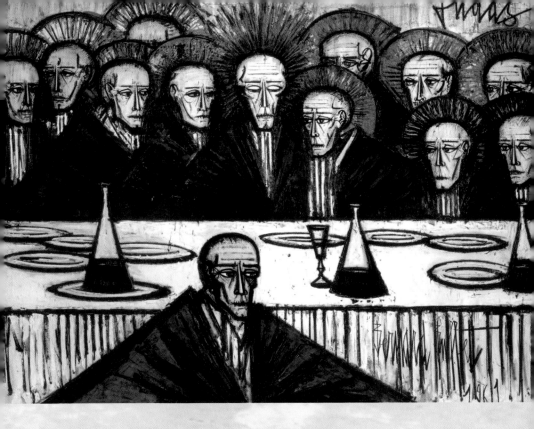

FAR LEFT **Last Supper**
(detail)
Leonardo da Vinci
1452–1519

ABOVE **Last Supper**
Bernard Buffet
1928–1999

LEFT **Last Supper**
M. Walbaum
17th century

OVERLEAF **Last Supper**
Juan de Juanes
c. 1510–1579

165

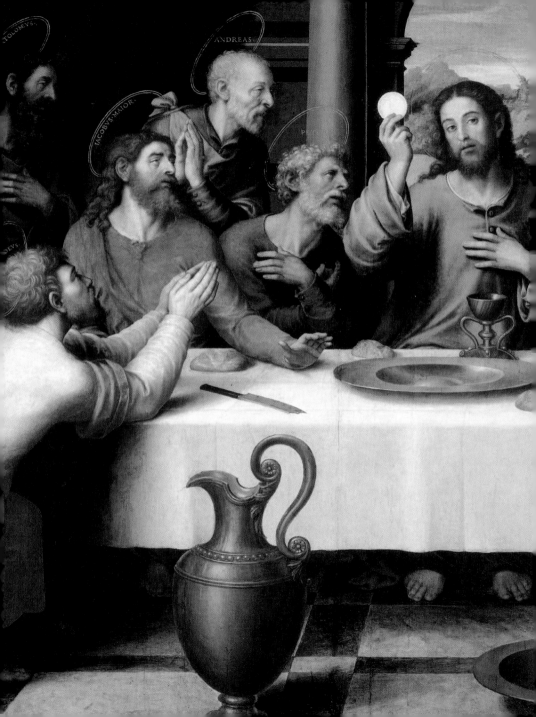

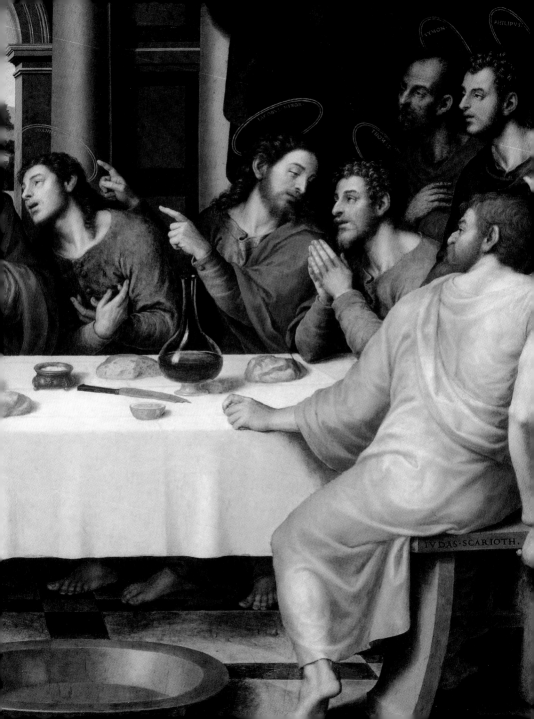

IVDAS·SCARIOTH.

Representations of the Last Supper in art seem to have been codified by Leonardo da Vinci's famous fresco in Milan, painted between 1495 and 1498 (see page 164). Christ is placed at the center of a long table, with the other participants situated on either side. The disciples are shown reacting to his statement that one of them will betray him. In some paintings of the Last Supper, John "the beloved disciple" is shown leaning against Christ's breast, either fainting or apparently asleep.

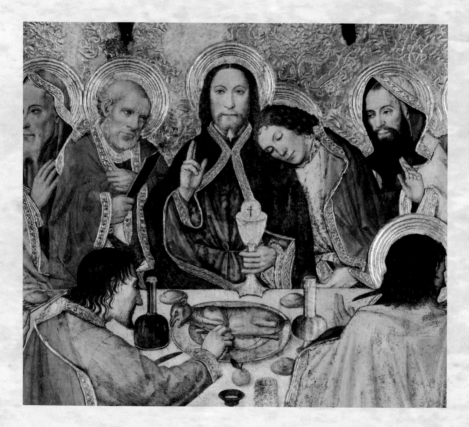

Above **Last Supper**
Jaime Huguet
c. 1415–c. 1492

Right **Last Supper (after Vermeer)**
Hans Anthonius van Meegeren
1889–1947

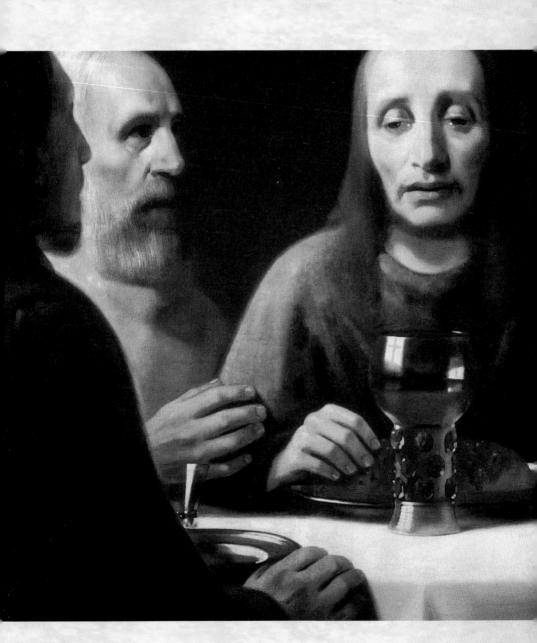

The Agony in the Garden

The struggle between the mortal and immortal elements in Christ's nature is embodied in this incident. Christ is shown struggling to accept his impending fate. He says: "Abba, Father, all things are possible unto thee; take away this cup from me: nevertheless, not what I will, but what thou wilt." (Mark 14.36). The Gospel of St. Luke speaks of an angel, appearing to strengthen Christ (Luke 22.43). This moment is often represented by artists.

BELOW LEFT **Christ on the Mount of Olives** (detail)
Domenico Feti
1589–1624

BELOW RIGHT **The Agony in the Garden of Gethsemane** (detail)
El Greco
c. 1541–1614

RIGHT **Agony in the Garden**
Filippo Tarchiani
17th century

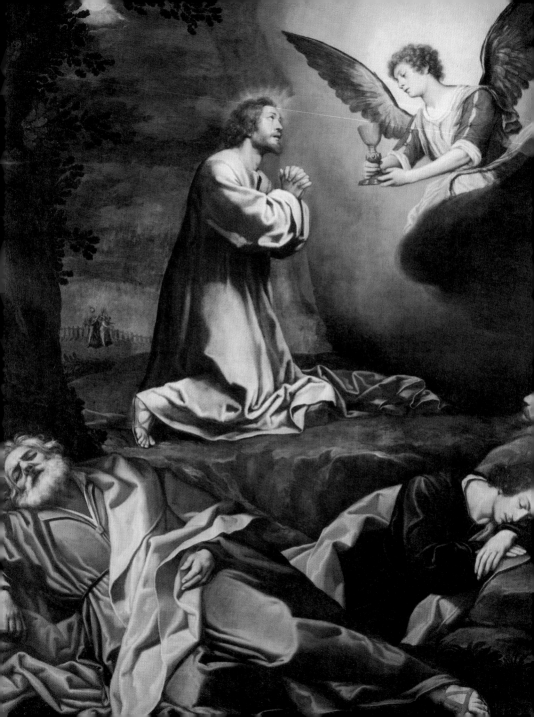

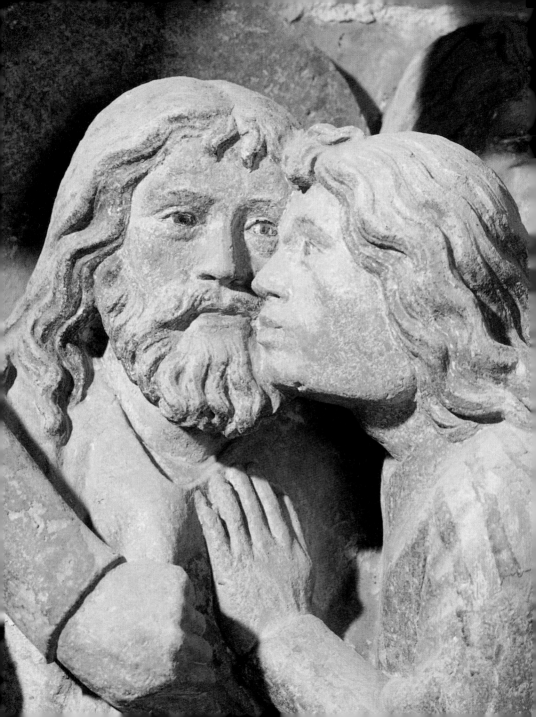

Arrest of Christ

Men greeting other men with a kiss was a long-established custom in ancient Judea, and when Christ visited the house of Simon the Pharisee, he reproached him for not offering one (Luke 7.45). The fact that Judas sealed his betrayal of Christ with a kiss made this act of treachery particularly brutal.

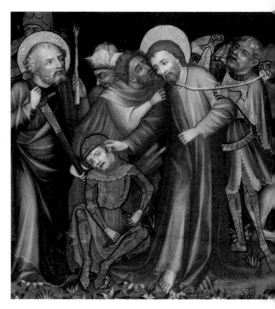

LEFT **The Taking of Christ (detail)**
Master of Naumburg
13th century

ABOVE **Taking of Christ (detail)**
Master of the Altar of Mary
15th–16th century

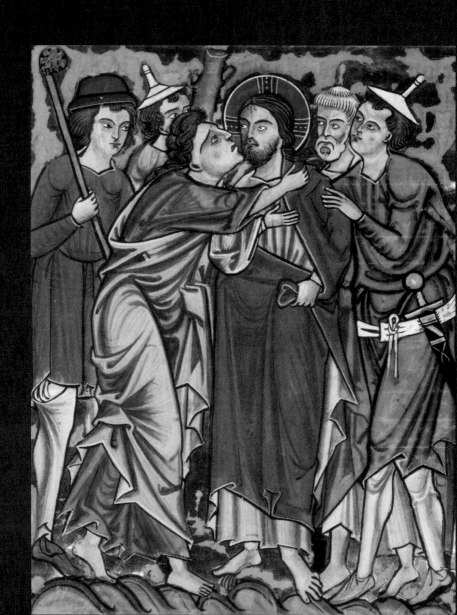

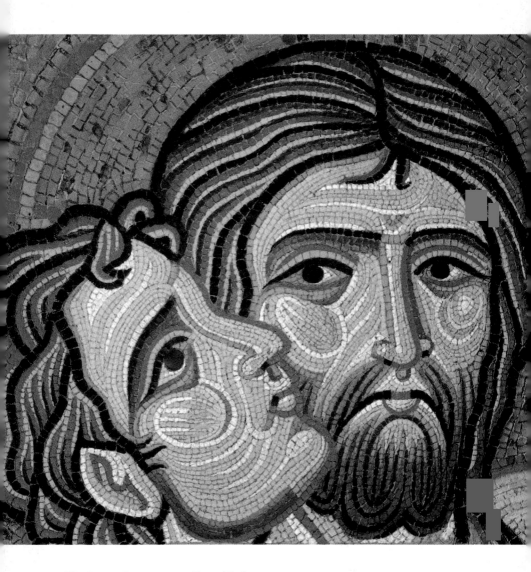

LEFT **The Betrayal**
Romanesque illumination
c. 1200

ABOVE **Kiss of Judas**
Copy of Romanesque mosaic
19th century

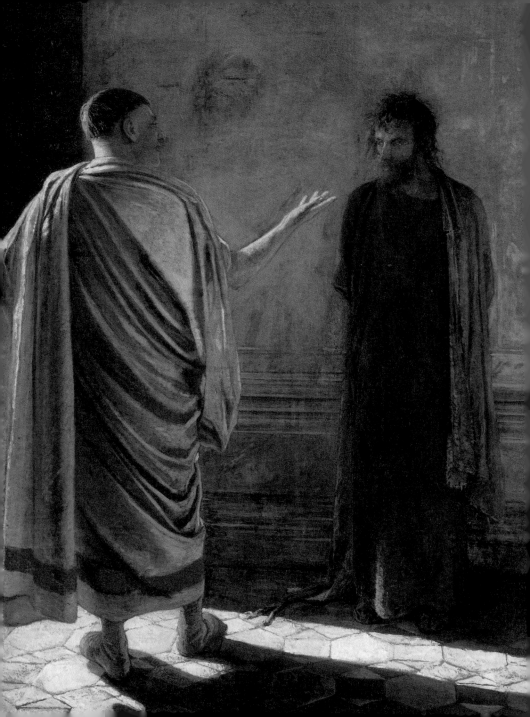

Christ Before Pilate

Pontius Pilate was only firmly established as an historical figure by an inscription discovered in 1961, at Caesarea Maritima, which names him as "prefect of Judea."

His confrontation with Christ illustrates some of the tensions between the Roman occupiers and the Jewish religious authorities. These culminated in the Jewish revolt of 66 AD and the destruction of the Temple. The Sanhedrin, the ancient Jewish court, had arranged for Christ's arrest, but could not condemn him to death without the prefect's authorization. If Christ claimed directly to be "King of the Jews," he would put himself in direct opposition to the Roman imperial power.

Pilate questioned him on this subject, and received answers that were initially ambiguous (John 18.33–34). Finally Christ tells him, "My kingdom is not of this world…Thou sayest that I am a king. To this end was I born, and for this cause I came into the world, that I should bear witness unto the truth." (John 18.36–37).

LEFT **What is the Truth?**
(Christ Before Pilate)
Nikolay Ghe
1831–1894

RIGHT **Scene from the Life of Christ**
Romanesque
c. 1200

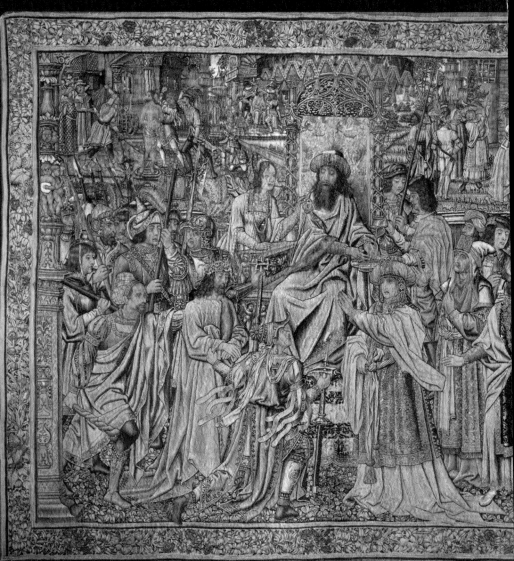

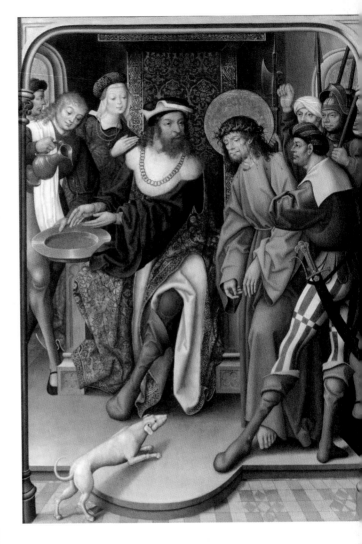

LEFT **Christ Led by Pilate**
Tapestry
c. 1500

ABOVE **Christ Before Pilate**
Master of Cappenberg
c. 1520

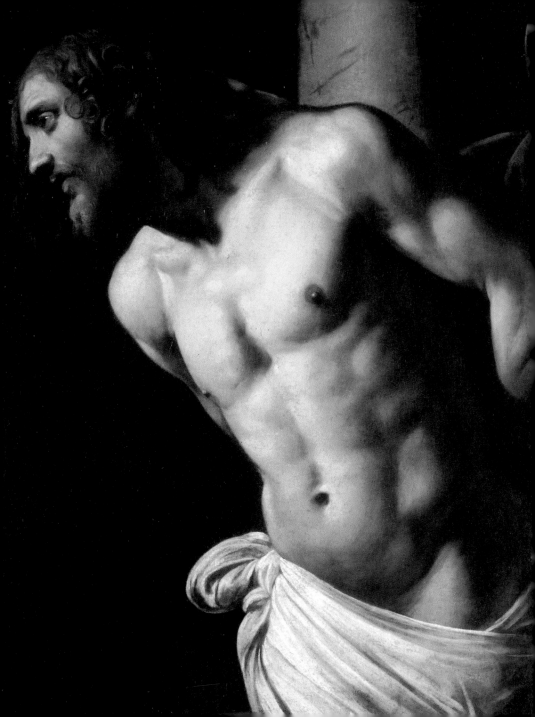

Flagellation

As a condemned prisoner, Christ was severely beaten. The intention was not simply to humiliate, but to make his ultimate crucifixion more agonizing, as his lacerated back would be against the upright of the cross as he tried to relieve the strain on his arms. Painters such as Caravaggio used this subject as a pretext for depicting the heroic male nude.

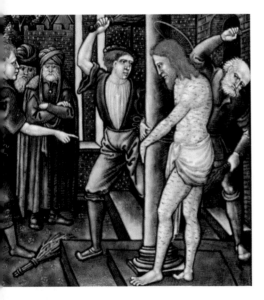

LEFT **Flagellation of Christ**
Caravaggio
1571–1610

ABOVE **The Flagellation**
Pierre Reymond
c. 1513–1584

ABOVE RIGHT **Christ at the Column**
Georges Desvallières
1861–1950

ABOVE **Flagellation**
Wolfgang Huber
c. 1490–1553

RIGHT **Flagellation**
Gregorio Fernández
1576–1656

FAR RIGHT **Christ at the Column**
Sodoma
1477–1549

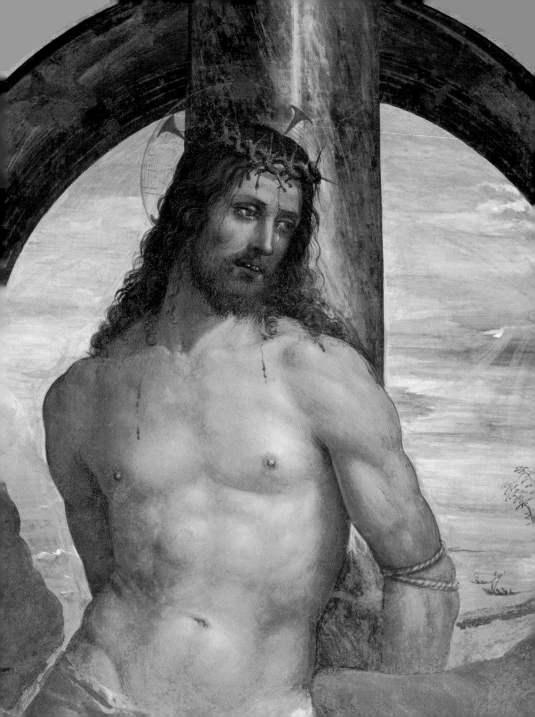

Crowning with Thorns

Dressed in a royal robe and wearing a crown of thorns, Christ was shown to the people who had been clamoring for his death. This was in mockery of his supposed claim to be "King of the Jews."

The image is doubly ironic. Christ is shown as being abject—already wounded and humiliated, though not as yet dead. At the same time, the royal reference foreshadows the triumph that is to come.

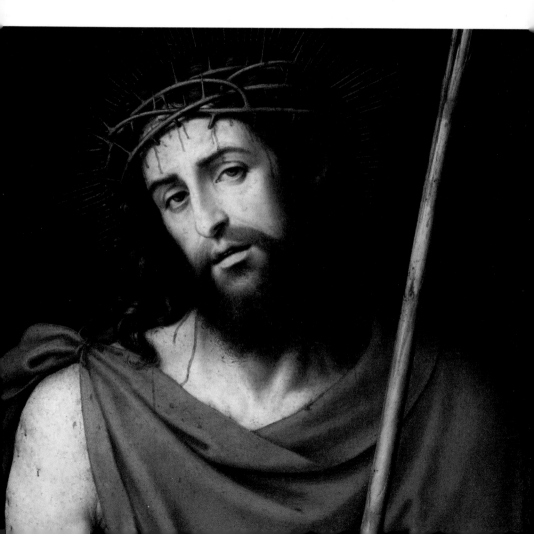

LEFT **Ecce Homo**
Juan de Juanes
c. 1510–1579

ABOVE **The Mocking of Christ**
Otto Lange
1879–1944

CROWNING WITH THORNS **185**

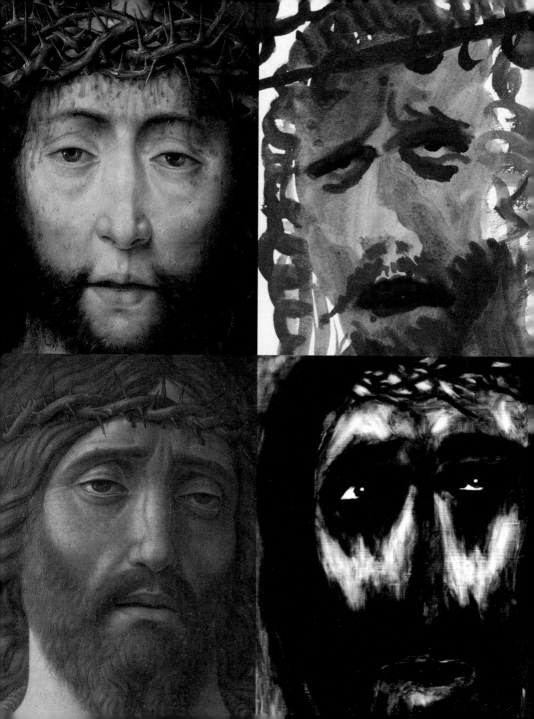

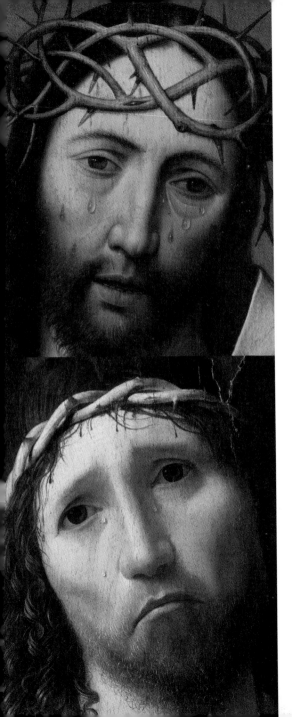

Some of the most iconic images of Christ are those that show him with the crown of thorns, which emphasizes both his suffering and his transcendent kingly status. In the Middle Ages, the supposedly authentic crown of thorns was at the center of a cult of relics. The exquisite Sainte-Chapelle, a Gothic chapel in Paris, was built to house it.

1. Christ Crowned with Thorns
Albrecht Bouts
c. 1460–1549

2. Ecce Homo
Andrea Mantegna
c. 1431–1506

3. Christ Rose
Marc-Édouard Nabe
b. 1958

4. Christ Crowned with Thorns
Guy Ganachaud
1923–2000

5. Christ Crowned with Thorns
Jan Mostaert
c. 1475–c. 1555

6. Ecce Homo
Antonello da Messina
c. 1430–1479

Journey to Calvary

Only one Gospel, that of St. John, says that Christ was compelled to carry his own cross to Golgotha (John 19.17). The other three say that a passerby was pressed into service: "And as they came out, they found a man of Cyrene, Simon by name: him they compelled to bear his cross." (Matthew 27.32; also mentioned in Mark 15.21 and Luke 23.26). Almost without exception, the paintings that

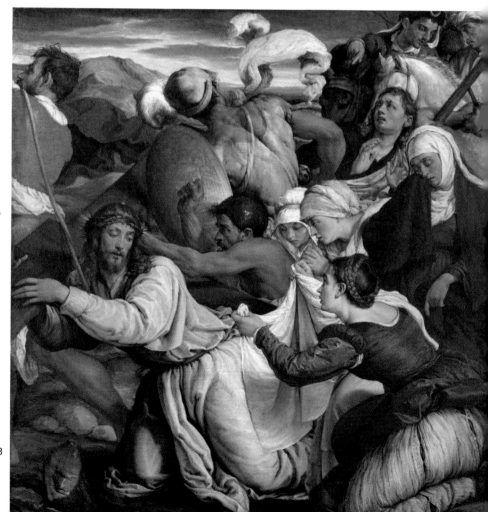

depict Christ carrying the cross show him with it complete. In fact, it would probably only have been possible for him to carry the crossbeam, as the complete cross would have been too heavy to lift.

None of the Gospels give a detailed account of Christ's laborious journey to his death. The story of St. Veronica, the pious woman who gave Christ a cloth to wipe his face as he staggered under the weight he was forced to bear, and who had it returned to her with an imprint of his face, was not fully elaborated until as late as about 1380. At this time, the incident achieved canonical status as the sixth Station of the Cross.

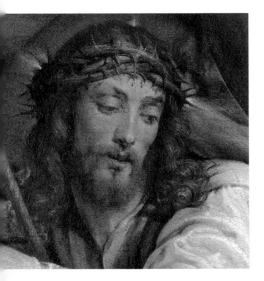

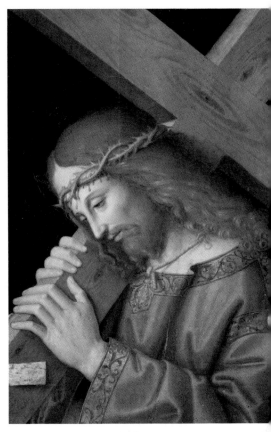

LEFT AND ABOVE (DETAIL) **The Way to Calvary**
Jacopo Bassano
c. 1510–1592

RIGHT **Jesus Carrying the Cross**
Marco Palmezzano
c. 1458–1539

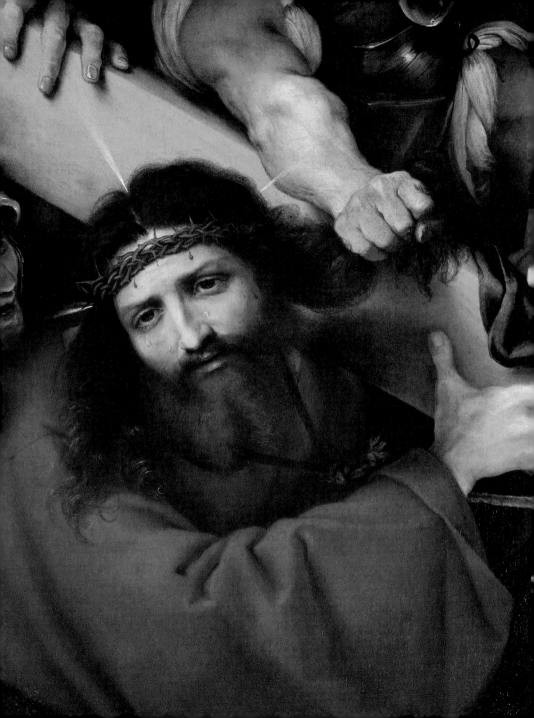

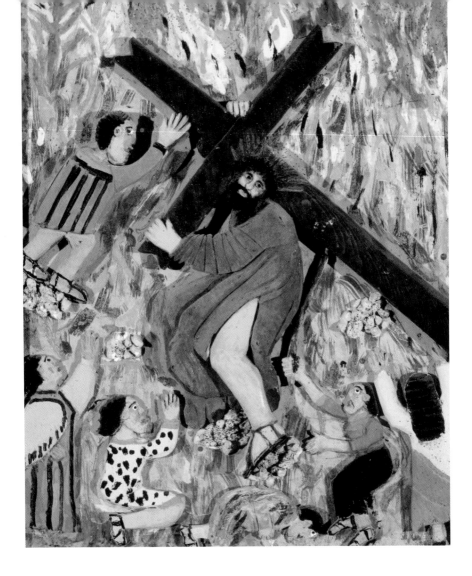

LEFT **Christ Carrying the Cross**
Lorenzo Lotto
c. 1480–c. 1556

ABOVE **Christ Carrying the Cross**
Elijah Pierce
1892–1984

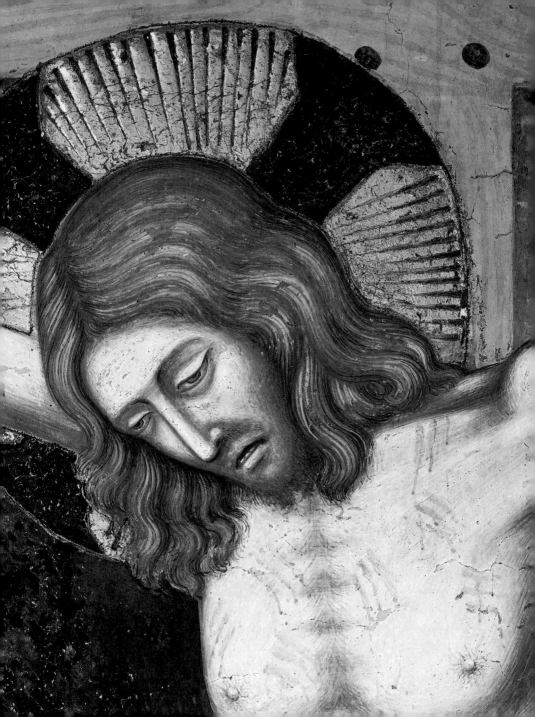

THE CRUCIFIXION

33 And when they were come
unto a place called Golgotha,
that is to say, a place of a skull,
34 They gave him vinegar to drink
mingled with gall: and when he had
tasted thereof, he would not drink.
35 And they crucified him, and
parted his garments, casting lots:
that it might be fulfilled which
was spoken by the prophet,
They parted my garments among
them, and upon my vesture did
they cast lots.
36 And sitting down they watched
him there;
37 And set up over his head his
accusation written, THIS IS JESUS,
THE KING OF THE JEWS.
38 Then there were two thieves
crucified with him, one on the right
hand, and another on the left.

(Matthew 27.33–38)

FAR LEFT **Crucifixion** (detail)
Pietro Cavallini
13th–14th century

LEFT **Christ on the Cross**
Sculpture
17th century

BELOW **Crucifixion**
Olive wood tattoo stamp
used by pilgrims
17th–18th century

Crucifixion, as a form of capital punishment, seems to have been invented either by the Persians or the Carthaginians, and then taken over by the Romans. It was considered to be particularly degrading, and was rarely used on Roman citizens, but only on rebels and slaves. Part of its horror was that the victim remained alive for a long time, suffering agonizing cramps, and became increasingly unable to breathe.

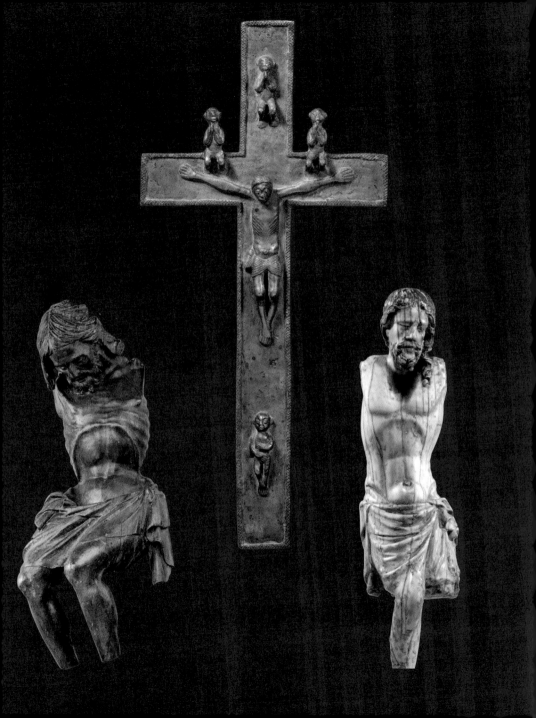

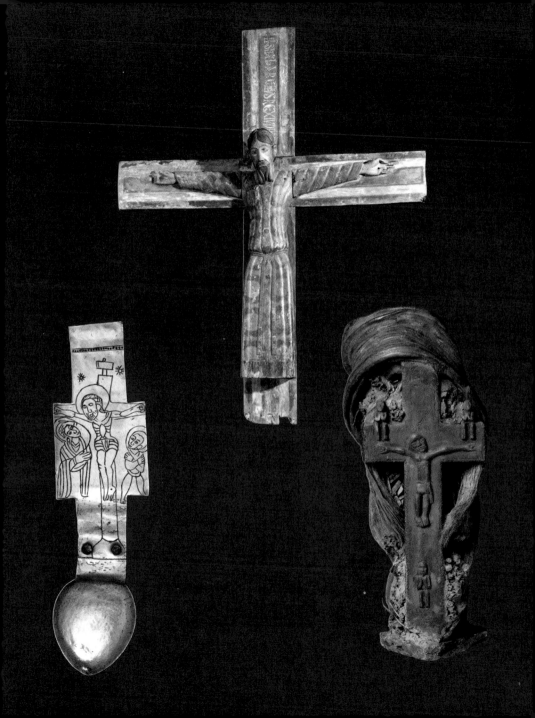

Images of the crucified Christ are
a primary symbol of the Christian
religion. Christ's expression in these
images varies. Sometimes his eyes
are downcast in sorrow, or even
completely closed, as his suffering at
last comes to an end. Sometimes he
looks upward, as if communicating
with his Heavenly Father.

1. Crucifixion (detail)
Francisco de Goya
1746–1828

2. Crucifix (detail)
Michelangelo
1475–1564

3. Crucifixion (detail)
Master of Naumburg
13th century

4. Crucifixion (detail)
Graham Sutherland
1903–1980

5. Crucifixion (detail)
Gaston Chaissac
1910–1964

6. Christ Crucified (detail)
Diego Velázquez
1599–1660

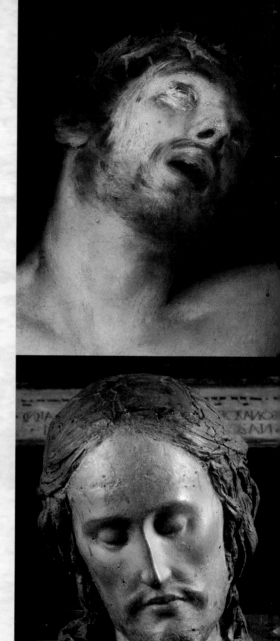

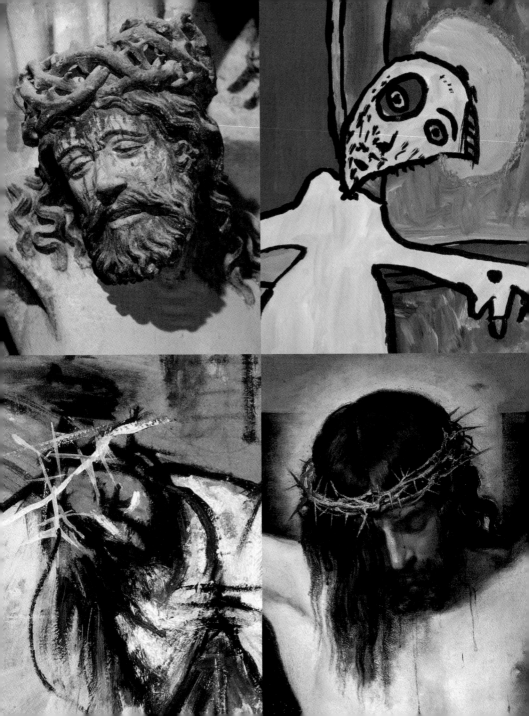

Crucifixion images are not always true to the facts that have come down to us. For example, Christ is rarely shown naked, which was invariably the case with victims of crucifixion. Artists who represent the Crucifixion have had a twofold aim. They want to bring home the magnitude of Christ's suffering, and to emphasize the sacrifice he made to redeem humankind. At the same time, they want to show him as potentially triumphant over death. Christ's body type also varies—he can be emaciated, or a muscular hero.

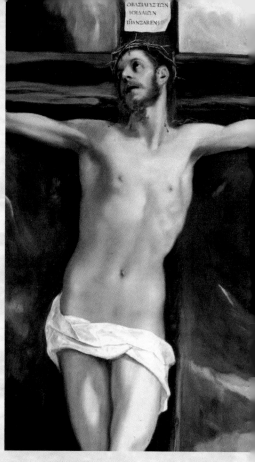

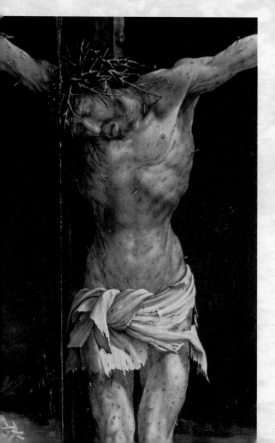

LEFT **Isenheim Altar: Crucifixion**
Mathis Grünewald
1445/55–c. 1528

ABOVE **Christ on the Cross**
El Greco
c. 1541–1614

RIGHT **The Descent from the Cross**
Max Beckmann
1884–1950

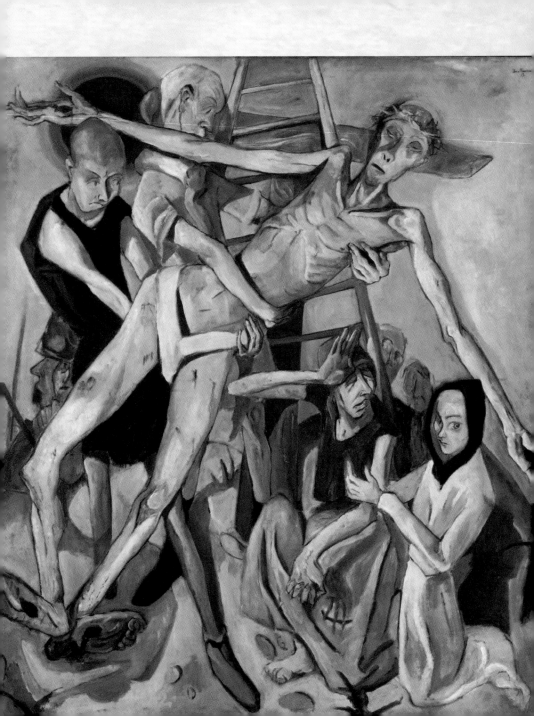

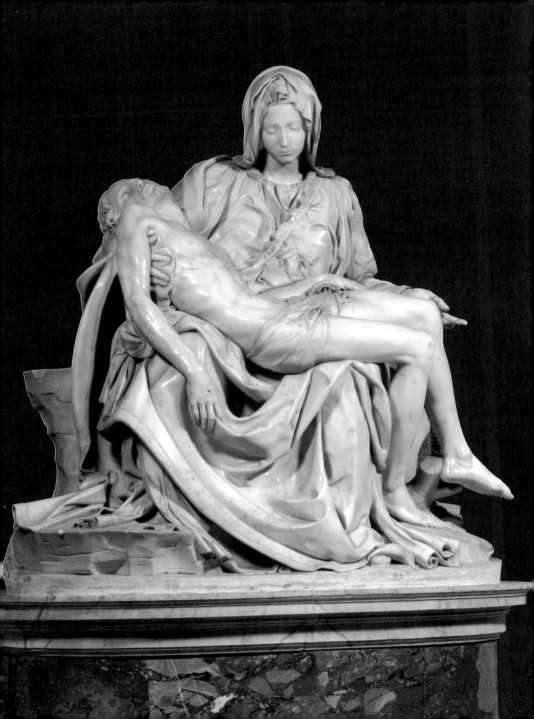

Pietà

The image of the Pietà—the dead Christ lying across the lap of the sorrowing Virgin Mary—developed from images of the body of Christ being taken down from the Cross, preparatory to burial. There is, in fact, no reference to this in scripture.

LEFT AND BELOW (DETAIL) **Pietà**
Michelangelo
1475–1564

BELOW RIGHT **Deploration with St. Mary and St. John**
Peter Paul Rubens
1577–1640

The Pietà image in its present form appeared in art quite late. The earliest examples are Gothic carvings of around 1300, created in Germany, though it also begins to appear in paintings during the fifteenth century. The idea was taken over by Michelangelo for the famous marble Pietà, now in St. Peter's in Rome. The composition is manipulated so subtly that most spectators do not notice that the Virgin, cradling a full-grown man of heroic proportions, has become a giantess in order to support his size and weight.

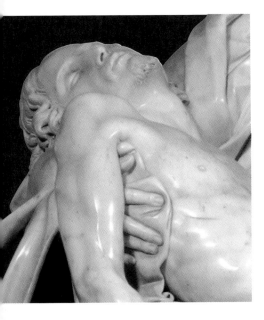

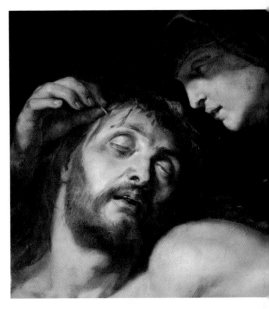

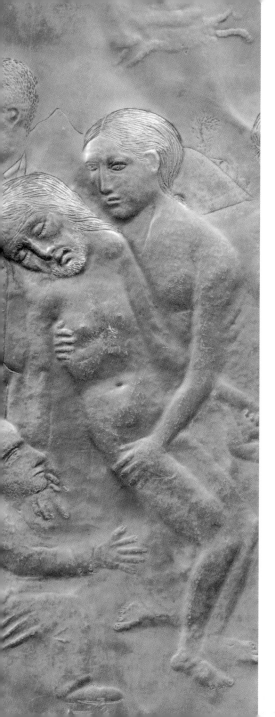

LEFT **Deposition**
Giacomo Manzù
1908–1991

BELOW **Pietà (after Delacroix)**
Vincent van Gogh
1853–1890

RIGHT **Pietà**
Pranas Gudaitis
b. 1948

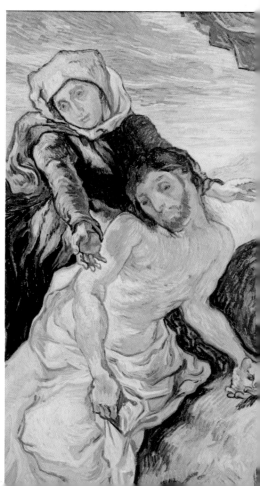

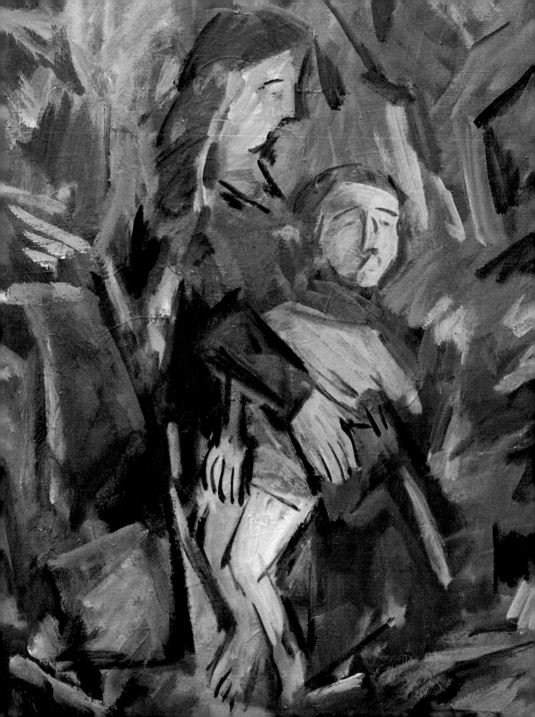

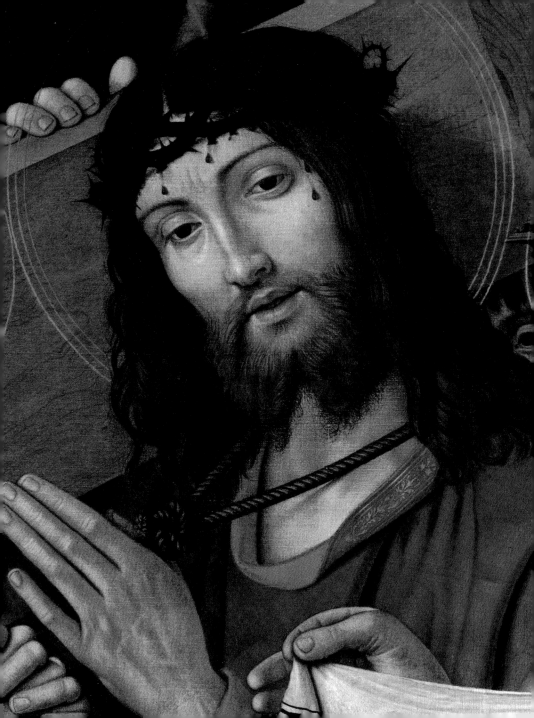

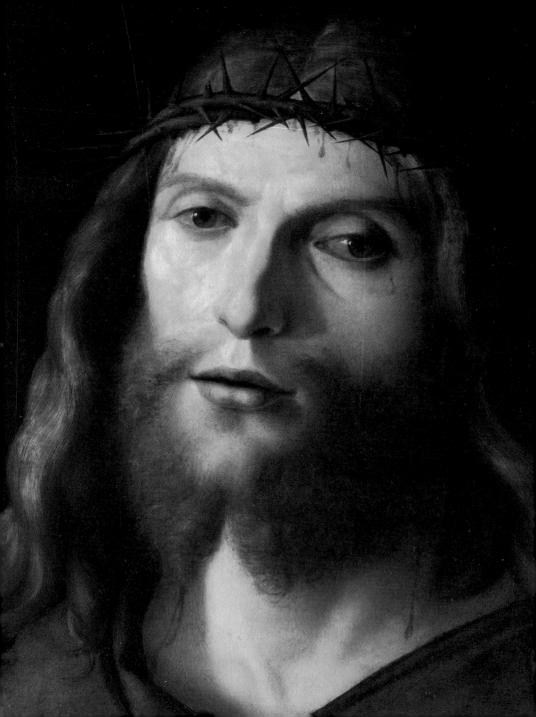

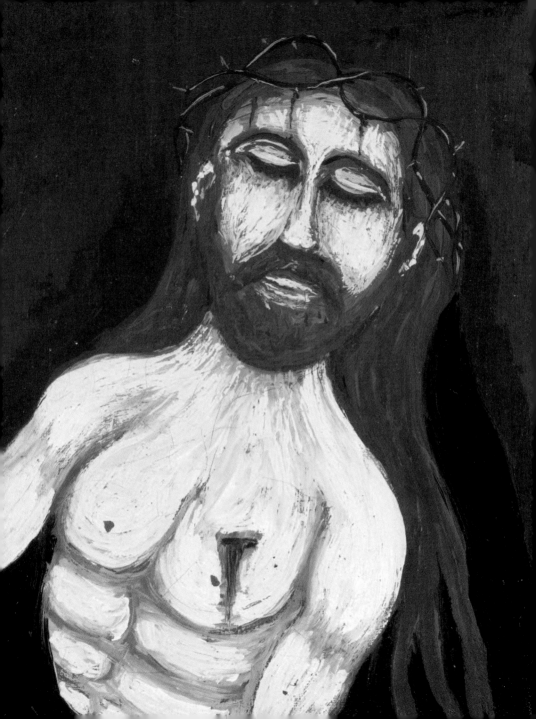

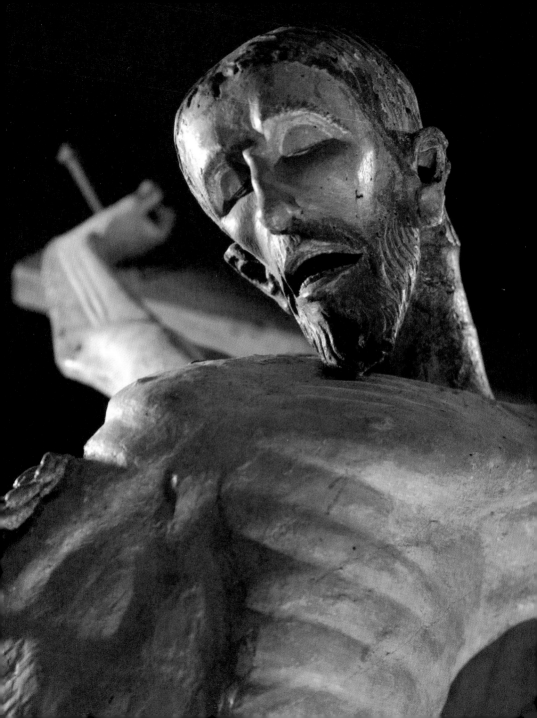

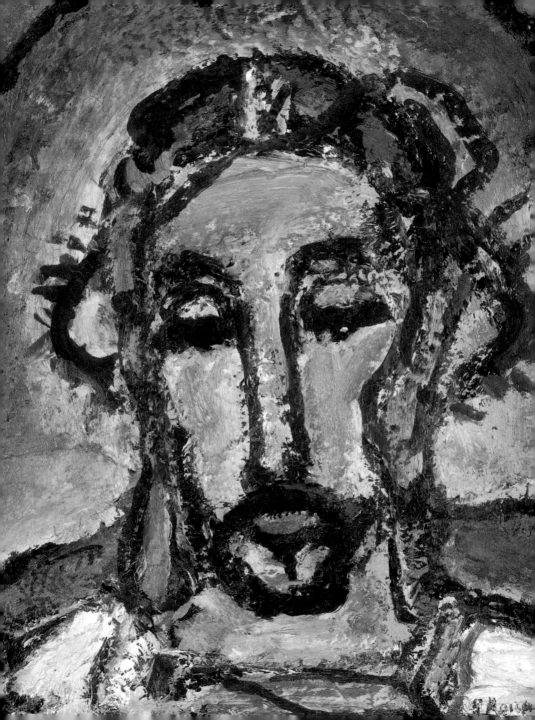

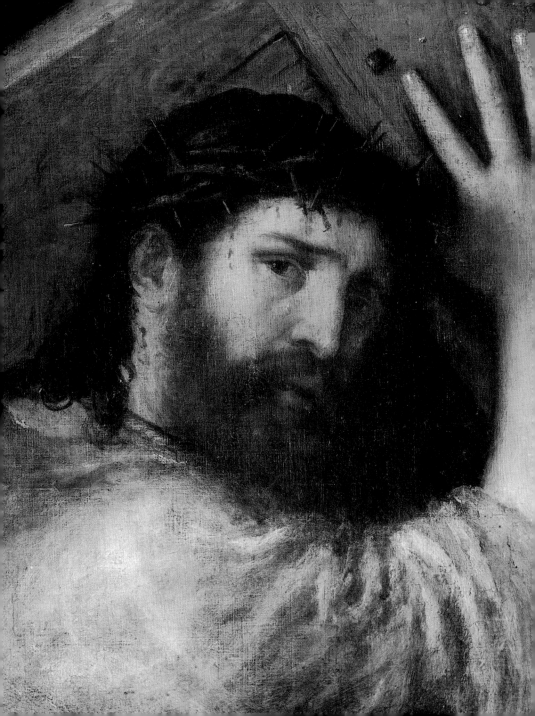

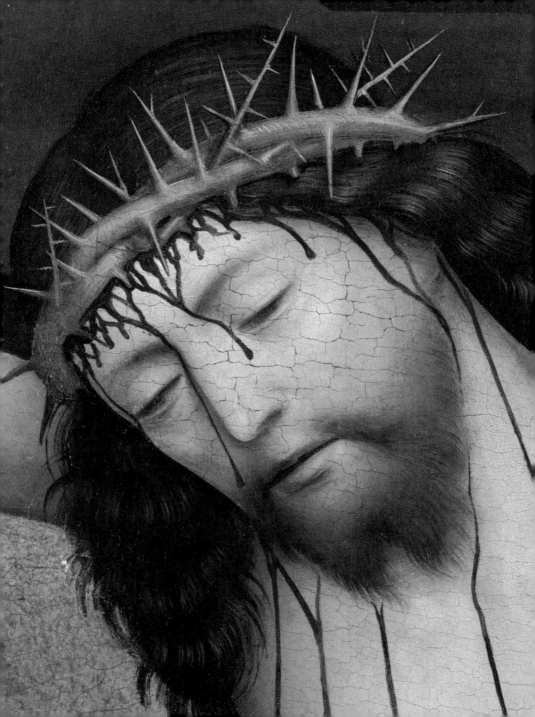

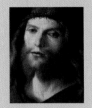

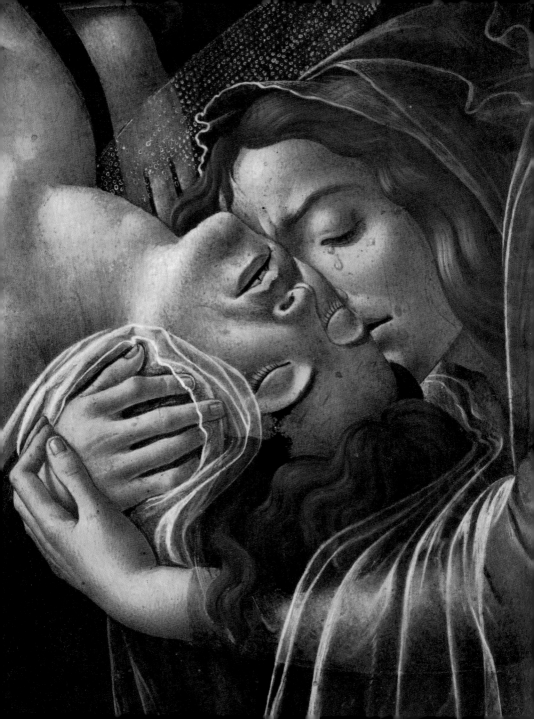

Resurrected Christ

The Gospels describe Christ's burial in a rock-cut tomb, not far from where the Crucifixion took place (Matthew 27.57–61; Mark 15.42–47; Luke 23.50–56; John 19.38–32). The Gospel of St. Matthew is the only one to say that a guard was placed on the tomb, at the request of the Jewish Council (Matthew 27.62–66), since Christ had already prophesied his own Resurrection.

There is no actual description of the Resurrection, though it has often been depicted in art. What the Gospels do describe is the early morning visit made immediately after the Sabbath by Mary Magdalene and "the other Mary" (Christ's mother), and their encounter with an angel, who had rolled away the stone blocking the door (Matthew 28.1–7; Mark 16.1–8; Luke 24.1–12; John 20.1–13).

Mary Magdalene then has an encounter with Christ himself, whom at first she does not recognize, but mistakes him for the gardener looking after the garden around the tomb (John 20.15). Christ reveals himself to her, but forbids her to touch him: "Touch me not; for I am not yet ascended to my Father: but go to my brethren, and say unto them, I ascend unto my Father, and your Father; and to my God, and your God." (John 20.17). This initiates a series of apparently random encounters between Christ and those who knew him, chiefly his disciples. In most of these, the disciples do not recognize him at first.

The most famous incident of this type is the Supper at Emmaus, where two of the disciples meet Christ, seemingly by chance, as they walk to a village near Jerusalem. They have some conversation with him and invite him to supper. It is only when he blesses the bread at table that they recognize him, and he then vanishes (Luke 24.30–31). On another occasion, he asks a disciple who doubts him to thrust a hand into the wound in his side (John 20.24–29). Finally, in the presence of the disciples, Christ ascends to heaven (Luke 24.50–53).

Lamentation over the Dead Christ (detail)
Sandro Botticelli
c. 1444–1510

Burial of Christ

The circumstances in which Christ was buried suggest that, despite his arrest and crucifixion, he retained the faith of a group of wealthy followers. Chief among them was Joseph of Arimathea, who begged Christ's body from the Roman governor (Matthew 27.57–59). There was also Nicodemus, "a ruler of the Jews" (John 3.1), who brought costly spices— "a mixture of myrrh and aloes"

(John 19.39)—to preserve the body from decay. The chief priest and his followers, who had demanded the death of Christ, asked the governor to put a guard on the tomb "lest his disciples come by night and steal him away." (Matthew 27.62–66).

BELOW **Dead Christ**
Byzantine textile
14th century

RIGHT **Deposition**
Caravaggio
1571–1610

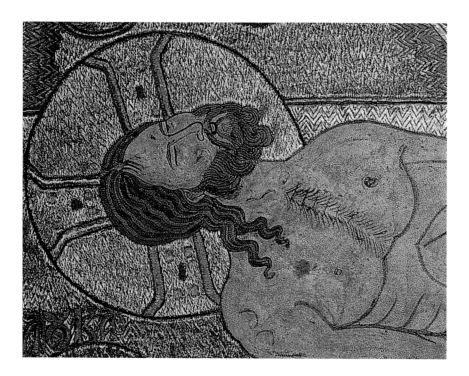

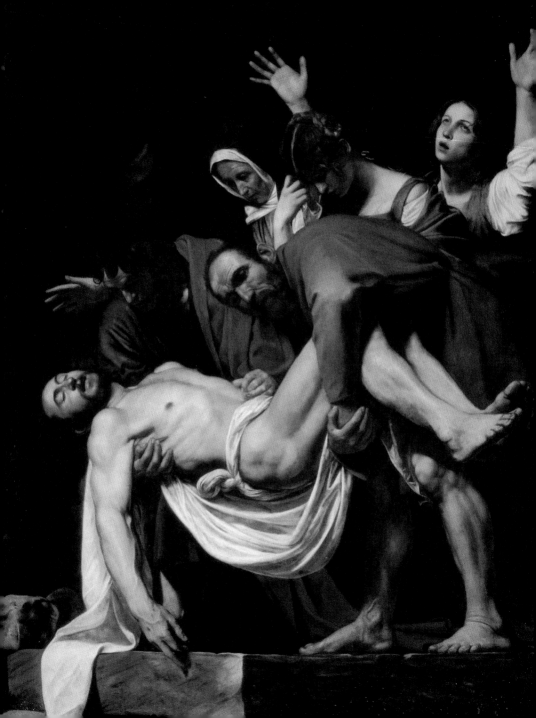

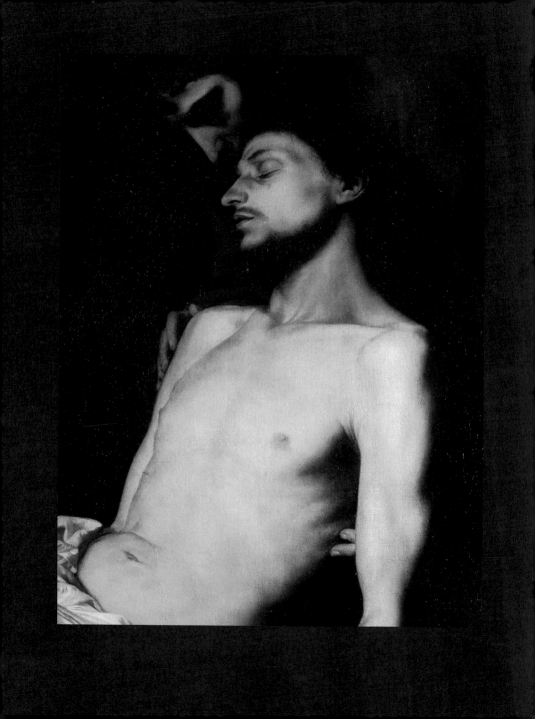

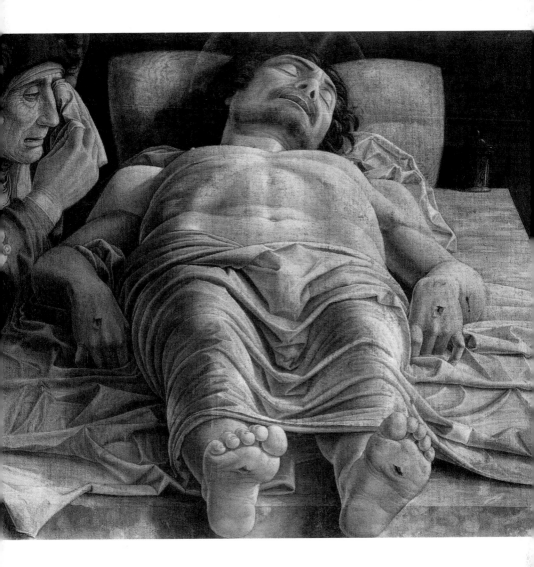

LEFT Lamentation over the Dead Christ (detail)
Jusepe de Ribera
c. 1588–c. 1652

ABOVE The Dead Christ
Andrea Mantegna
c. 1431–1506

BURIAL OF CHRIST **221**

Shroud of Turin

A number of relics exist today that claim to show the true image of Christ, miraculously imprinted on cloth, without human intervention. By far the most famous of these is the Holy Shroud of Turin, which is claimed to be the winding sheet that was used to wrap the body of Christ before it was placed in the tomb. The Gospels say that the corpse was wrapped in linen by Joseph of Arimathea before the burial (Matthew 27.59; Mark 15.46). However, there is no certain mention of the shroud now known to us until 1390, when the Bishop of Troyes in France wrote to Pope Clement VII, denouncing it as a forgery. Recent scientific tests on the cloth have been

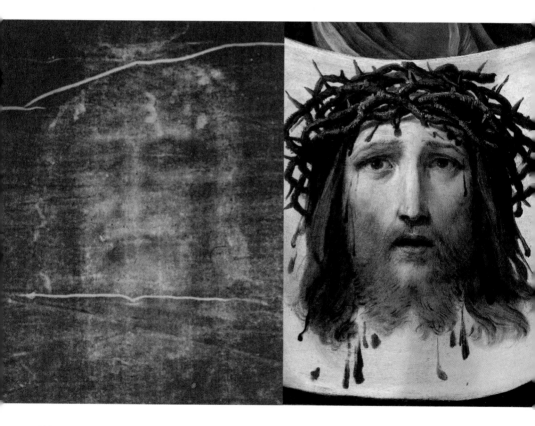

inconclusive. The image of Christ's head, with closed eyes, is extremely impressive but is close in style to paintings made in the 13th and 14th centuries. The shroud is kept in the chapel at the Cathedral of St. John the Baptist in Turin, Italy.

FAR LEFT **Turin shroud (detail)**

LEFT **The Veronica (detail)**
Guido Reni
1575–1642

BELOW LEFT **The Veronica (detail)**
El Greco
c. 1541–1614

BELOW RIGHT **The Holy Face**
Georges Rouault
1871–1958

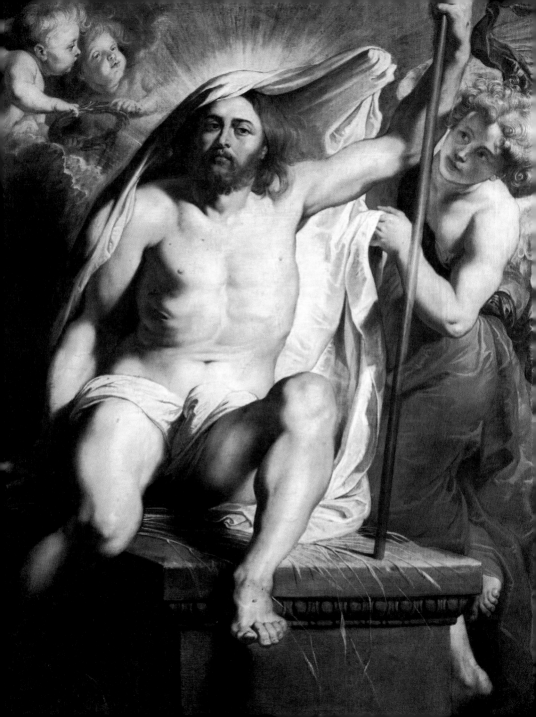

Resurrection

Although there is no description of Christ's Resurrection in the Gospels, we know about it from the reactions of those who come to visit Christ's tomb and find it empty, with the stone that closed it rolled aside. There is, however, one element of the miraculous. When the mourners arrive to visit the tomb, after the Sabbath, they find an angel awaiting them (Mark 16.1–8), or perhaps two angels (Luke 24.1–12; John 20.11–13). This is in fact one of few occasions when these heavenly beings manifest themselves in the Gospel texts.

The fact of the Resurrection is nevertheless the justification for everything that has preceded it. Because the texts on the subject are so reticent, artists have been able to give their imaginations full rein. The soldiers who were ordered to guard the tomb are bewitched and lie brutishly asleep as Christ steps triumphantly out of his sepulcher.

LEFT **Christ Risen**
Peter Paul Rubens
1577–1640

RIGHT **The Resurrection**
William Blake
1757–1827

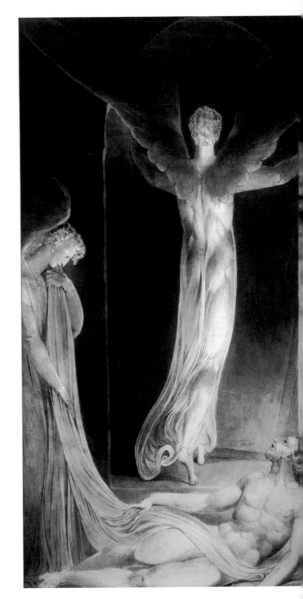

The aim of artists, when they depict the resurrected Christ, has generally been to convey a sense of otherness. Christ has become a being who no longer fully inhabits the world of everyday reality. There is a much stronger sense of the divinity of Christ in these images than there is in illustrations to the stories told in the main Gospel narrative.

| 1 | 3 | 5 |
| 2 | 4 | 6 |

1 Christ Resurrected (detail)
Salvator Rosa
1615–1673

2 Risen Christ (detail)
Michelangelo
1475–1564

3 Resurrection of Christ (detail)
Giovanni Bellini
c. 1430–1516

4 The Redeemer (detail)
Florentine School
c. 1400

5 The Resurrection (detail)
Pierre Reymond
1513–1584

6 Christ Rising from the Tomb (detail)
Gaudenzio Ferrari
d. 1546

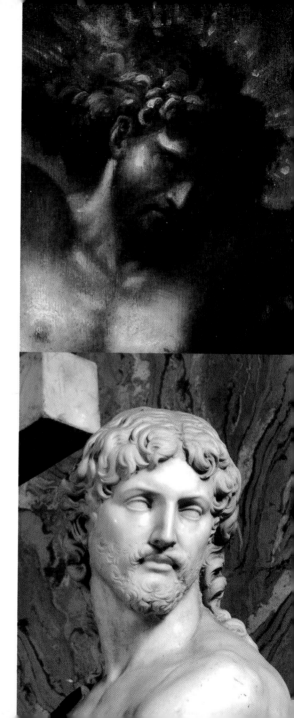

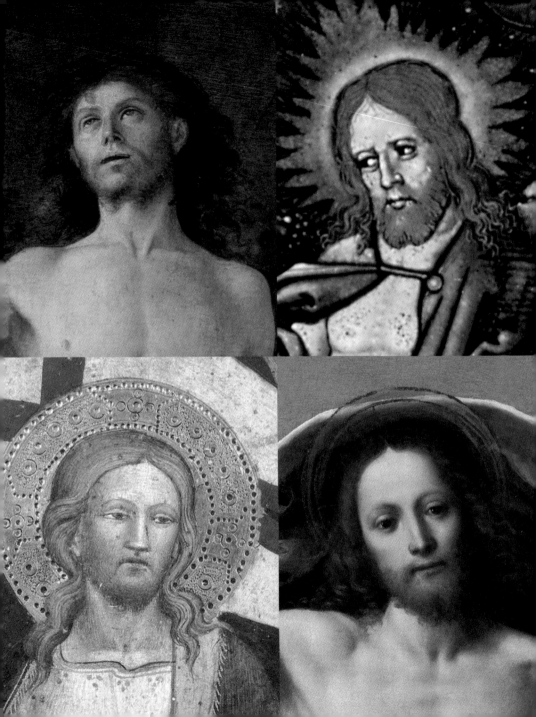

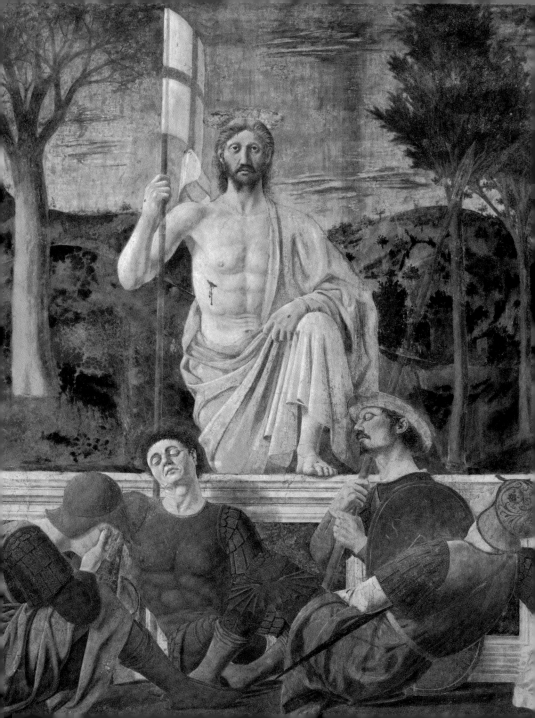

Christ at Emmaus

The story of the walk to Emmaus, and the supper that followed, is only told in full in the Gospel of St. Luke (Luke 24.13–35). It is typical of a number of stories about Christ in the period following the Resurrection. Christ appears to people who knew him well, and at first they do not recognize him. When they do, he suddenly vanishes. Artists symbolize this in various ways. Rembrandt shows Christ backlit, without detail. Caravaggio shows him without a beard.

ABOVE **The Road to Emmaus**
Altobello Melone
16th century

RIGHT **Supper in Emmaus (detail)**
Caravaggio
1571–1610

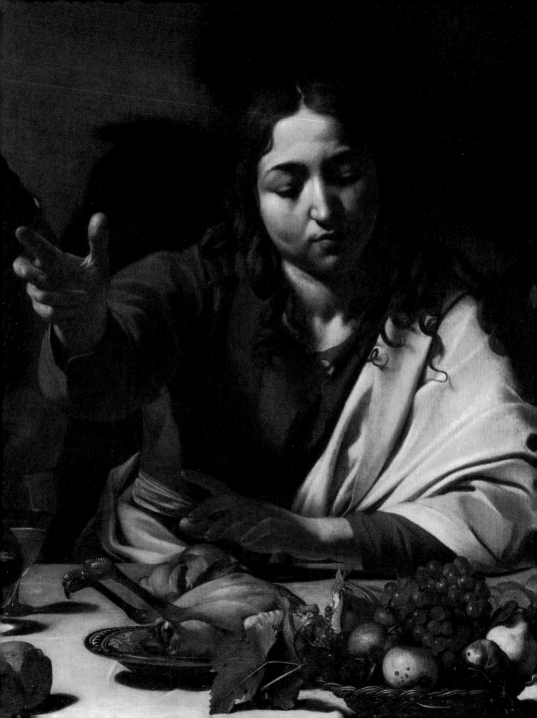

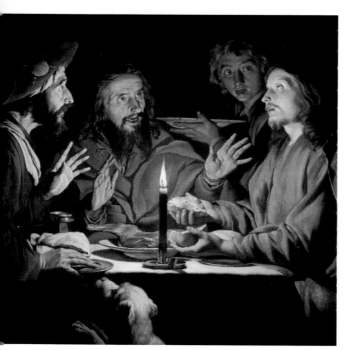

ABOVE **Supper at Emmaus**
Matthias Stomer
1600–c. 1650

RIGHT **Christ at Emmaus**
Rembrandt
1606–1669

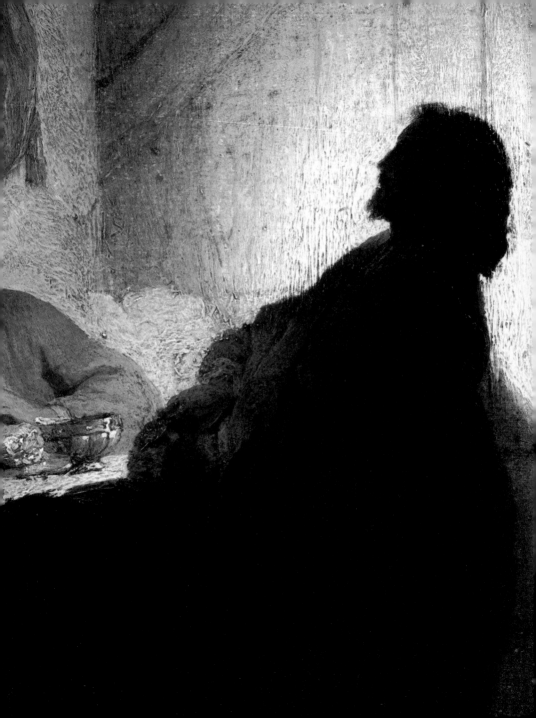

Noli Me Tangere

Christ's encounter with Mary Magdalene immediately after the Resurrection (John 20.11–18) supplies another example of his being at first not recognized by someone who was close to him, then becoming immediately recognizable. The Magdalene at first mistakes him for a gardener. When she reaches out to touch him, Christ forbids it, saying, "Touch me not; for I am not yet ascended to my Father."

Above **Noli Me Tangere** (detail)
Federico Barocci
c. 1526–1612

Right **Noli Me Tangere** (detail)
Correggio
c. 1489–1534

Far Right **Noli Me Tangere**
Master of the Lehman Crucifixion
c. 1352–1399

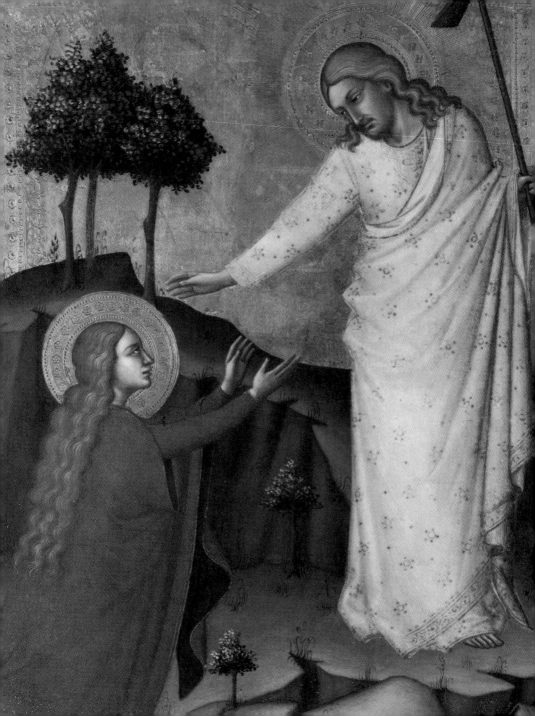

ABOVE (DETAIL) AND RIGHT **Appearance of Christ to the Magdalene**
Alexandr Ivanov
1806–1858

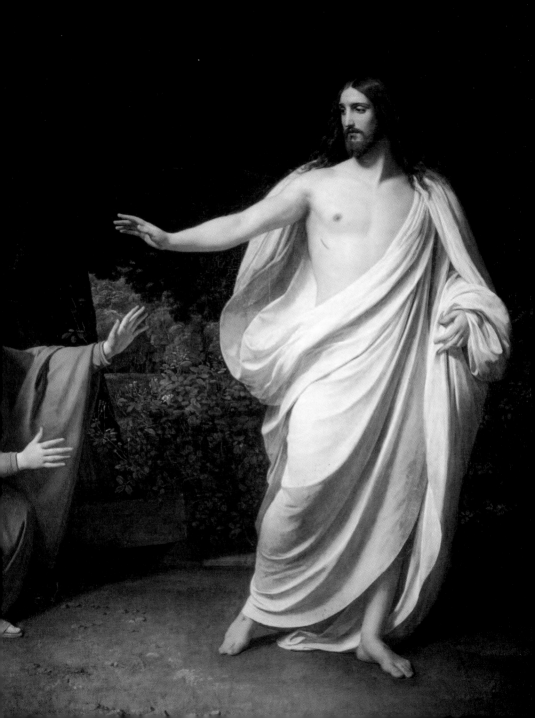

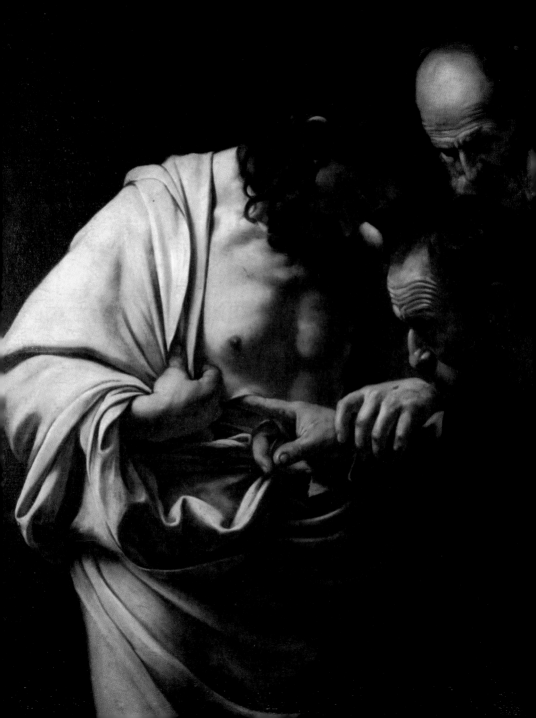

Doubting Thomas

Caravaggio's picture of the Incredulity of St. Thomas was his most copied masterpiece in his own time—twenty-two copies from the seventeenth century are known to exist. It is a great irony that this painting now hangs in the gallery of Frederick the Great's palace at Potsdam in Germany, since Frederick was notorious as an unbeliever.

Thomas the Apostle, not present when Jesus appeared to his companions, insisted in thrusting a finger into the wound in Christ's side, before he would believe that this was truly his resurrected master (John 20.24–29). In doing so, he was permitted to go much further than Mary Magdalene, who was not allowed to touch Christ at all when he appeared to her. Christ used the occasion, as he had done previously when he raised Lazarus from the dead, to stress the importance of faith: "Jesus said unto him, Thomas, because thou hast seen me, thou hast believed; blessed are they that have not seen, and yet have believed."

Incredulity of St. Thomas
Caravaggio
1571–1610

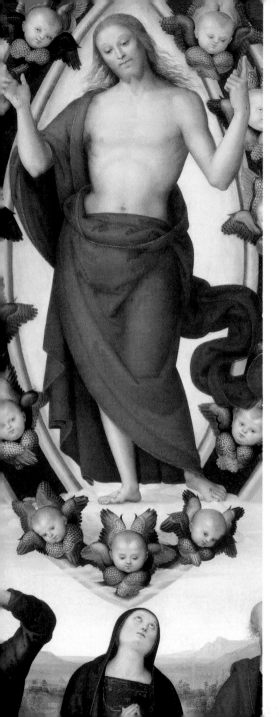

Ascension

Considering its importance to the Christian story, it is remarkable how little space Christ's ascension to heaven occupies in the Bible—exactly six verses in two Gospels (Mark 16.19–20; Luke 24.50–53). There is no description—the Evangelists simply state that the event took place. "And he led them out as far as to Bethany, and he lifted up his hands and blessed them. And it came to pass, while he blessed them, he was parted from them and carried up into heaven."

Artists throughout the ages have been ready to fill the gap, often showing Christ uplifted by groups of angel attendants. In a sense, these are the images of Christ where Christian art seems most pagan. The personage shown in these representations is easily assimilated to images of the Greek and Roman gods—Olympian Zeus, for example, presiding over the world from his place in heaven. Christ is transformed—no longer a living being, whose corporeal reality was attested to by many witnesses during his period on earth, but a symbol of complex moral ideas.

LEFT **Ascension** (detail)
Perugino
c. 1446–1523

RIGHT **Ascension** (detail)
Illuminated manuscript
c. 1155

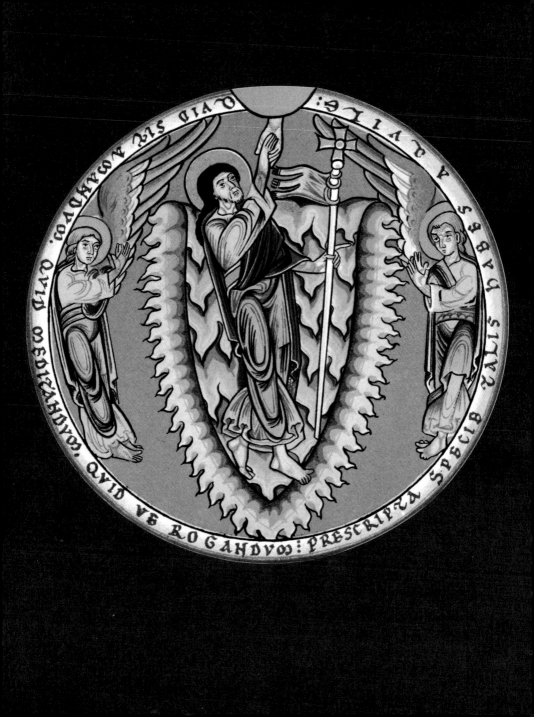

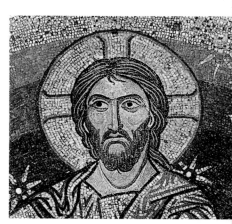

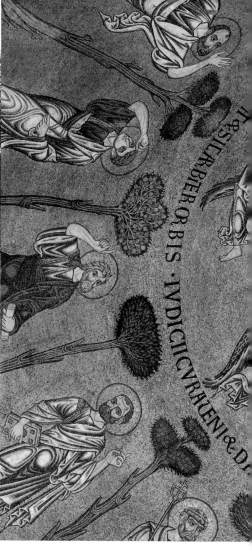

Dome of the Ascension
Byzantine mosaic
1150–1200

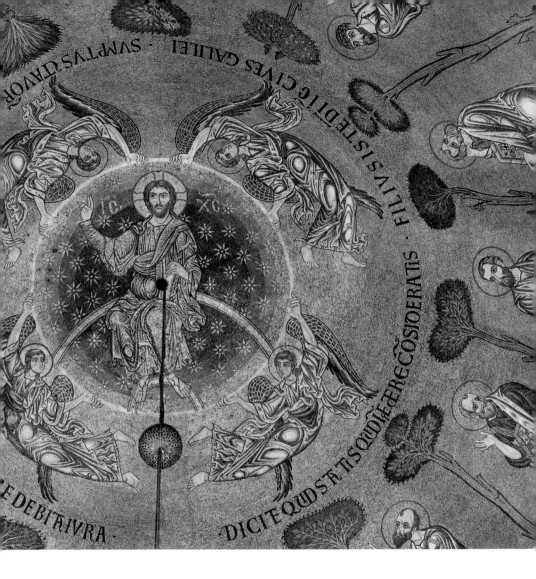

CENTER LEFT **Ascension** (detail)
Giovanni della Robbia
1469–1529

LEFT **Ascension of Christ** (detail)
Perugino
c. 1446–1523

THE LAST JUDGMENT

31 When the Son of man shall come in his glory, and all the holy angels with him, then shall he sit upon the throne of his glory:

32 And before him shall be gathered all nations: and he shall separate them one from another, as a shepherd divideth his sheep from the goats:

33 And he shall set the sheep on his right hand, but the goats on the left.

34 Then shall the King say unto them on his right hand, Come, ye blessed of my Father, inherit the kingdom prepared for you from the foundation of the world:

35 For I was an hungred, and ye gave me meat: I was thirsty, and ye gave me drink: I was a stranger, and ye took me in.

(Matthew 25.31–35)

ABOVE **Last Judgment**
Ethiopic manuscript
17th–18th century

RIGHT **Last Judgment** (detail)
Hans Memling
1430/40–1494

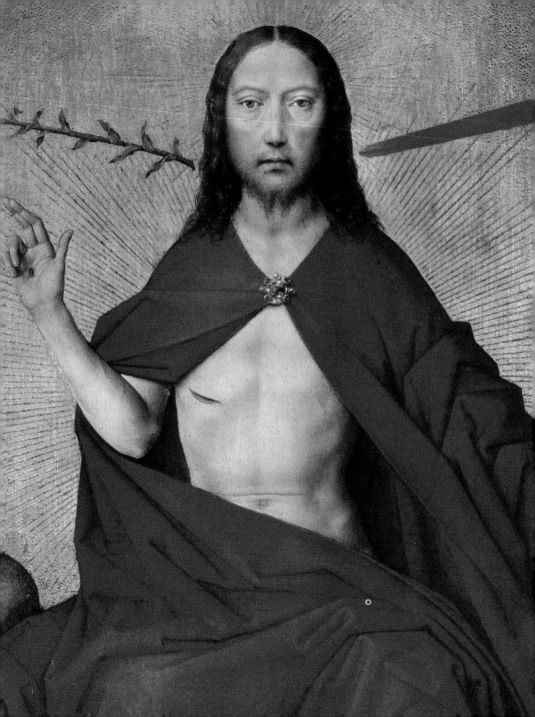

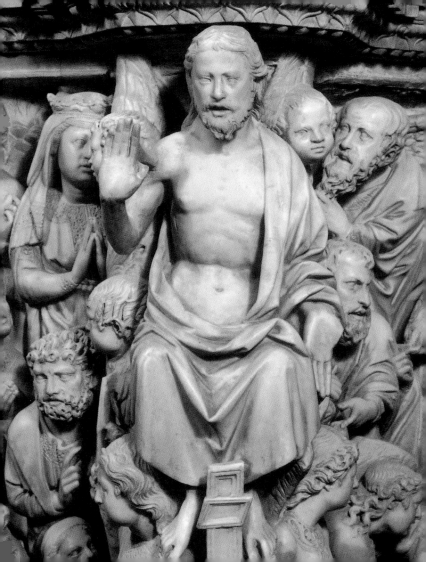

Images of Christ at the Last Judgment have been influenced not only by the passage from St. Matthew already quoted on page 244, but also by a description in the Book of Revelation:

"And I saw a great white throne, and him that sat on it, from whose face the earth and the heaven fled away; and there was found no place for them. And I saw the dead, small and great, stand before God; and the books were opened: and another book was opened, which is the book of life: and the dead were judged out of those things which were written in the books, according to their works." (Revelation 20.11–12)

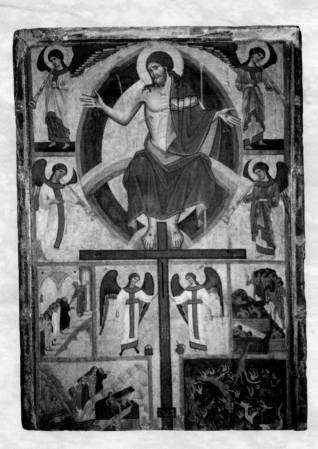

FAR LEFT **Pulpit: Last Judgment (detail)**
Nicola Pisano and assistants
c. 1220–c. 1284

LEFT **Last Judgment**
Guido da Siena
13th century

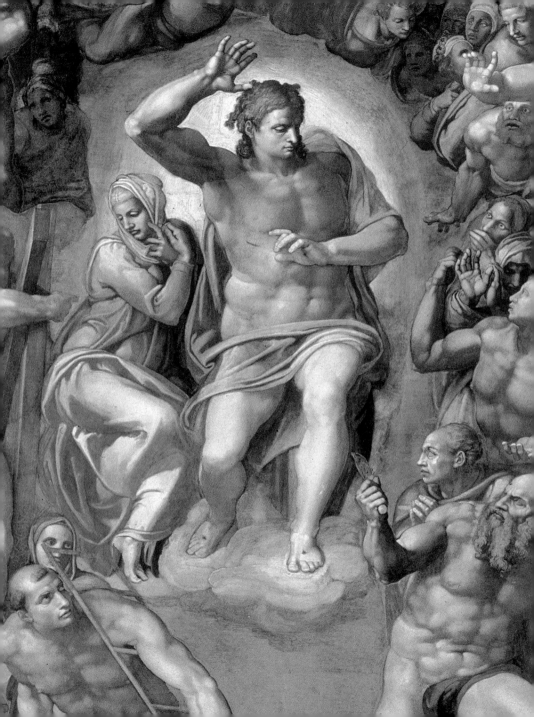

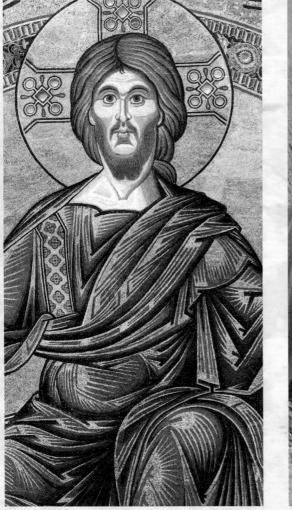

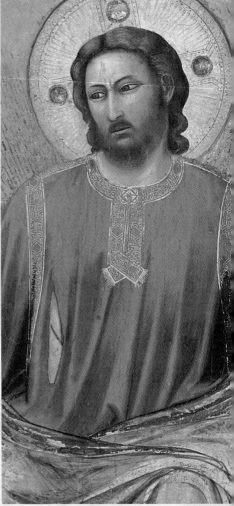

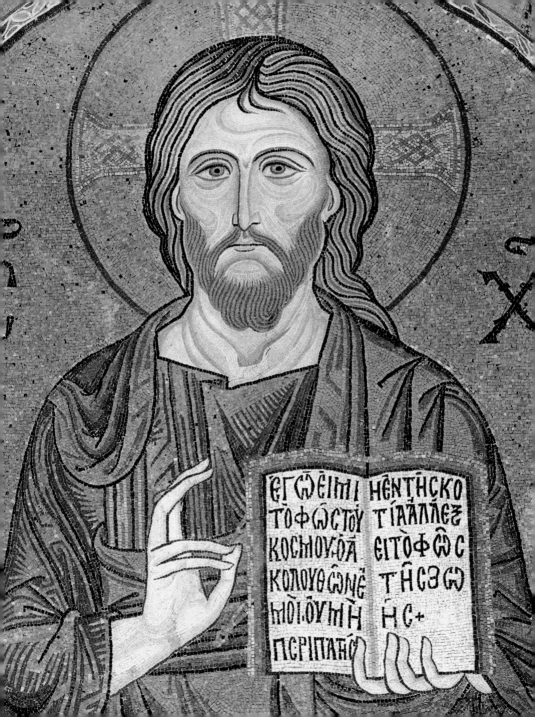

ΕΓѠΕΙΜΙ ΗΕΝΤΗϹΚΟ
ΤΟΦѠϹΤΟΥ ΤΙΑΑΛΛΕΞ
ΚΟϹΜΟΥΟΑ ΕΙΤΟΦѠϹ
ΚΟΛΟΥΘѠΝΕ ΤΗϹΖѠ
ΜΟΙΟΥΜΗ ΗϹ+
ΠΕΡΙΠΑΤΗϹ

The Pantocrator

Christ Pantocrator is a depiction of Jesus as the Almighty, common in Byzantine art. The term comes from the Greek, and is a compound of the Greek words for "all" and "strength." A significant detail is the gesture of Christ's right hand, raised as if to admonish the spectator. The fingers of this hand are often arranged so that they seem to spell out the Greek letters ICXC —an abbreviation of the first and last letters of the two words "Jesus Christ" in Greek. The Greek letter we know as S was written as C in Byzantine Greek.

Pantocrator images have an obvious parentage in pagan Greek and Roman representations of Zeus, the ruler of the gods, and also in the portraits of sternly bearded Roman emperors.

LEFT **Christ Lux Mundi**
Byzantine mosaic
c. 1140

TOP RIGHT **Christ the Pantocrator**
Rock crystal, Byzantine
c. 1000

RIGHT **Christ the Pantocrator**
Romanesque sculpture
12th century

PAGE 252 **Christ in Glory**
From the Westminster Psalter
c. 1200

PAGE 253 **Christ the Pantocrator**
Romanesque fresco
Third quarter of 12th century

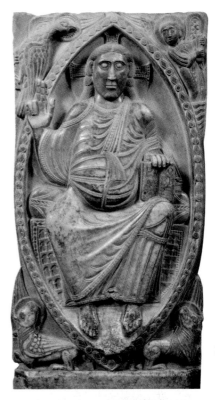

251

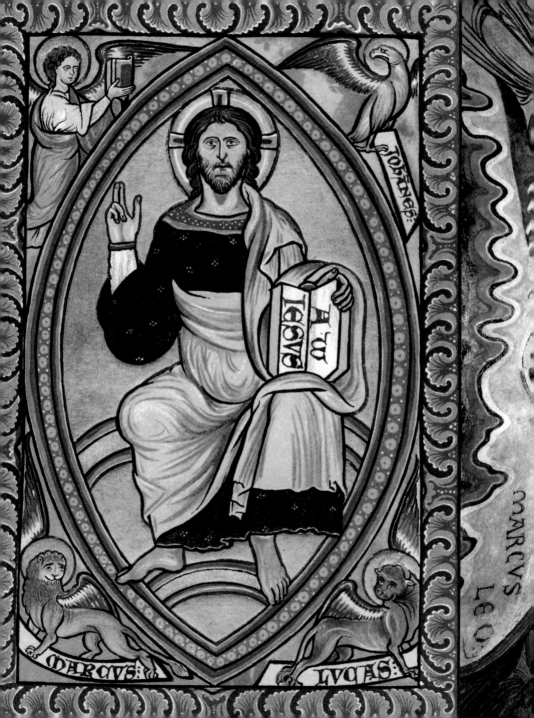

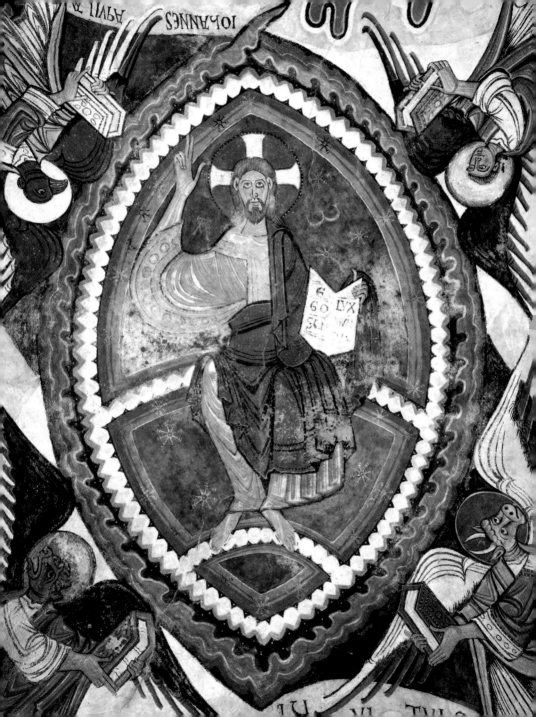

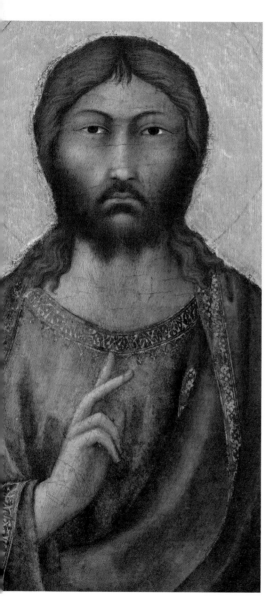

254

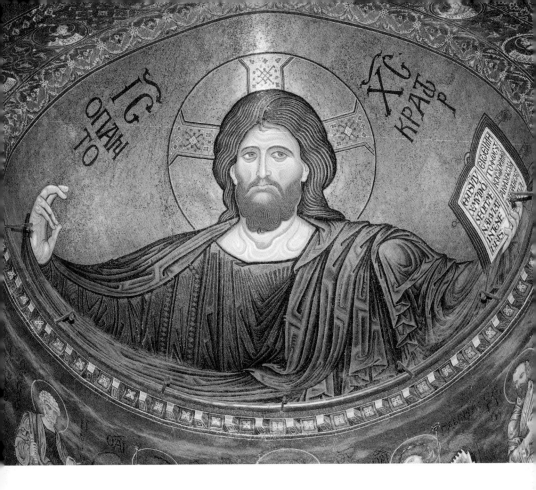

FAR LEFT **The Redeemer Giving His Blessing**
Simone Martini
1284–1344

LEFT **Christ in Glory**
Albert Gleizes
1881–1953

ABOVE **Christ Giving His Blessing**
Romanesque mosaic
Last quarter of 12th century

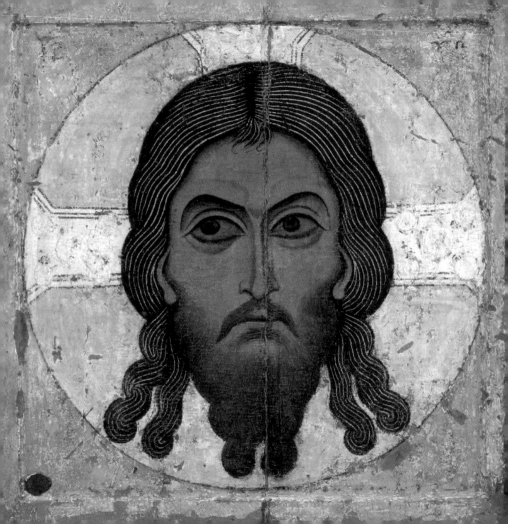

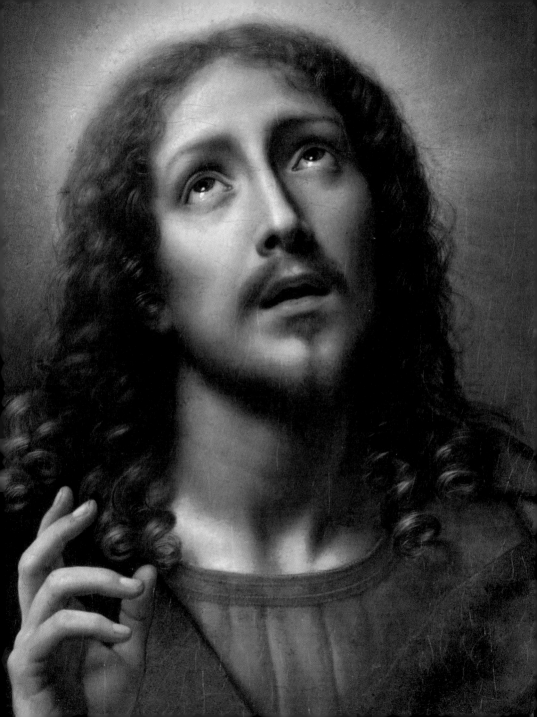

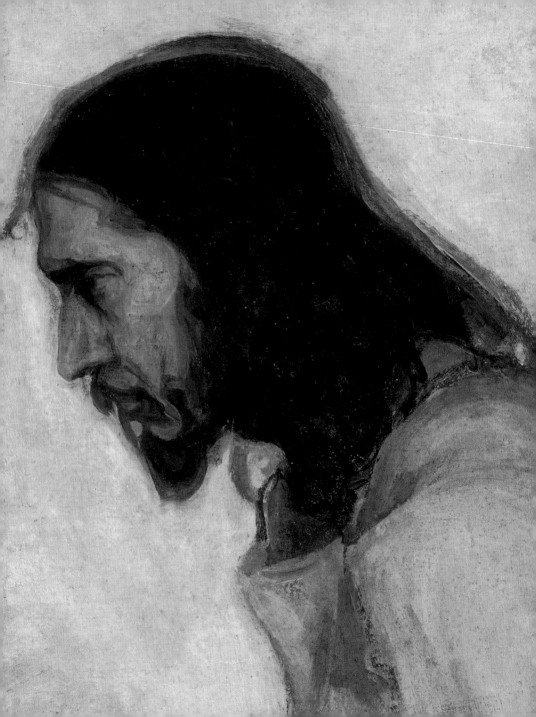

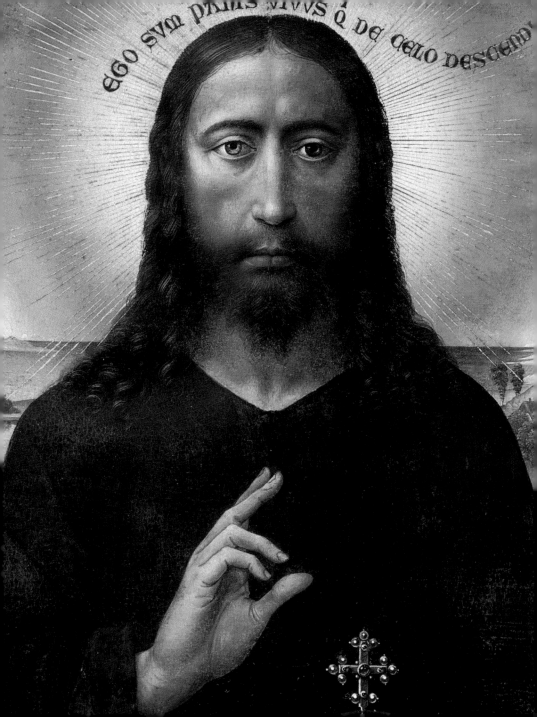

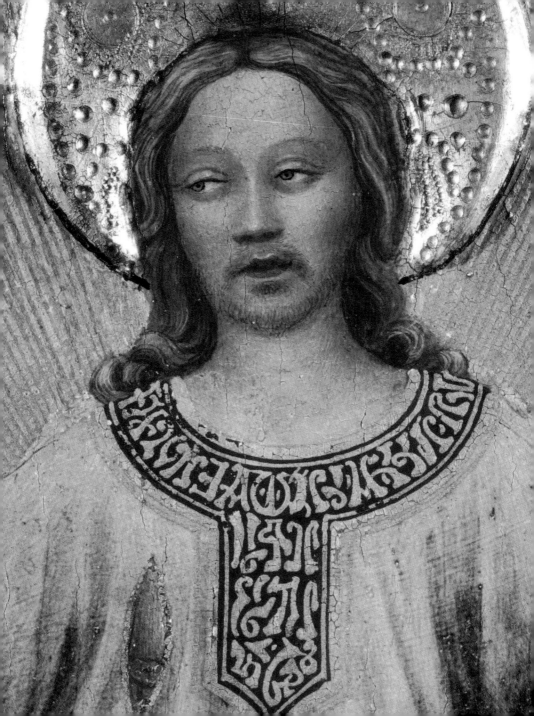

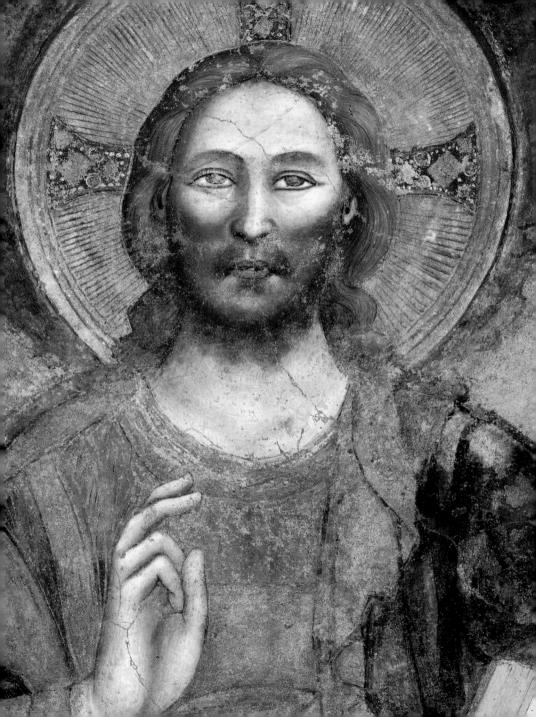

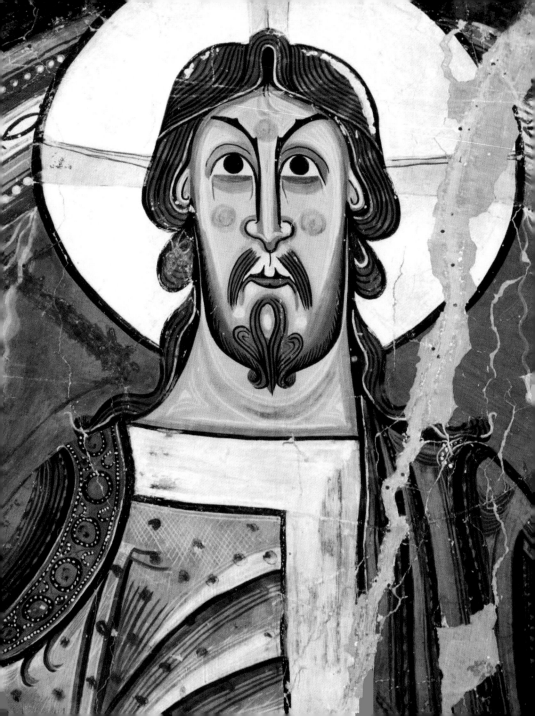

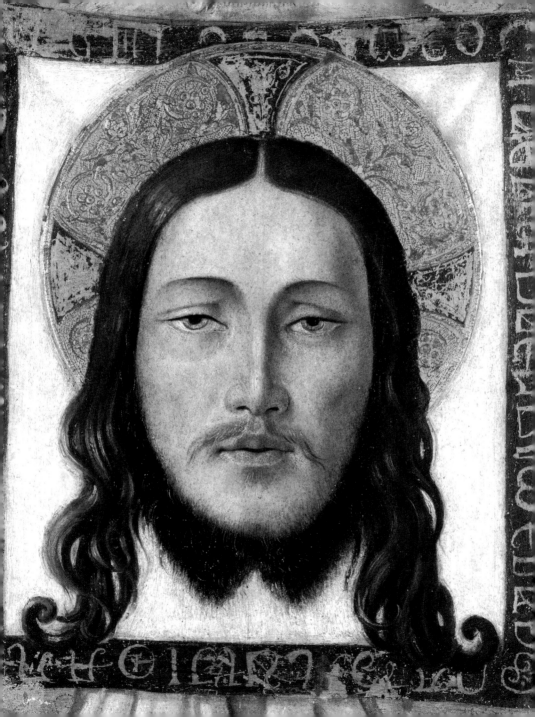

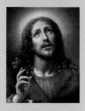

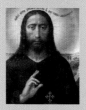
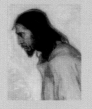

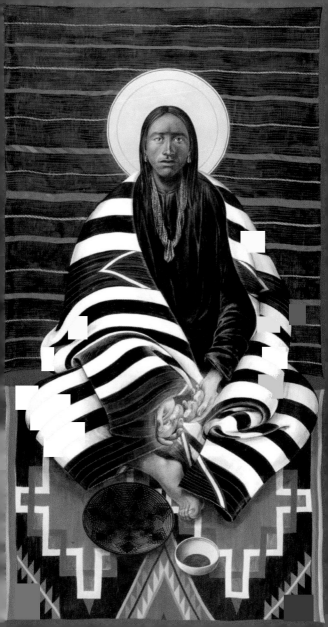

CHRIST AROUND THE WORLD

THE IMAGE OF CHRIST has necessarily changed with the growth of the Christian religion. Christians are subject to three different impulses. One is to see in Christ the image of the perfect man—perfect in physical beauty as well as in inner strength. Another is to seek for an absolutely authentic likeness, handed down intact through the ages that have passed since Christ's time on earth. The third, and perhaps in the end the most powerful, seeks to assimilate the appearance of Christ to their own culture and ethnicity.

Christianity is now a universal religion, with deep roots in regions remote from the Palestine where Christ lived as a man and carried out his earthly mission. Western Europeans have tended to think of Christ as a man made in their own likeness, not least because Christianity has played such a major role in the history of the European continent. Americans of European stock have followed suit. They are sometimes surprised to find that there are images of Christ in which the Savior is a black man, or an Asiatic.

These images may seem to contradict historical truth—though the fact is that we have absolutely no concrete information about the way Christ actually looked. The earliest surviving images of Christ in art seem to draw on preexisting pagan prototypes—sometimes Apollo, the youthful sun god, more often Zeus the All-Father or his Egyptian counterpart Serapis. In Roman Egypt, according to a letter in the Historia Augusta attributed to the Emperor Hadrian, those who worshiped Serapis often described themselves as Christians, and vice versa.

What these images from Africa, Asia, the Caribbean, and other countries do tell us is that the Christian message is sent and belongs to the whole of humankind. Its relevance is not confined to a particular time and place, nor to a single ethnic group, but to anyone who is prepared to listen.

Navajo Christ
Father John Giuliani (USA)
20th century

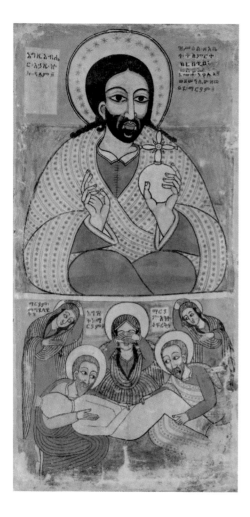

ABOVE **Savior's Head and Burial of Christ**
Ethiopia
18th century

RIGHT **Christ in the Wilderness**
Ivan Kramskoy (Russia)
1837–1887

268 CHRIST AROUND THE WORLD

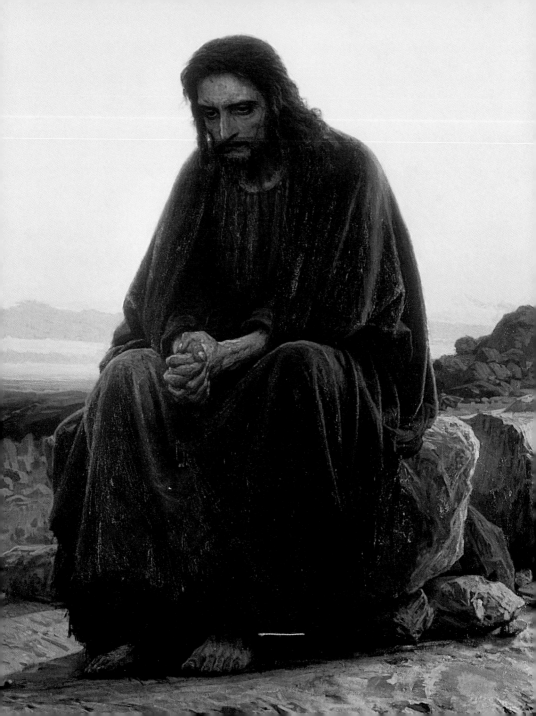

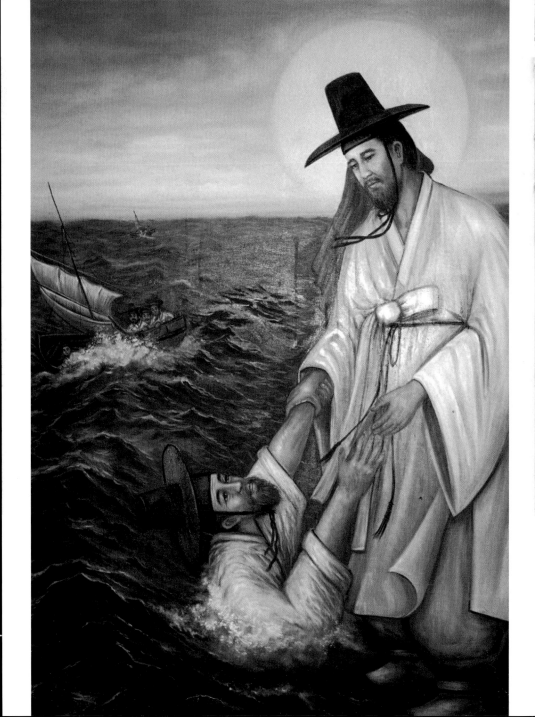

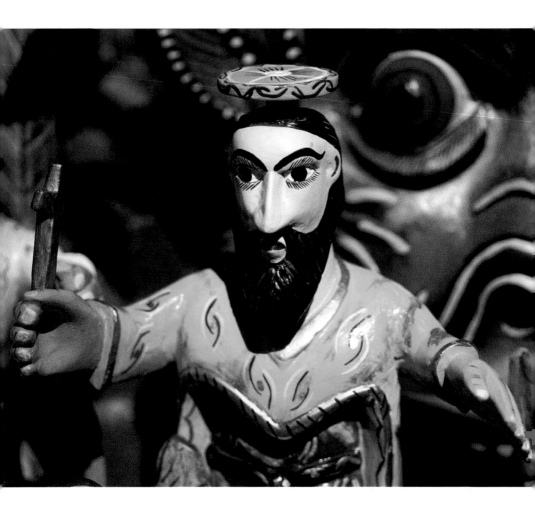

LEFT **Jesus Rescuing the Drowning St. Peter**
South Korea
20th century

ABOVE **Jesus Holding a Cross**
Papier mâché figure from Mexico
2002

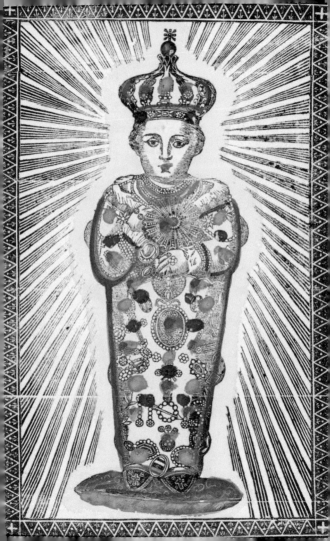

The Holy Child

Christians throughout the ages have made images of the infant Christ and his mother in forms that correspond to their own cultural traditions. The Madonna can be portrayed as an African woman or a Pacific islander; the Christ child in a jewel-encrusted gown.

FAR LEFT **Christ Child**
Woodcut from Bengal
19th century

LEFT **Madonna and Child**
Sculpture from Solomon Islands
Late 19th–mid-20th century

RIGHT **Madonna and Child**
Sculpture from Africa
Late 19th–mid-20th century

The Last Supper

Both these images show the Last Supper, with Christ surrounded by his disciples as shown in European versions of the scene. Yet there are unfamiliar elements. It is not simply that the participants are non-European. In one image the supper will be eaten with chopsticks. In another, Jesus and his disciples have dreadlocks.

ABOVE **Last Supper**
Chinese School
19th century

RIGHT **Last Supper**
Painting on a Rasta home in Barbados
20th century

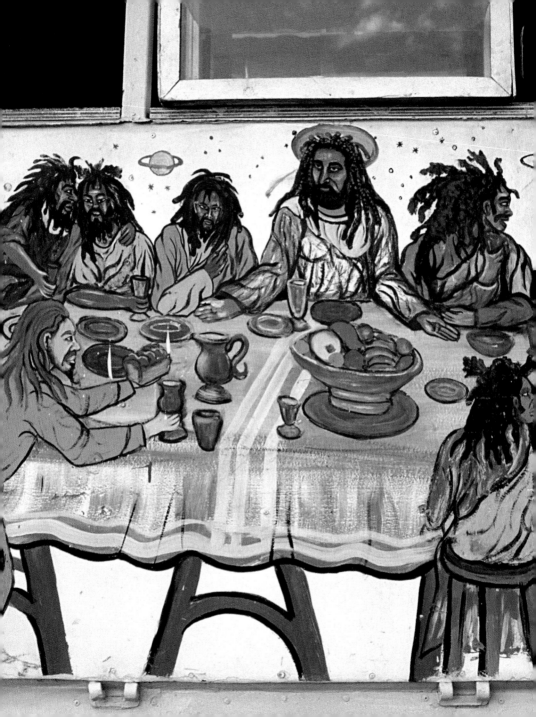

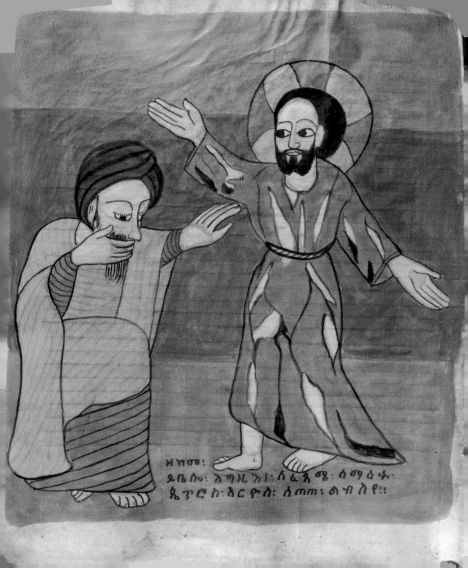

ዘከመ፡
ዴቤሎ፡ እግዚእ፡ ለፈዴ ፳ ፡ ሰማዕታ፡
ጼጥሮ ስ እርዮስ፡ ሰጠ፡ ልብ ለየ፡፡

The Passion

Christ's Passion has been interpreted and reinterpreted by artists from all over the world. They present it in all sorts of guises, some of them at first glance surprising. In an Ethiopian wall painting, the crucified Christ has breasts. Perhaps this is to make the point that the Christian message is addressed to all humankind.

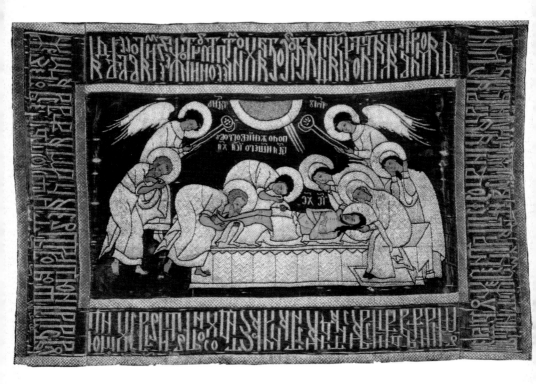

LEFT **Incredulity of St. Thomas**
Ethiopic manuscript
17th–18th century

ABOVE **Epitaphios (embroidered ceremonial cloth)**
Russia
c. 16th century

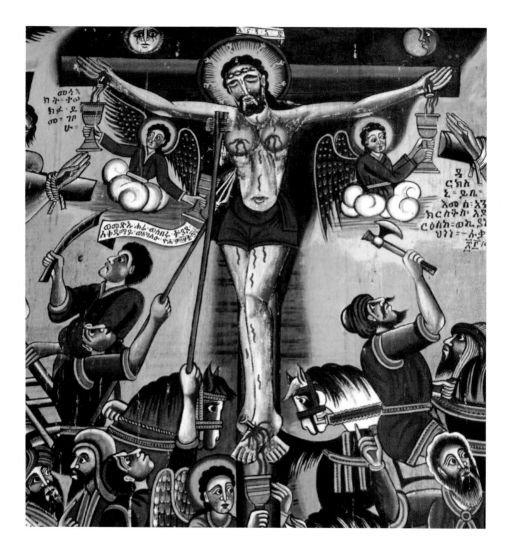

LEFT **Christ on the Cross
as a Woman**
Wall painting from Ethiopia
1960s

ABOVE **Resurrection**
Crucifix from Congo, Brazzaville
20th century

PAGE 280 **Christ Carried
by Angels**
Turkish School
16th century

PAGE 281 **The Ascension**
Castera Bazile (Haiti)
1923–1966

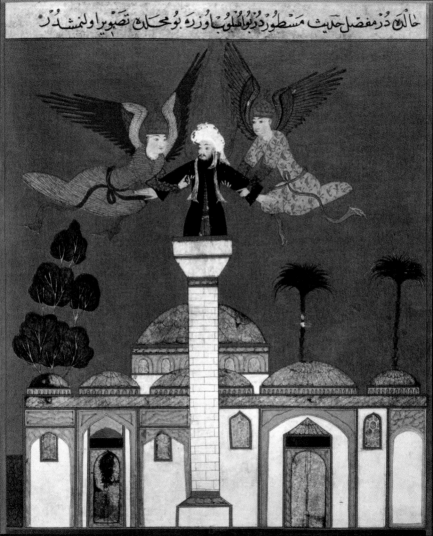

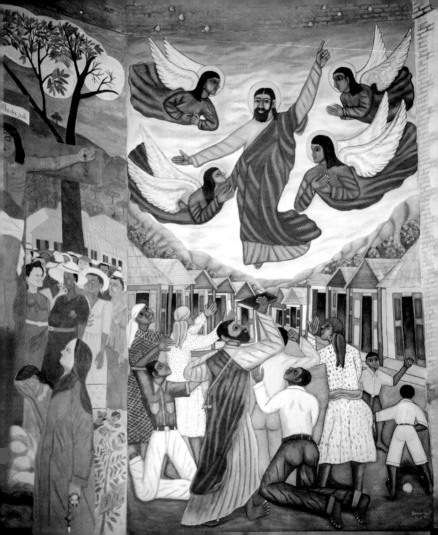

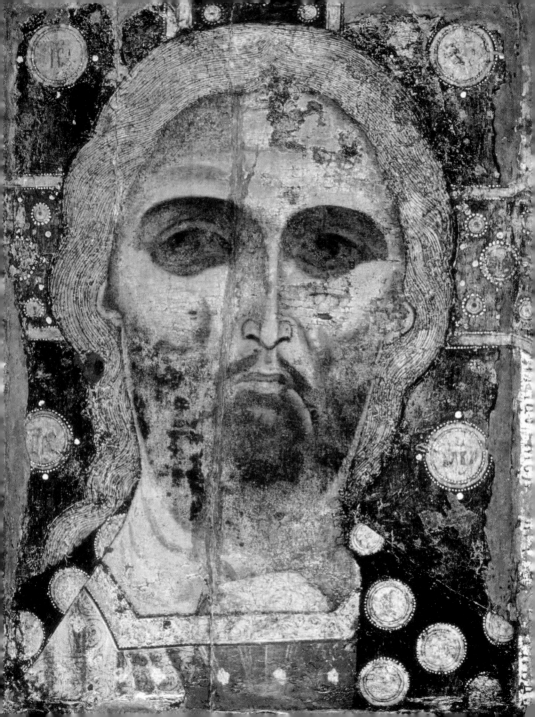

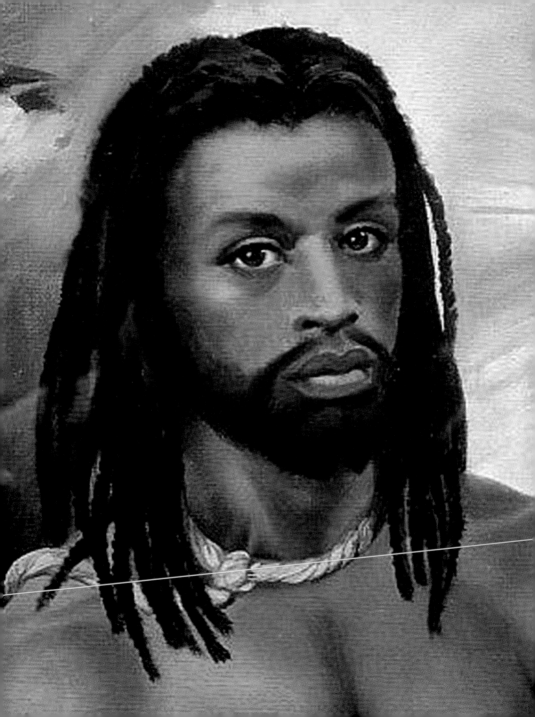

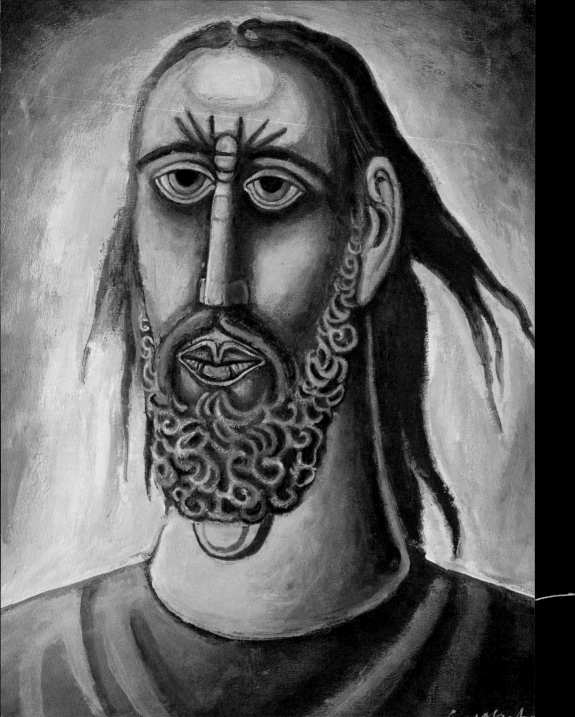

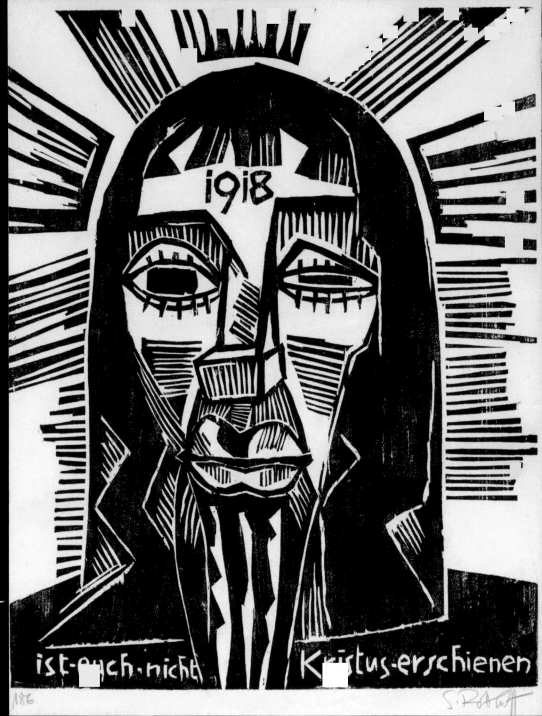

1918

ist·euch·nicht Kristus·erschienen

186

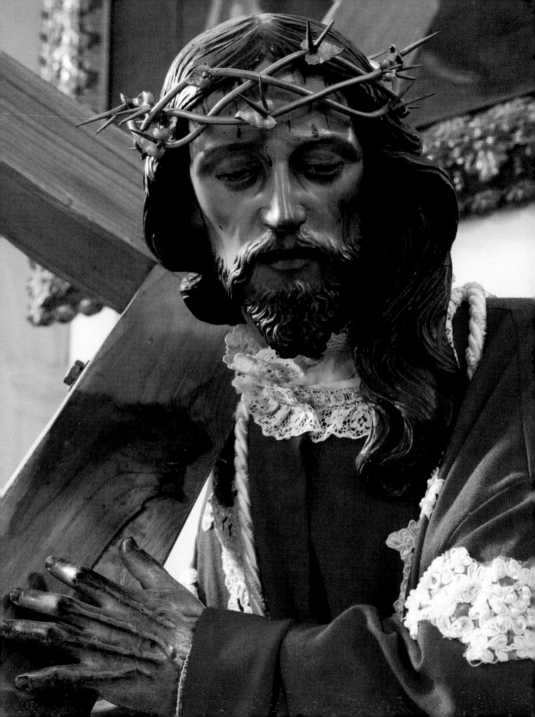

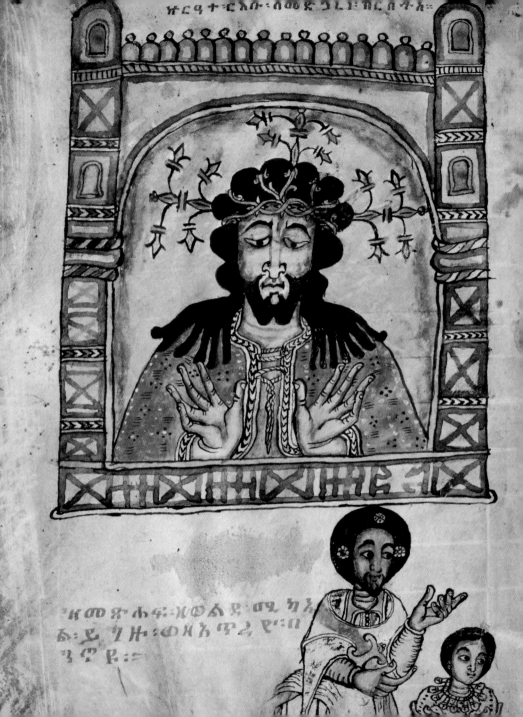

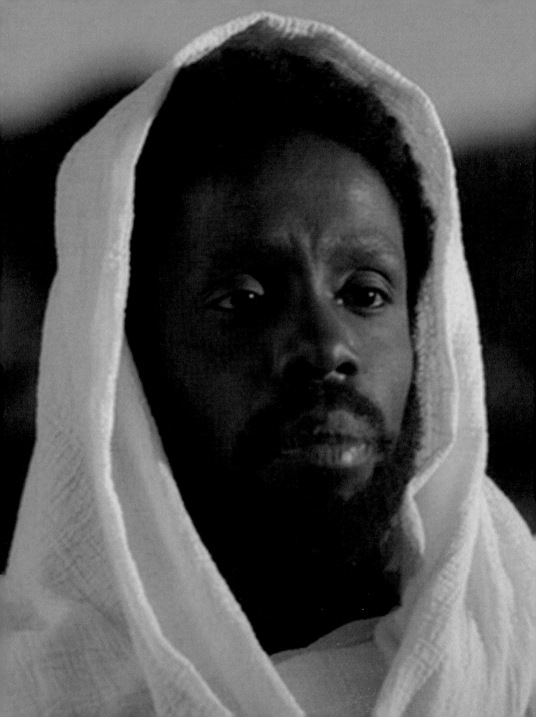

CHAPTER 8

CHRIST TODAY

THE IMAGE OF CHRIST HAS BEEN ABSORBED INTO THE MODERN WORLD through the cinema—the first movies about Jesus were a series of silent shorts produced by the Pathé company in France between 1902 and 1905—and, more recently, through miniseries on television. While each director has approached the Gospel story in his own fashion, the way in which the central actor is presented has nearly always tended to be influenced by long-established traditions in Western art, particularly by religious paintings of the sixteenth and seventeenth centuries.

Christ is almost invariably played by a handsome Caucasian actor whose heritage is neither specifically Jewish nor generically Mediterranean. One interesting exception to this was Enrique Irazoqui, of partly Basque, partly Italian Jewish origin, who played Jesus Christ in Pier Paolo Pasolini's *The Gospel According to Saint Matthew* (1964).

The first black Christ was featured relatively recently. The actor was the Haitian-American Jean-Claude La Marre, who starred in *Color of the Cross* (2006), directed by himself. This movie, which follows the story of the Passion, depicts Christ as a black Jew, but otherwise follows established stereotypes: handsome, very masculine, with long hair and a beard.

The image of Christ has become a popular motif on T-shirts, sometimes as a declaration of religious faith, but quite often in more ambiguous guise, as, for example, in the shirts that portray Christ as a surfer or as an ice-hockey star. Christ also figures in tattoos, now increasingly fashionable, and in comic books. He has even made appearances in animated television sitcoms, such as *The Simpsons* and *South Park*.

Still from *Color of the Cross*
Directed by Jean-Claude La Marre
2006

Christ in the movies

The actors who have played Christ in the movies seldom have a truly Mediterranean look. For example, Jeffrey Hunter (Christ in *King of Kings*, 1961); Max von Sydow (in *The Greatest Story Ever Told,* 1964); Robert Powell (in Franco Zeffirelli's six-hour TV epic, *Jesus of Nazareth*, 1977); and Jim Caviezel (in Mel Gibson's *The Passion of the Christ*, 2004) all have blue eyes. Playing Christ has seldom been a good career move, however. The public identifies the actor so much with the role that it is later hard for him to be accepted in other parts.

Enrique Irazoqui, one of the most convincing of all film Christs, was studying economics and had no acting experience when recruited by Pasolini, whom he met by chance. Enrique made just three more films and retired to become an expert on computer chess. Today he describes himself as an agnostic.

LEFT Still from *The Greatest Story Ever Told*
Directed by George Stevens
1965

BELOW Stills from *The Gospel According to St. Matthew*
Directed by Pier Paolo Pasolini
1964

LEFT **Still from *Jesus Christ, Superstar***
Directed by Norman Jewison
1973

RIGHT **Still from *The Last Temptation of Christ***
Directed by Martin Scorsese
1988

BELOW **Stills from *Jesus of Nazareth***
Directed by Franco Zeffirelli
1977

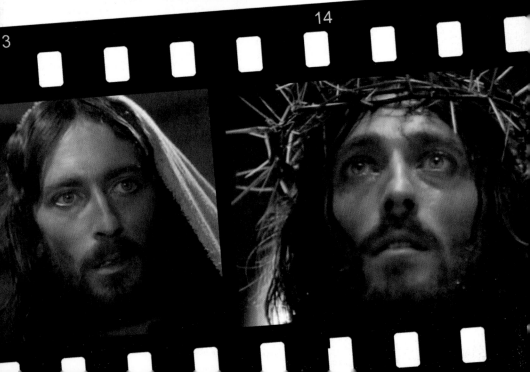

3

14

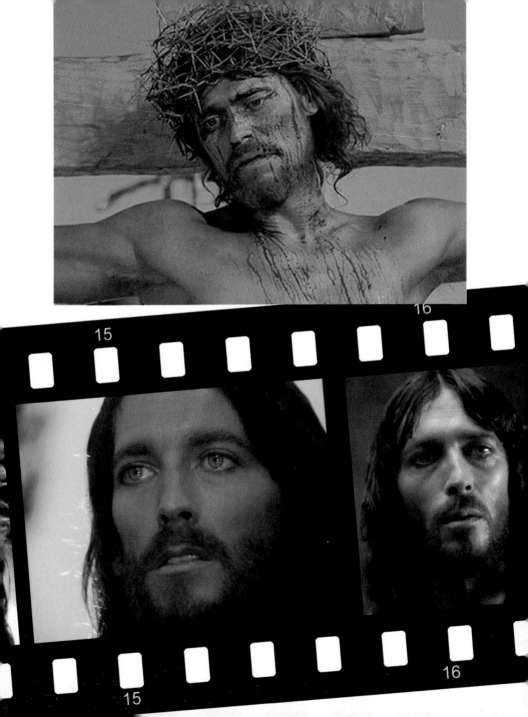

Macho Christ

The image of Christ is a popular theme for tattoos, but the connotations are often ambiguous. The designs can be a declaration of faith. They can also suggest that the wearer has "suffered like Christ," and has been betrayed by society. They serve as a declaration of swaggering machismo, to which is added a contradictory note of masochism.

BELOW **Shattered**
Ricardo Cinalli
b. 1948

TOP RIGHT **Christ tattoo**
Jimmy Johnson

CENTER RIGHT **Christ tattoo**
Enrique Castillo

FAR RIGHT **Christ tattoo**
Jorge "Crow" Rodriguez

BELOW RIGHT **Christ tattoo**
Josh Adams

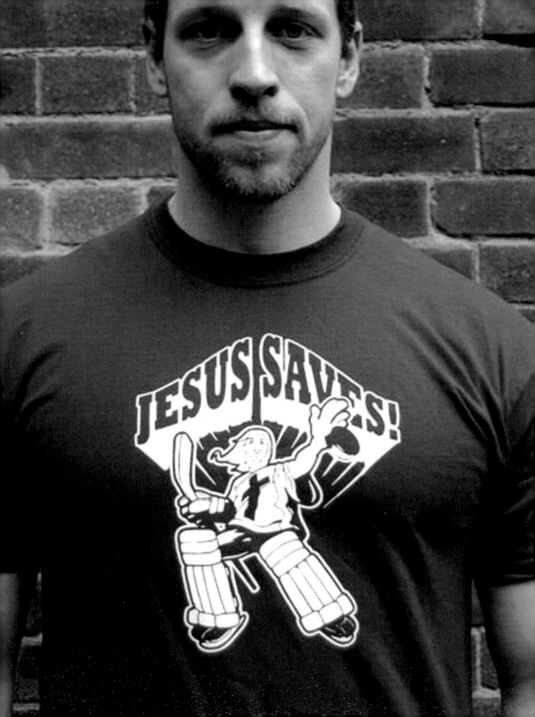

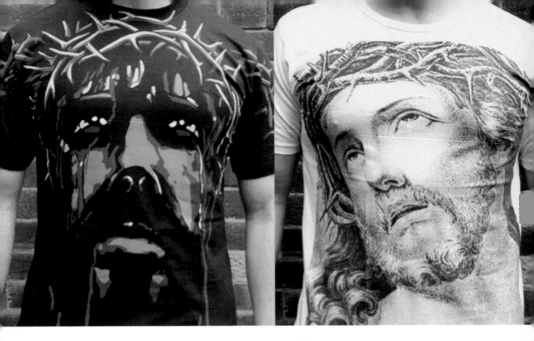

Universal Christ

The image of Christ now appears in a huge variety of popular forms that demonstrate its continuing vitality within contemporary culture. It can be found on postage stamps and T-shirts, on posters and in comic books. There are cartoon Christs and Christs drawn by schoolchildren. It is still one of the most universal of emblems.

LEFT, ABOVE, AND RIGHT
Selection of T-shirts

ABOVE **Jesus**
Oscar, aged 7

TOP RIGHT **Jesus**
Brody, aged 11

RIGHT **Jesus**
Selma, aged 5

FAR RIGHT TOP *Picture Stories
from the Bible* (1944)
Don Cameron

FAR RIGHT BELOW Burundi postage stamp

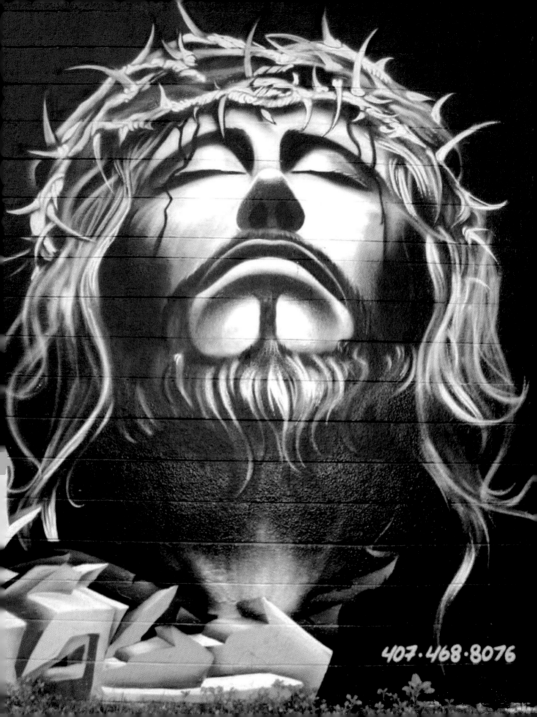

407·468·8076

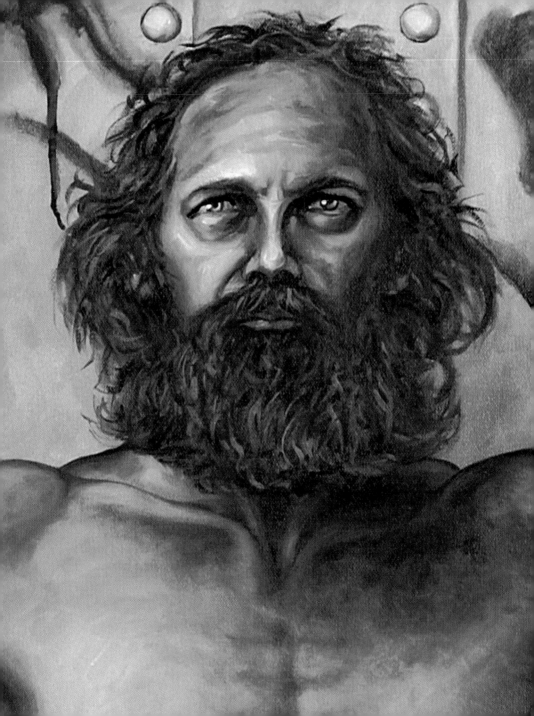

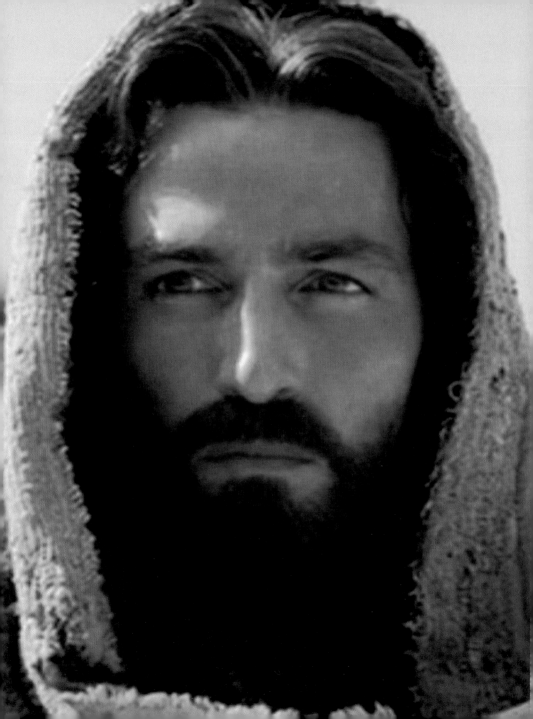

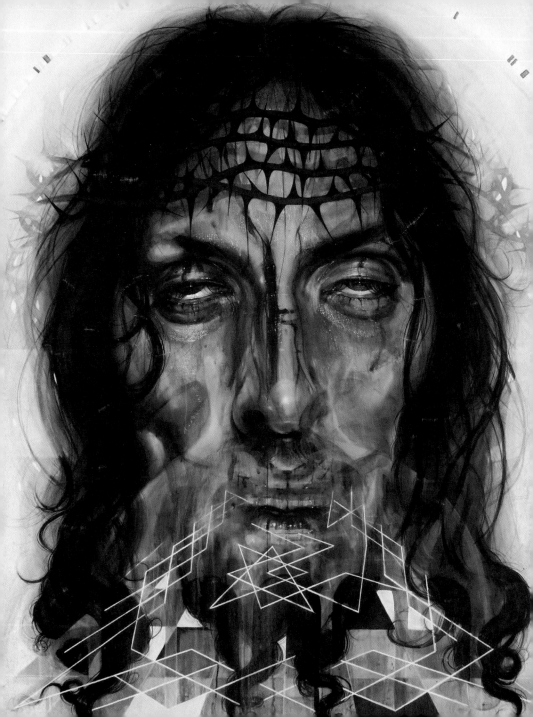

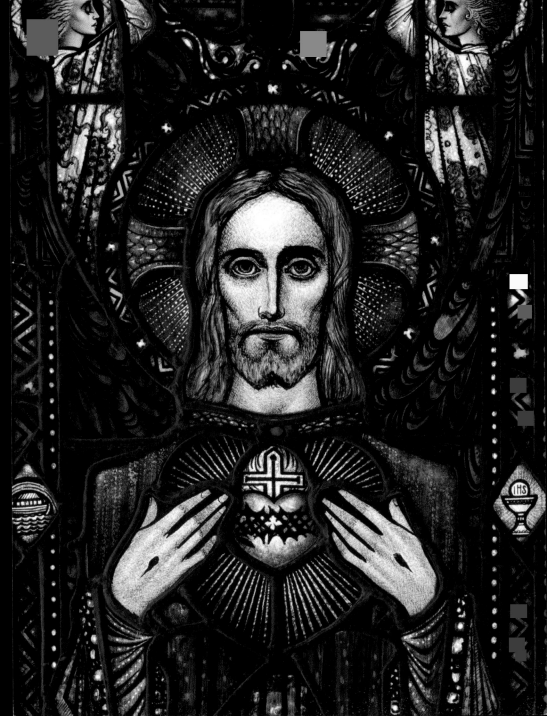

Index

Acknowledgments

This book was conceived, edited, and produced by Barbara Marshall Ltd and SCALA GROUP spa. All rights reserved.

The majority of illustrations were provided by SCALA GROUP spa, the largest source of color transparencies and digital images of the visual arts in the world: Offline/online professional libraries of art, travel and culture, color images for reproduction, multimedia databases, publishers of CD-Rom, DVD and illustrated art and guide books, broadband educational and edutainment, exclusive worldwide representatives for image licensing of the Museum of Modern Art, New York, and many more main museums and institutions.

The Publishers would like to thank the museums, collectors and archives for permitting reproduction of their work. Every effort has been made to trace all copyright owners, but if any have been inadvertently overlooked, the Publishers will be pleased to make the necessary arrangements at the first opportunity.

Special thanks to Dave Goodman, our designer, and Jinny Johnson, our editor—who brought together all of the many parts of this book—and to Emmanuelle Peri for researching the pictures, and to Filippo Melli of Scala for all his help.

Author's thanks
Thank you to everyone who has helped to make this book. In particular, I would like to thank the following for generously allowing me to include their work: Felipe Cardena, Ricardo Cinalli, and Delmas Howe. Also many thanks to Robert Luzar, for modeling the T-shirts with Christ's image.
Edward Lucie-Smith

EDWARD LUCIE-SMITH
Edward Lucie-Smith was born in 1933 in Kingston, Jamaica, and moved to Britain in 1946. An internationally known art critic and historian, he is also a published poet (member of the Académie de Poésie Européenne and winner of the John Llewellyn Rhys Memorial Prize), an anthologist, and a practicing photographer. He has published more than a hundred books in all and is generally regarded as the most prolific and most widely published writer on art. A number of his art books, among them *Movements in Art Since 1945*, *Visual Arts of the 20th Century*, *A Dictionary of Art Terms*, and *Art Today*, are used as standard texts throughout the world. He has also written *The Glory of Angels* and a biography of Joan of Arc.

Scala credits

RIGHT **Christ the Savior and Lifegiver**
Metropolitan John the Icon-painter
14th century